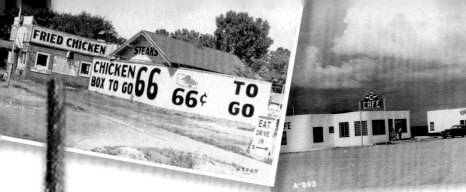

Joe Sonderman

Get Your Pics on

Route 66

Postcards from America's Mother Road

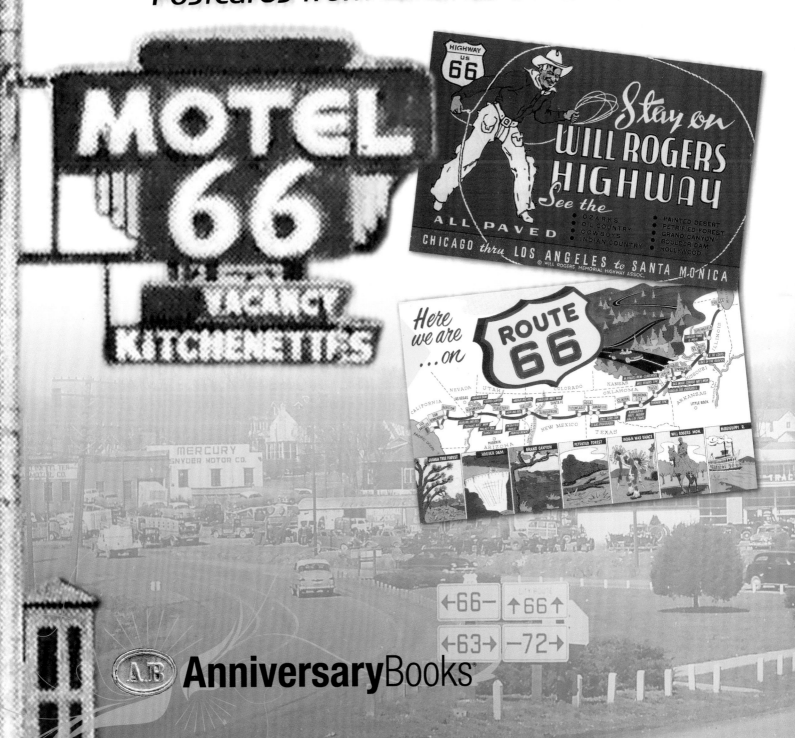

AB Anniversary Books

66 Hotel Court
U. S. Hwy. 66
Litchfield, Ill.
AAA
Recommended

66 HOTEL COURT

45 COTTAGES COOK'S COURT
TRAV-O-TEL

Plaza and Old Church, Laguna Indian Pueblo 18

OKLAHOMA
LEAD & ZINC
MINE
TOUR
UNDERGROUND
TOUR

LOCATED ON HIGHWAY 66, TWO MILES SOUTH OF BAXTER SPRINGS, KANSAS

COCKTAIL LOU
Modern in every way, yet moderately priced.
FABULOUS STEAKS
Kingman, Arizona
"On Top Of The Town"
Photo by Dean Riggins

AERI
VI
O
METE
CRA

Show
Ro
to
Observa
Poin
on t
Crate
Rim

19 mi
WWest

Winsl
Arizo
E-420

POST CARD

STATE CAPITOL, SPRINGFIELD, ILL.

OLDEST HOUSE IN U.S.A.-Santa Fe, New Mexico
S.W. Post Card Co.
Albuquerque

TUNNELS, LOS ANGELES, CALIFORNIA.

All postcards, photos and memorabilia come
from Joe Sonderman's private collection
except: postcard 344 on page 117 (Courtesy
Jim Coad); postcards 345 on page 118, 377
on page 128, 386 on page 131 (Courtesy Phil
Gordon); postcard 312 on page 108 (Courtesy
Michael Truax); postcards 289 on page 102,
311 on page 108, 320 on page 111 (Courtesy
Nancy Tucker); postcards 171 on page 64, 196
on page 73, 285 on page 85 (Courtesy Mike
Ward).

THE CURTEICH-CHIC
Amarillo, Tex.

Statale 17 vs Route 66

In books such as Kerouac's On the Road, *we can read things like: "That evening we left, Jack, Dean and I, in Dean's dad's old 1955 Pontiac and we made it from Omaha to Tucson all in one go". Translated into Italian, that passage could become: "That evening we left in the old Fiat 1100 that belonged to Giuseppe's father and we travelled from Piumazzo to Sant'Anna Pelago all in one go"*

Francesco Guccini[1], presenting the song *Statale 17* during a concert

The reader might ask why an Italian editor would be interested in a book about Route 66. For those like me who live "between the Via Emilia and the West"[2] Route 66 embodies the American legend, the dream of finding the "Promised Land" at the end of the never-ending strip of asphalt immortalized in song by Bruce Springsteen.

This book looks at the legend of Route 66. It is a journey through time, as well as through physical space, a guide book that leads us "from Chicago to LA." It takes us to back to the days when Route 66 was the way West. It was before the Interstate blasted through the landscape, devastating many small towns and businesses that relied on the traffic.

Route 66 is more than a ribbon of asphalt. It is a pop culture icon, known all around the world. In *The Grapes of Wrath*, John Steinbeck called it, "The Mother Road." Since Nat King Cole first sang "(Get Your Kicks on) Route 66," it has been celebrated in story and song, as well as by television shows and movies. Most recently, the Disney movie *Cars* has bolstered the legend and introduced a whole new generation to Route 66. The fictional town of Radiator Springs symbolizes what has been lost, a time when cars were big, rock and roll was king and life was simpler. It was a time when Route 66 was truly the Main Street of America.

Thanks to the work and passion of Joe Sonderman, a true custodian of the Route 66 memories, the reader can return to the time when small towns were ablaze with neon. An unceasing flow of truckers, tourists and migrants kept the colorful motels filled. The pump jockeys hurried to check the oil and wash the windshield and the waitresses scurried to refill steaming cups of black coffee.

Joe, from his privileged location in St. Louis, breathed the atmosphere of Route 66 since he rode in the back of his father's station wagon. Today, his enormous collection of postcards is complimented by stories of those who loved along Route 66. The 400 postcards featured in this book tell most of those stories. During the golden age of Route 66, postcards were a cheap way for business to promote themselves, and an easy way for the traveler to send a note to the folks back home.

In those days before mass media, it was the postcards that helped create the images of Route 66 in the minds of those thousands of miles away. A typical image might be a big car parked on a main street, as shown here. But this view was actually made in Italy. Here, a chrome-laden Pontiac is riding on a street that could be Statale 17. It illustrates that in our minds, Gatteo Mare is not far from the end of Route 66 at the Santa Monica pier.

Paolo Battaglia

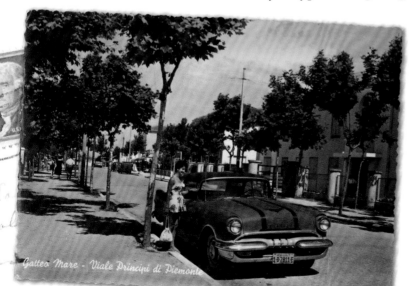

1. Francesco Guccini has been one of the most famous Italian songwriter and singers for over 40 years. His first record, the Dylan-inspired *Folk Beat*, dated 1967, includes the song *Statale 17* that tells the tale of a hitchhiking trip along an Italian State Highway.

2. Another quotation by Guccini to describe the Valley that crosses over Northern Italy, around the ancient Roman road known as *Via Aemilia* (today Via Emilia).

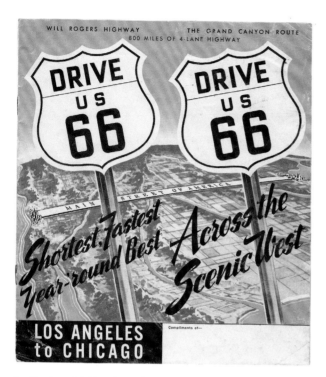

By the late 1940s, the U.S. Highway 66 Association boasted that Route 66 included 800 miles of four-lane highway and was the "First Choice of Experienced and Informed Travelers."

History of Route 66

Route 66 is arguably the most famous road in the world. But it was never just a road. Roads take you to a destination. Route 66 is a destination. It's for those who think that getting there is at least half the fun. Today, Americans travel at 75 miles per hour in air conditioned cruise- controlled comfort, distracted by stereos, DVD players and video games. They don't have time to admire the landscape and meet the people. The same generic chain motels and fast food restaurants are clustered at each freeway exit. If you want to savor life, it begins at the Interstate off ramp.

Parts of Route 66 follow old Indian Trails and early overland wagon routes, such as Beale's Wagon Road, the Santa Fe Trail, California and Overland Trails. The railroads closely followed these routes and dominated travel until the beginning of the 20th Century. The number of registered automobiles in the U.S. grew from just 500,000 in 1910 to almost 10 million by 1920. Motorists, commercial agricultural interests and other business groups launched a movement for better roads and Congress passed the Federal Aid Road Act of 1916, providing the first federal assistance to the states for road building.

Meanwhile, promoters were developing a tangled web of roads across the U.S. They gave their road an important sounding name, and painted color-coded stripes on fence posts, telegraph poles or any handy surface. Drivers followed the confusing colors to travel the Lincoln Highway, the Dixie Highway, or the Old Spanish Trail. In 1917, an association mapped out the Ozark Trail route from St. Louis to Romeroville, New Mexico. From there, it joined the National Old Trails Road to Los Angeles.

By 1920, the situation was out of hand. Some of the associations made money from "contributions" by merchants to have the highway routed past their business. It didn't take long for the hapless driver to realize he had been taken miles out of his way to be routed past a store or through a certain town. Sometimes, highways would take two or more different routes, so the promoters could collect from merchants in other towns. Many of the routes overlapped, and poles and fence posts were often painted top to bottom with a confusing rainbow of colors. The promoters often spent little of the money on actual road improvements or maintenance.

In 1925, the American Association of State Highway Officials approved a numbering system calling for east-west federal highways to be assigned even numbers. The north-south routes would be given odd numbers. The most important

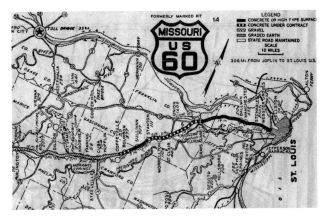

Missouri's 1926 road map showed the Chicago to Los Angeles Route as U.S. 60.

Cyrus Avery, "The Father of Route 66," proposed the route and formed the U.S. 66 Highway Association.

east-west routes would end in zero, and the primary north and south routes would end in one or five. The important-sounding 60 was assigned to the highway between Chicago and Los Angeles.

Maps went to press in Missouri showing Route 60 linking St. Louis and Joplin. But Kentucky Governor William J. Fields had other plans. Governor Fields was upset that no routes ending in the important-sounding "0" passed through his state. He persuaded federal officials to assign the number 60 to the highway running between Newport News, Virginia and a point near Springfield, Missouri. The highway between Chicago and Los Angeles was to be designated U.S. 62. Of course, this didn't set too well with officials in Missouri and Oklahoma. Missouri State Highway Commission Chief Engineer A.H. Piepmeier and Cyrus Avery, Chairman of the Oklahoma Department of Highways, said they would accept only the number 60 for the Chicago to Los Angeles route. Angry telegrams flew.

Cyrus Avery is often referred to as "The Father of Route 66." Avery's family operated a service station and restaurant complex outside Tulsa, so he had more than a passing interest in good roads and pushed for the Ozark Trail route to pass through his hometown. Avery later headed the board that chose which existing state highways would make up part of the new federal system. He fought the trail promoters and politicians to ensure that the Chicago to Los Angeles route followed the old Ozark Trail.

Avery and Piepmeier continued their battle with the Governor of Kentucky on into April of 1926. At a meeting with Avery and Piepmeier in Springfield, Oklahoma Chief Highway Engineer John Page noticed that the catchy sounding "66" had not been assigned. On April 30, 1926, they fired off another telegram to federal officials, saying they would be willing to accept the number "66" for the Chicago to Los Angeles Route. Springfield can thus lay claim to being the birthplace of Route 66.

The Secretary of Agriculture approved the 96,000 mile Federal Highway System routes on November 11, 1926. Within a few months, representatives from several states on the route founded the U.S. 66 Highway Association. The stated goal of the association was to promote the highway and the businesses lining the route. John T. Woodruff of Springfield was named as the first president. Woodruff built the Kentwood Arms Hotel in Springfield

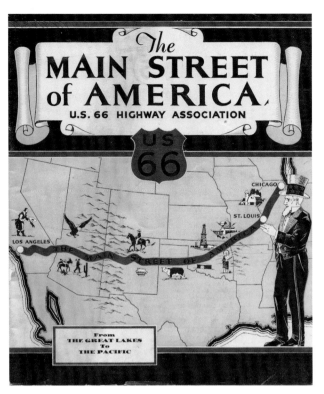

Another U.S. 66 Highway Association brochure promoted Route 66 as "The Main Street of America," a phrase coined by Cyrus Avery.

along the future Route 66. He was also one of the original backers of the Ozark Trail. At the U.S. 66 Highway Association's first meeting in Tulsa in February 1927, Cyrus Avery coined the name "The Main Street of America" for promotional materials.

Route 66 was a great highway in name only. Only 800 miles were paved, with only 64 miles of pavement between the Texas line and California. The other 1,221 miles had a surface ranging from bricks and gravel to dirt and mud. Illinois and Kansas were the only states where Route 66 was completely paved.

The U.S. 66 Highway Association immediately went to work promoting the highway. Billboards went up, maps went out, and press releases flowed, touting Route 66 construction. But it was good old-fashioned foot power that put Route 66 on the map for good. In 1928, the U.S. 66 Highway Association teamed with flamboyant promoter C.C. "Cash and Carry" Pyle to stage a transcontinental foot race. It would prove to be one of the most grueling athletic events of all time. The runners would travel from Los Angeles to Chicago along 66, then swing towards the finish line in New York City! On March 4, 1928, 275 runners started in the "Bunion Derby." An army of reporters was close behind. The race actually was one of the first integrated sports events, but the black runners faced abuse from hostile crowds.

Pyle planned to charge communities along the route to host his traveling circus, complete with sideshow attractions, the world's largest coffee pot and the first portable radio station. But many of his deals fell through and Pyle failed to provide adequate food and shelter while he traveled in comfort aboard a custom motor coach. Some runners cheered when Pyle's motor coach was repossessed in Illinois.

There were just 72 runners left when they crossed the Mississippi at St. Louis on April 27. Only 70 runners made it to Chicago. Just 55 were left when a part-Cherokee Indian from the Route 66 town of Foyil, Oklahoma crossed the finish line in the Big Apple on May 26th. Andy Payne made the 3,400 mile run in 87 days, or about 573 hours of actual time on the road. Payne won 25,000 dollars, C.C. Pyle lost a pile of money, and Route 66 reaped the publicity.

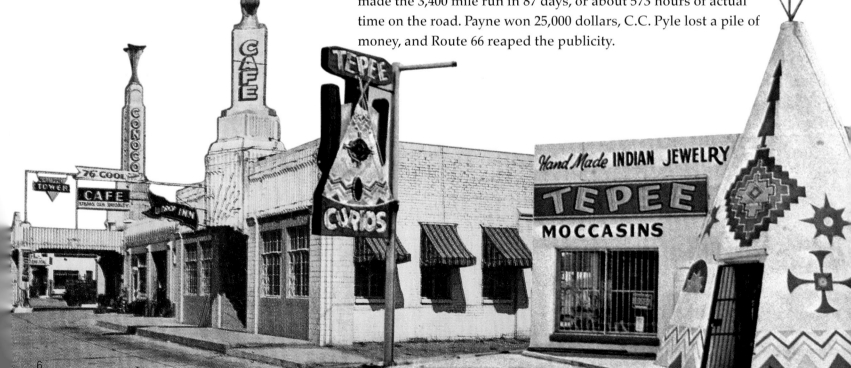

These "Okies," with a mattress tied to the roof of their battered car, were photographed in Amarillo, Texas in 1941.

As travel increased, businesses quickly sprang up to serve the traveler. Early motorists avoided the finery of the big city hotels, at first simply camping on the side of the road wherever they pleased. But local farmers soon had their fill of what they derisively called "tin can tourists." Some communities, eager to attract tourist dollars, began sponsoring local free campgrounds. But the camps also attracted undesirables and most were closed. Modern motels were soon being constructed, with the architecture and signage becoming more elaborate as competition increased.

The images of choking black dust clouds and overloaded jalopies are enduring symbols of Route 66 during the 1930s as thousands fled drought and crop failure in Oklahoma, Kansas, Missouri and Arkansas. In *The Grapes of Wrath*, his 1939 novel describing the plight of a fictitious family of refugees, John Steinbeck wrote,

"66 is the path of a people in flight, refugees from dust and shrinking land, from the thunder of tractors and shrinking ownership, from the desert's slow northward invasion, from the twisting winds that howl up out of Texas, from the floods that bring no richness to the land and steal what little richness is there. From all of these the people are in flight, and they come into 66 from the tributary side roads, from the wagon tracks and the rutted country roads.

66 is the mother road, the road of flight."

But 66 also provided an economic lifeline for those who stayed to operate cafes, tourist courts and gas stations.

Government relief programs also put men to work improving the highway. In May 1938, the last gap in the Route 66 pavement was closed in Oldham County, Texas. It was just in time for Route 66 to play a vital role for the military during World War II. The movement of troops and equipment and construction of military bases and airfields spurred improvements to the highway, particularly a section in the Missouri Ozarks near Ft. Leonard Wood. The war also triggered another western migration, as workers headed for aircraft and defense plants on the West Coast. But leisure travel was severely limited by shortages and rationing and the U.S. 66 Highway Association faded away.

The post-World War II era is considered the golden age of Route 66. Roadside hucksterism was at its height. Establishments tried hard to set themselves apart from the competition. They turned to roadside reptile ranches, basket weaving, rock curios or concocted legends about outlaw Jesse James. Jack D. Rittenhouse described the attractions and amenities along the route in his self published *A Guide Book to Route 66*. Original copies are now prized collectibles.

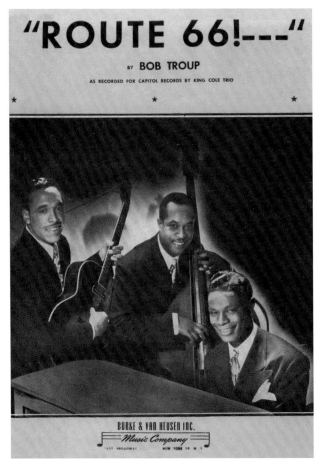

The Nat King Cole Trio recorded the most famous version of Bobby Troup's "Route 66" in 1946. It has since been recorded by dozens of artists.

A hit song made Route 66 an even bigger pop culture icon. Songwriter Bobby Troup was on a trip west with his wife Cynthia when she suggested he write a song about Route 40. Troup said that would be silly, since they would soon be traveling on Route 66. Just outside St. Louis, Cynthia whispered "Get Your Kicks on Route 66." Nat King Cole recorded the song on March 16, 1946 and it just missed the top ten on the pop chart. Since then, it has been recorded by dozens of other artists.

In 1947, the U.S. Highway 66 Association was re-organized, operated by Jack and Gladys Cutberth out of their home in Clinton, Oklahoma. They promoted Route 66 as "The Shortest, Fastest Year-'Round Best Across the Scenic West." They were able to boast "800 miles of 4-lane Highway," because a major transformation was taking place. The modern highway brought safety and convenience for the motorists, but had dire consequences for those who depended on the roads. The big chains and franchises and road improvements were forcing mom and pop motels, café and gas station owners out of business.

The U.S. Highway 66 Association continued its work to promote the highway. In 1952, they launched a cross-country promotional caravan to dedicate 66 as The Will Rogers Highway, in honor of the comedian and philosopher who said "I never met a man I didn't like." (People had been calling 66 the Will Rogers Highway for years anyway) The tour coincided with the release of the movie *The Story of Will Rogers*. The Association placed ads in travel publications and magazines such as *The Saturday Evening Post*.

Even as businesses along 66 reveled in the post war boom, change was already in the air. During World War II, General Dwight David Eisenhower saw how good roads were vital for national defense. He also saw construction as a way to stimulate the economy. Congress passed his Federal Highway Aid Act in 1956. On August 2, 1956, Missouri became the first state to award a contract under the new law, for work on four-lane Route 66 in Laclede County. The nation's first actual Interstate construction took place west of the Missouri River on I-70 at St. Charles, west of St. Louis, Missouri.

While the Interstate began replacing the narrow and often dangerous two lane roads, a whole new generation was discovering the allure of Route 66. Beginning on October 7, 1960, the television series *Route 66* beamed images of the Mother Road into the nation's living rooms. *Route 66* told the story of a pair of young drifters, Buz Murdock (played by George Maharis) and Tod Stiles (portrayed by Martin Milner). Maharis left the show in 1963, and

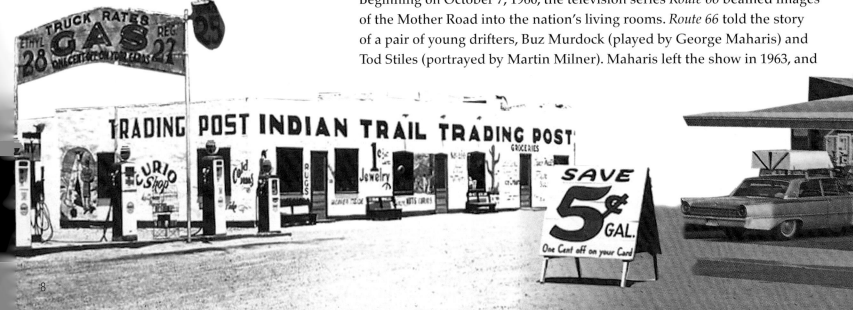

Interstate 44 overshadowed Route 66 in Missouri by the late 1960s. It took five interstates, 55, 44, 40, 15 and 10, to replace Route 66 across the U.S.

was replaced by Glen Corbett as Linc Case. The show was one of the most unique dramas of the 1960s, and one of the first series to leave Hollywood behind for locations on Route 66 and across the country. The theme song by Nelson Riddle became a big pop hit.

In 1962, the State of Missouri took the lead in asking federal highway officials to designate I-55, I-44, I-40, I-15 and I-10 as Interstate 66 from Chicago to Los Angeles. The request was denied because the Interstates used a different numbering system. I-66 was given to a short and nondescript stretch of highway in the Virginia suburbs of Washington, D.C. The Highway Beautification Act of 1965 further crippled the fading roadside small businesses, regulating the billboards they needed to compete with the chains on the Interstate. The big companies with money and political power managed to find loopholes in the law. The small businesses were squeezed out, and today's billboards are even larger and just as numerous.

October 13, 1984 marked the opening of Interstate 40 around Williams Arizona, the last community on Route 66 to be bypassed. In 1985, Route 66 was officially decertified. But the Mother Road didn't die. Nostalgia buffs and roadside rebels continued to seek out the tourist traps, motels and gas stations that still held on for life on 66. They kept the Mother Road alive during those dark days.

Angel Delgadillo, a barber in Seligman, Arizona, gathered a group of business owners who formed the Route 66 Association of Arizona in February 1987. With Angel as an unofficial spokesman dubbed the "Guardian Angel of Route 66," their efforts sparked a revival that spread along the entire highway. In 1990, Michael Wallis published *Route 66 - The Mother Road*. His wonderful prose and pictures captured the romance of the road and inspired even more people, including myself, to take the next exit and discover America at a slower pace. Route 66 has since inspired more preservation efforts, countless books and websites. Today, people come from all over the world to experience the magic of Route 66. It's still there, waiting at the next exit.

Joe Sonderman

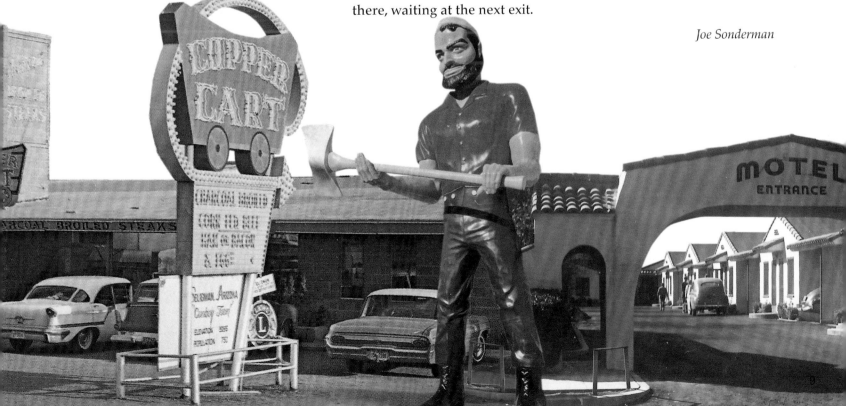

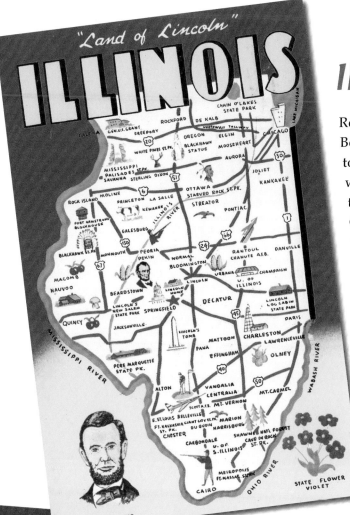

"Land of Lincoln"
ILLINOIS

© CURT TEICH & CO., INC.

Illinois The Land of Lincoln

Route 66 begins in Chicago, originally starting at Michigan and Jackson Boulevards. The terminus was moved to Lake Shore Drive at the entrance to Grant Park in 1937. In 1953, Jackson became one-way eastbound, so westbound 66 traffic was moved to Adams Street. The route passes through the skyscraper canyon and past Lou Mitchell's Restaurant, a Chicago institution since 1923. They still hand out Milk Dud candies to the ladies.

Route 66 passes through Cicero, once the headquarters of ruthless gangster Al Capone. After passing through seemingly endless suburbs and the city of Joliet, the route crosses the Kankakee River and soon opens up onto the great prairie in the heart of Illinois. Before the national highway system was laid out in 1926, this route was the old Pontiac Trail and then State Highway Number 4. The Interstate is boring here, but 66 parallels the railroad into the heart of communities such as Gardner, Dwight, Pontiac, Chenoa and Lexington. The Route 66 Hall of Fame and Museum is in Pontiac. Normal is the birthplace of the Steak n' Shake Restaurant chain, with the motto "In Sight it must be Right," and neighboring Bloomington is "The Hub of the Corn Belt." South of Bloomington, make sure to pick up some maple "sirup" at Funk's Grove. The Dixie Travel Plaza at McLean was once the Dixie Trucker's Home, which opened in 1928. Atlanta is next and then Lincoln, the first community named after the great president while he was still alive.

Springfield was Abraham Lincoln's home and is his final resting place. The life of the 16th president is celebrated at the Abraham Lincoln Presidential Library and Museum. Springfield is also the home of the Cozy Dog, a hot dog on a stick dipped in batter and fried. The Waldmire family has been serving them up since 1946. This was the home of Bob Waldmire, beloved Route 66 artist and traveling philosopher who died in 2009. The original 1926 alignment of Route 66 between Springfield and Staunton offers some old sections still paved with brick, including one winding through the cornfields near Auburn.

The Our Lady of the Road shrine keeps watch over travelers near Raymond as the highway slices straight as an arrow towards St. Louis, reminding us that Route 66 could be a dangerous highway. There are few vintage motels on this segment of Route 66, as the trip between Chicago and St. Louis could easily be made in one day. A four-lane highway was constructed around most of the communities after World War II. Much of the old four-lane survives.

The Ariston Café in Litchfield may be the oldest restaurant still in operation on Route 66. It's been a family run business at this location since 1935. In Staunton, Rich Henry's Rabbit Ranch offers real bunnies as well as Volkswagen Rabbits. The Volkswagens are stuck in the ground, imitating the Cadillac Ranch in Texas.

At Edwardsville, the scenery begins to give way to the suburbs again, with the recommended route turning west through Mitchell. This is the home of the Luna Café. In Al Capone's heyday, the Luna offered illicit gambling and ladies of the evening. It was said that when the cherry on the neon sign was lit, the girls were "in." From the Luna, it's not far to the mighty Mississippi River and the historic old Chain of Rocks Bridge, the gateway to Missouri.

"Large letter" postcards are very popular with collectors, each showing several scenes from the cities and towns. Many of these were printed by the Curt Teich Company of Chicago.

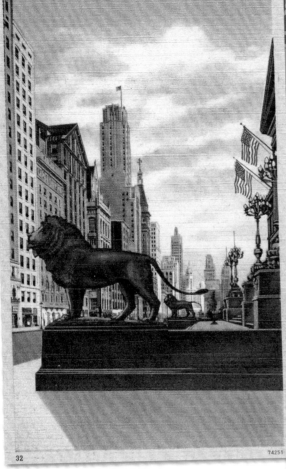

Art institute, Michigan Avenue and Adams Street, Chicago

32 74251

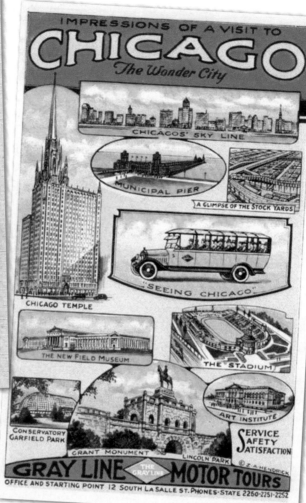

CHICAGO'S SKY LINE

IMPRESSIONS OF A VISIT TO

CHICAGO
The Wonder City

CHICAGOS' SKY LINE

MUNICIPAL PIER

A GLIMPSE OF THE STOCK YARDS

"SEEING CHICAGO"

CHICAGO TEMPLE

THE NEW FIELD MUSEUM

THE STADIUM

CONSERVATORY GARFIELD PARK

GRANT MONUMENT LINCOLN PARK

ART INSTITUTE

SERVICE SAFETY SATISFACTION

GRAY LINE THE GRAY LINE **MOTOR TOURS**
OFFICE AND STARTING POINT 12 SOUTH LA SALLE ST. PHONES-STATE 2250-2251-2252

(1) These bronze lions sculpted by Edward L. Kemeys watch over the Art Institute of Chicago at Michigan Avenue and Adams, built on top of rubble from the Great Fire of 1871. It was constructed to be used during the 1893 world's fair and then turned over to the institute.

Native Americans first used the future path of Route 66 between the Chicago and Illinois Rivers. Jacques Marquette and Louis Jolliet explored the area in 1763. Jean Baptiste Point du Sable, a black fur trader from Haiti, made the first permanent settlement in 1781 and Ft. Dearborn was constructed at the mouth of the Chicago River in 1803. The construction of the Illinois and Michigan Canal and the arrival of the railroad in 1848 made Chicago a major transportation hub. The Great Fire of 1871 destroyed 17,450 buildings, but the city recovered to host the World Columbian Exposition of 1893. Chicago is the birthplace of the skyscraper, the zipper, the vacuum cleaner, *Playboy* magazine and the Ferris wheel. It is also home to the tallest building in North America. The Willis Tower (formerly the Sears Tower) is 1,450 feet tall.

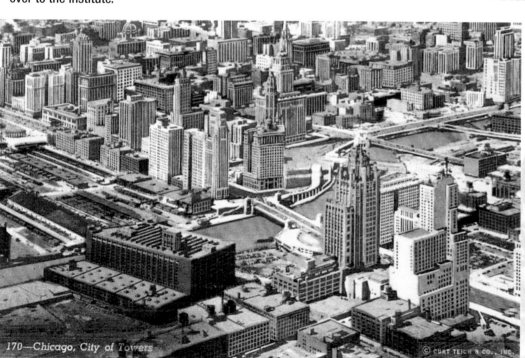

170—Chicago, City of Towers

© CURT TEICH & CO., INC.

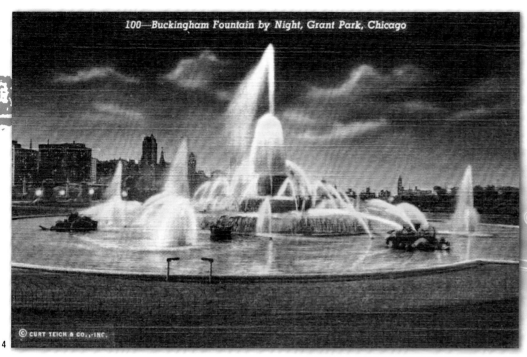

100—Buckingham Fountain by Night, Grant Park, Chicago

© CURT TEICH & CO., INC.

(4) The Buckingham Fountain in Grant Park was dedicated in 1927 and modeled after the Latona Fountain at the Palace of Versailles. It was donated to the city by Kate Buckingham in honor of her brother Clarence.

The fountain symbolizes Lake Michigan and is a symbolic start for Route 66.

(5) The new Union Station, between Jackson and Adams on both sides of Canal Street, was constructed in 1924. Route 66 would use Ogden Avenue **(6)** leaving the city, because a viaduct on Ogden between Western Avenue and Rockwell Street was the only way to cross a sea of railroad tracks. Ogden Avenue continues through Cicero past Henry's Drive-In, famous for its Chicago style hot dogs. The post 1928 route turns briefly onto Harlem Avenue at Lyons, before picking up Joliet Road through Countryside and disappearing beneath I-55.

Henry's "IT'S A MEAL IN ITSELF"

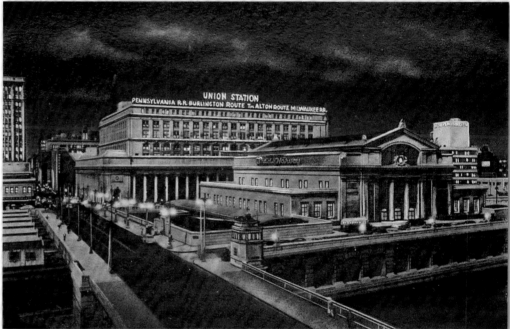

UNION STATION
PENNSYLVANIA R.R. BURLINGTON ROUTE T& ALTON ROUTE MILWAUKEE RR.

5
6

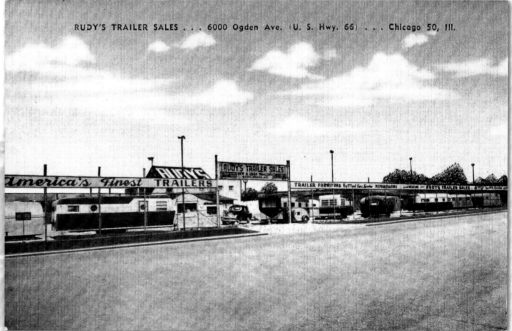

RUDY'S TRAILER SALES . . . 6000 Ogden Ave. (U. S. Hwy. 66) . . . Chicago 50, Ill.

Irv Kolarik ran a gas station and lunch counter in Willowbrook but decided to focus solely on food. Two local women offered him their fried chicken recipe and Irv soon needed more room. In 1946, his "Nationally Famous Chicken Basket" (7) moved to a building next door that had once housed the Club Roundup and Triangle Inn. To attract business in the winter, Irv flooded the roof of the restaurant with water and hired ice skaters. Dell Rhea and his wife Grace bought the restaurant in 1963. Rhea's son Patrick took over in 1986.

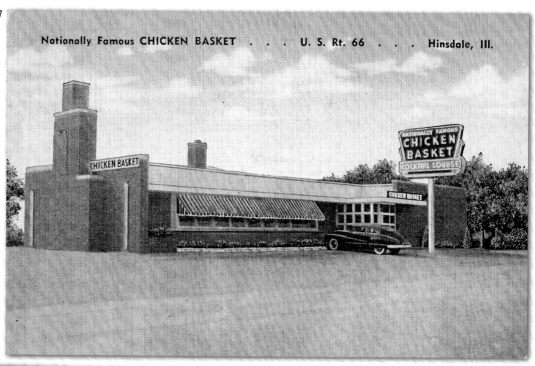

Nationally Famous CHICKEN BASKET . . . U. S. Rt. 66 . . . Hinsdale, Ill.

SUNNYSIDE MOTEL

U. S. RTS. 66 and 45 — LA GRANGE, ILL.

John Blackburn built the Wishing Well Motel (9) at Route 66 and Brainard Avenue in 1941. Emil and Zora Vidas took over in 1958 and connected the 10 original cabins. Emil died in 1985, Zora passed away in 2004 and the Wishing Well was demolished in 2007. The wishing well from the courtyard and the sign were saved and are on display at the Route 66 Museum in Pontiac.

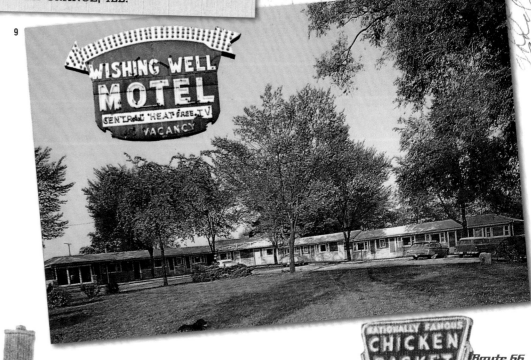

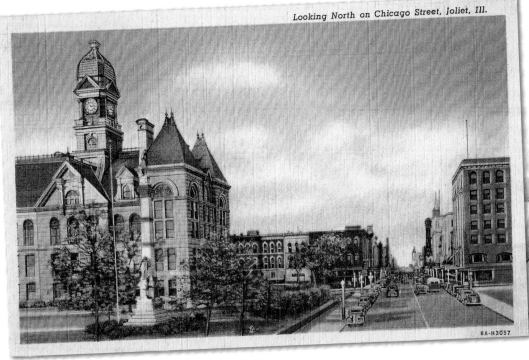

Looking North on Chicago Street, Joliet, Ill.

8A-H3057

10

Hotel
LOUIS JOLIET
JOLIET, ILLINOIS

11

22698N

UNITED STATES POSTAGE
1 CENT 1

OST CARD

(handwritten address)

IN THE *Center* OF EVERYTHING...

Hotel
LOUIS JOLIET
JOLIET, ILLINOIS

Manor Motel - U. S. 6 and 66 - Joliet, Ill.

12

Route 66 originally followed Chicago Street (10) through Joliet. Chicago Street later became one-way southbound and northbound traffic used Ottawa Street. In 1940, the route was moved to pass through Plainfield and the Joliet route became "Alternate 66." Joliet was originally named Juliet, probably a corruption of the name of explorer Louis Jolliet. The name was changed in 1845. Route 66 met the Lincoln Highway here at the "Crossroads of America." Route 66 landmarks include the Rialto Theatre, constructed in 1926 and the White Fence Farm Restaurant, dating back to 1920. The former Stateville Correctional Prison, now the Joliet Correctional Center, was featured in the 1980 film *The Blues Brothers*.

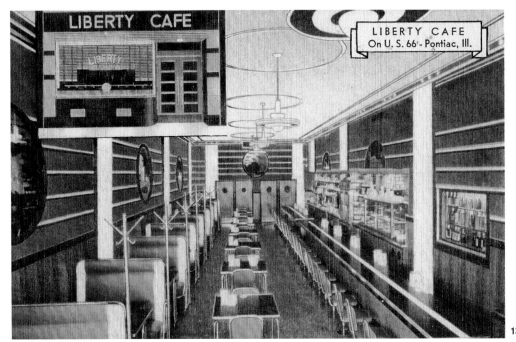

The Route 66 Association of Illinois Hall of Fame and Museum is located in the restored city hall and fire station in Pontiac. P. N. Petropoul's Liberty Café **(13)** was nearby on the square.

Steve Wilcox, a chef at the Wahl Brothers Café, took over the operation in 1930s. Steve's **(14)** was the first air conditioned restaurant in Illinois outside of Chicago. The Chenoa Motel **(16)** was nearby at the intersection of Route 66 and U.S. 24.

Joe and Victor Selotti used cedar phone poles to build the Log Cabin Inn **(15)** in 1926. They turned the building around to face the new highway in the 1940s. Little has changed since.

13

14

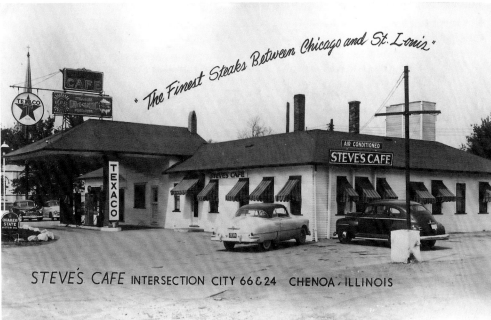

STEVE'S CAFE INTERSECTION CITY 66 & 24 CHENOA, ILLINOIS

"The Finest Steaks Between Chicago and St. Louis"

15

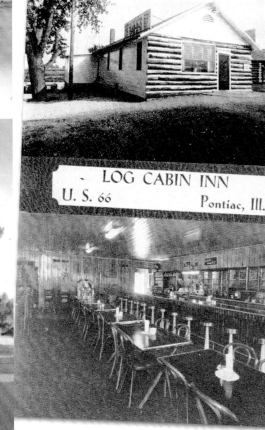

16

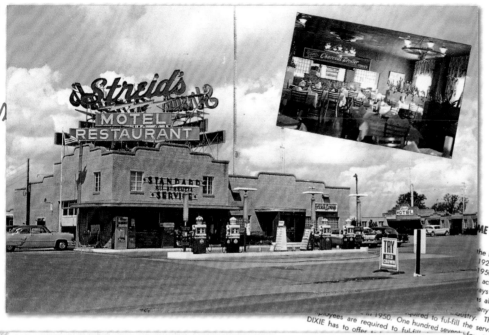

Paul Streid's restaurant **(17)** was located on the 1941 Beltline route around Bloomington, an early expressway.

This postcard for the Hotel Illinois **(18)** shows the system of paved state highways in place before Route 66 was commissioned.

J.P. Walters and his son-in-law John Geske opened the Dixie Trucker's Home **(19-20)** at McLean in 1928. Fire destroyed the original building in 1965. The Dixie was family owned until 2003.

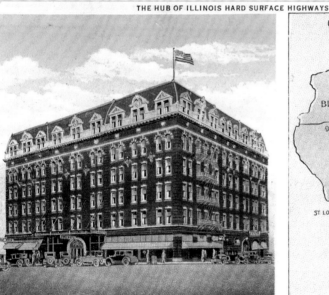

THE HUB OF ILLINOIS HARD SURFACE HIGHWAYS

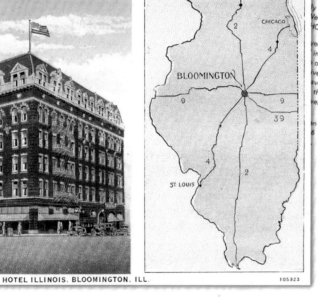

FIREPROOF

HOTEL ILLINOIS, BLOOMINGTON, ILL.

105923

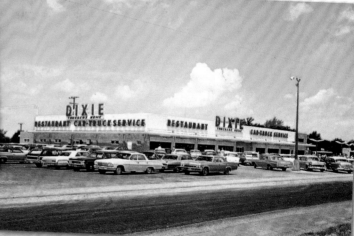

The Lincoln motel (21) was located in the only town named after Abraham Lincoln while he was still alive. Honest Abe himself used watermelon juice to christen the town of Lincoln in 1853.

In 1940, a bypass route around Springfield was created using 31st Street (later the Dirksen Parkway) and Linn Avenue, now Adlai Stevenson Drive. The Broadview Motor Court (22) was located at the intersection with Sangamon Avenue, U.S. 54.

Greetings from

ON U. S. 66
Two Blocks South of City Limits

A. LINCOLN MOTEL

2927 South Sixth Street - Dial 4-1701
Springfield, Illinois

AAA

Springfield's Ultra Modern Court - Brick Construction - Tile Baths

Telephones - Television - Air-Conditioned

Note the western style gate with a steer head in this view of the Lazy A Motel (23). The motel still stands, converted to apartments.

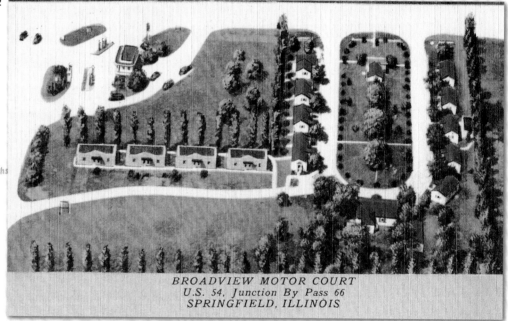

BROADVIEW MOTOR COURT
U.S. 54, Junction By Pass 66
SPRINGFIELD, ILLINOIS

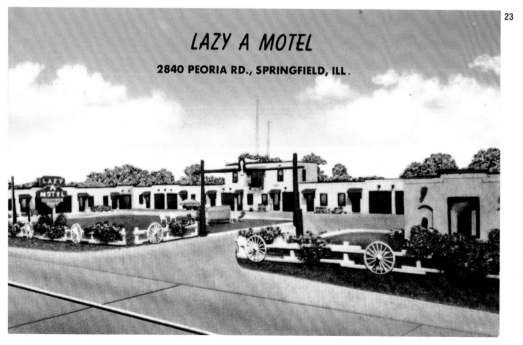

LAZY A MOTEL
2840 PEORIA RD., SPRINGFIELD, ILL.

South Fifth Street, Sp

The Hotel Abraham Lincoln (24) at 5th Street and Capitol Avenue opened in 1925. The once luxurious hotel was demolished in 1978.

Springfield was originally named Calhoun, in honor of South Carolina Senator John Calhoun. The name was changed in 1832 and the Illinois State Capitol was moved from Vandalia in 1837. The move was due partly to the efforts of a young politician named Abraham Lincoln. The sixth Illinois Capitol building (25) took 20 years to construct and is 74 feet taller than the U.S. Capitol.

Route 66 originally jogged through downtown Springfield, directly past the Capitol and then followed Illinois Route 4 through Chatham. In 1930, it was rerouted over 9th Street, exiting the city on 6th Street towards Litchfield.

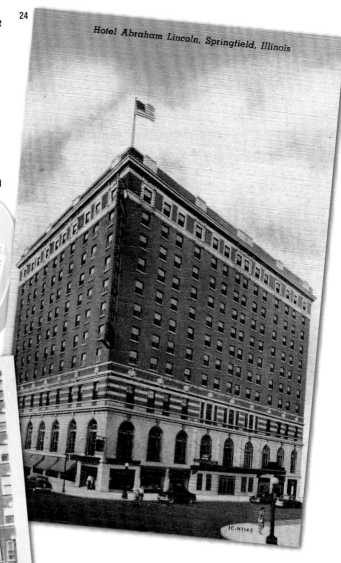

Capitol Avenue, Showing Illinois State Capitol, Springfield, Illinois

Abraham and Mary Todd Lincoln lived in the home (26) at 8th and Jackson Streets from 1844 to 1861. It was the only home they ever owned. The house, constructed in 1838, was enlarged to two stories in 1855. The magnificent Abraham Lincoln Presidential Library and Museum is located on North 6th Street.

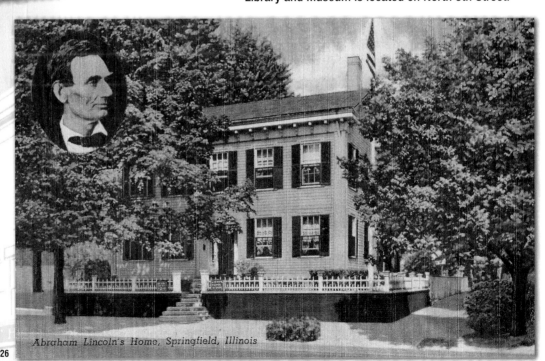

Abraham Lincoln's Home, Springfield, Illinois

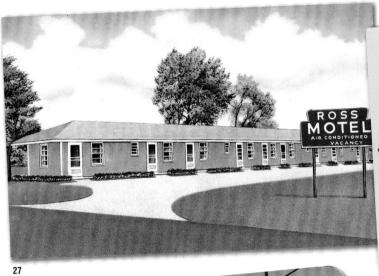

27

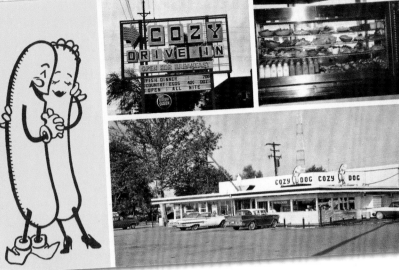

28

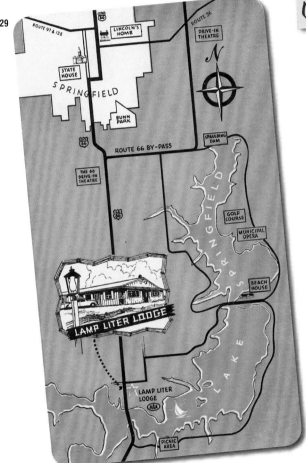

29

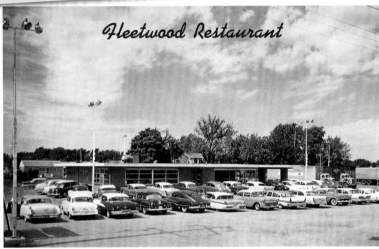

Fleetwood Restaurant

30

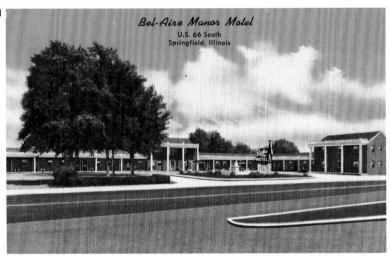

Bel-Aire Manor Motel
U.S. 66 South
Springfield, Illinois

31

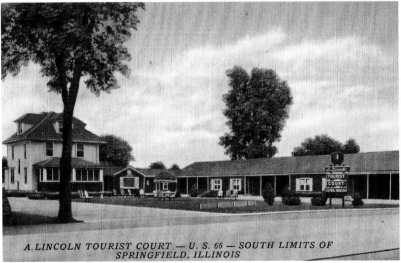

32

A. LINCOLN TOURIST COURT — U. S. 66 — SOUTH LIMITS OF
SPRINGFIELD, ILLINOIS

The Ross Motel **(27)**, the Bel-Aire Manor **(31)** and the Lamp Liter Lodge **(29)** offered accommodations in Springfield.

While stationed in Amarillo during World War II, Ed Waldmire Jr. and his friend Don Strand developed a battered and French-fried hot dog on a stick. His Cozy Dog drive-in **(28)** opened in 1950. Ed's son Bob was renowned Route 66 artist and free spirit, who died in 2009.

The Postgates lived in the home next to their A. Lincoln Motel **(32)**. The Cozy Dog moved to this site in 1996.

Famous for broasted chicken, the Fleetwood Restaurant **(30)** was in business from 1957 to 1993.

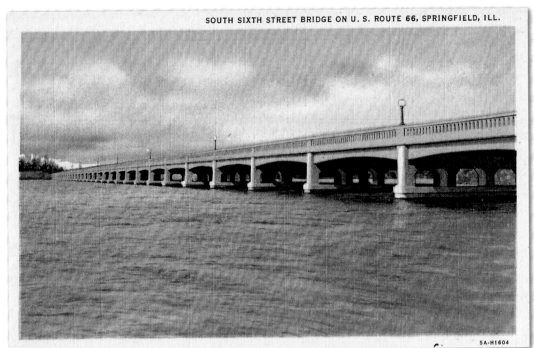

SOUTH SIXTH STREET BRIDGE ON U. S. ROUTE 66, SPRINGFIELD, ILL.

33

5A-H1604

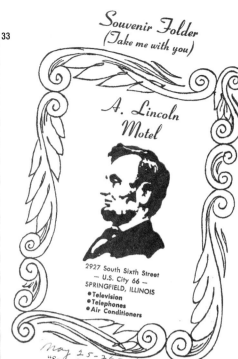

Souvenir Folder
(Take me with you)

A. Lincoln
Motel

2927 South Sixth Street
— U.S. City 66 —
SPRINGFIELD, ILLINOIS
• Television
• Telephones
• Air Conditioners

May 25-26-1957
"Springfield's Ultra-Modern Court"

MILES	TO
100	St. Louis, Mo.
200	Chicago, Ill.
335	Springfield, Mo.
397	Joplin, Mo.
567	Tulsa, Oklahoma
1213	Alburquerque, N. M.
2045	

FOR
RESERVATIONS:
Call

Recommended

34

CHICKEN SEAFOOD STEAKS

35

The South 6th Street Bridge (33) carried Route 66 over Lake Springfield, created in 1935.

Art's Motel and Restaurant (34), and the vintage sign, still stand near Divernon.

The Stuckey's chain (35), famous for pecan log rolls, pralines, and peanut brittle, had a location near Litchfield. The 66 Subway Cafe (36) once competed with the famous Ariston Café.

36

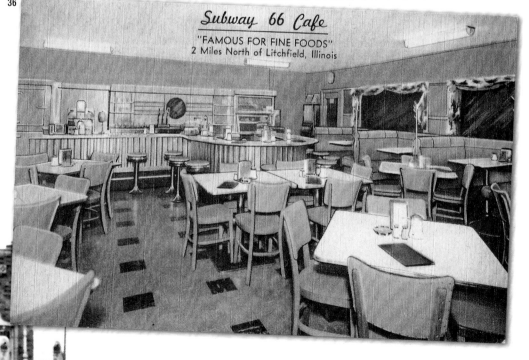

Subway 66 Cafe
"FAMOUS FOR FINE FOODS"
2 Miles North of Litchfield, Illinois

CAFE
Budweiser
ARISTON

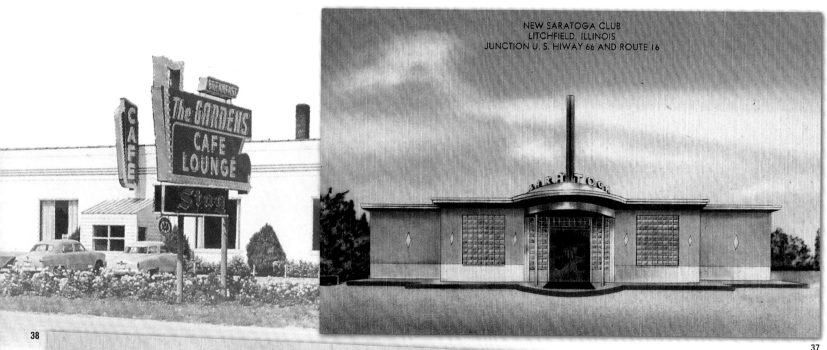

NEW SARATOGA CLUB
LITCHFIELD, ILLINOIS
JUNCTION U. S. HIWAY 66 AND ROUTE 16

Mother Jones Monument, Mt. Olive, Ill.

38

37

Lowell "Hydie" Orr's Saratoga Club (37) was often called most beautiful restaurant between Chicago and St. Louis. The front was covered with vitrolite.

The post 1930 route passes through Mt. Olive, where Henry and Russell Soulsby opened their Shell Station in 1926. Soulsby Service closed in 1993 but the station has been restored. A monument to Mary "Mother Jones" Harris (38), an early labor organizer, is located in the Union Miner's Cemetery on the north side of Mt. Olive. The 66 Terminal (39) once stood on the four-lane that became Interstate 55 just north of Staunton.

MT. OLIVE, ILL., 7-16 , 19 50

Charles Oshuner

SOULSBY'S SERVICE
1st South Street West on Route 66
Phone 3191
SHELL GAS and OIL

3525 tube

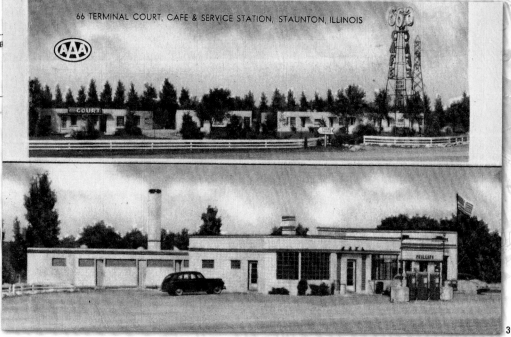

66 TERMINAL COURT, CAFE & SERVICE STATION, STAUNTON, ILLINOIS

39

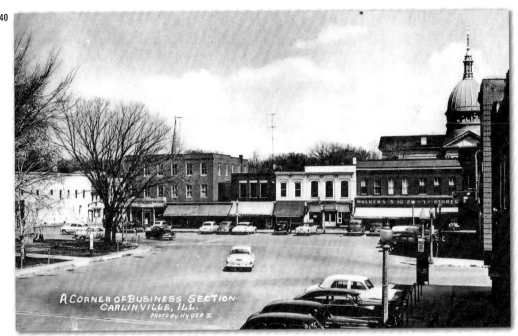

A CORNER OF BUSINESS SECTION
CARLINVILLE, ILL.
PHOTO BY HY GEO Z

From 1926 to 1930, Route 66 zig zagged through the fields along the original Illinois Route 4 between Springfield and Staunton. A rare section paved in brick remains north of Auburn. The old route passed the "Million Dollar Courthouse" in Carlinville (40). When completed in 1870, it was the largest courthouse west of New York City. The pre and post 1930 alignments meet near Hamel, following today's Illinois 157 past the site of Nelson's Cabin Camp (41) and into Edwardsville. Patrons at Orville and Virginia Legate's Motel (42) could catch their dinner in a big lake on the grounds. George Cathcart's Café (43) could seat 250 people and was open around the clock. Mr. Cathcart had a room next door and a bed in back so he could keep an eye on things.

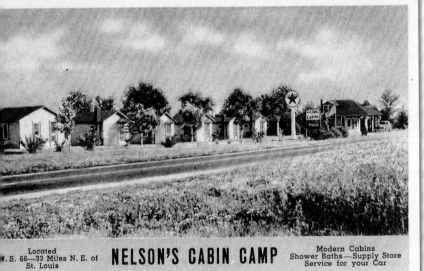

Located
U.S. 66—33 Miles N.E. of St. Louis

NELSON'S CABIN CAMP

Modern Cabins
Shower Baths—Supply Store
Service for your Car

D-5535

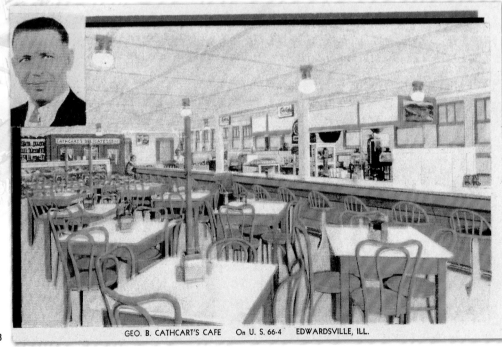

Legate's Modern Motel
U. S. 66 EDWARDSVILLE, ILL.

GEO. B. CATHCART'S CAFE On U. S. 66-4 EDWARDSVILLE, ILL.

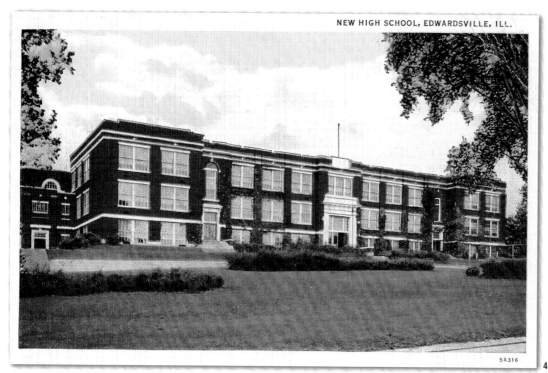

NEW HIGH SCHOOL, EDWARDSVILLE, ILL.

5A316

Edwardsville is the third oldest city in Illinois, and was proud of its new high school (44) in 1925.

Collinsville (46-47) is the "Horseradish Capital of the World," where an annual festival honors the aromatic root. Collinsville had the distinction of being on both Route 66 and U.S. 40. Just south of Route 66 in Collinsville, the Brooks Catsup Water Tower (45) at the old bottling plant is a roadside landmark. Built in 1946, it was narrowly saved from demolition and restored in 1995.

44

45

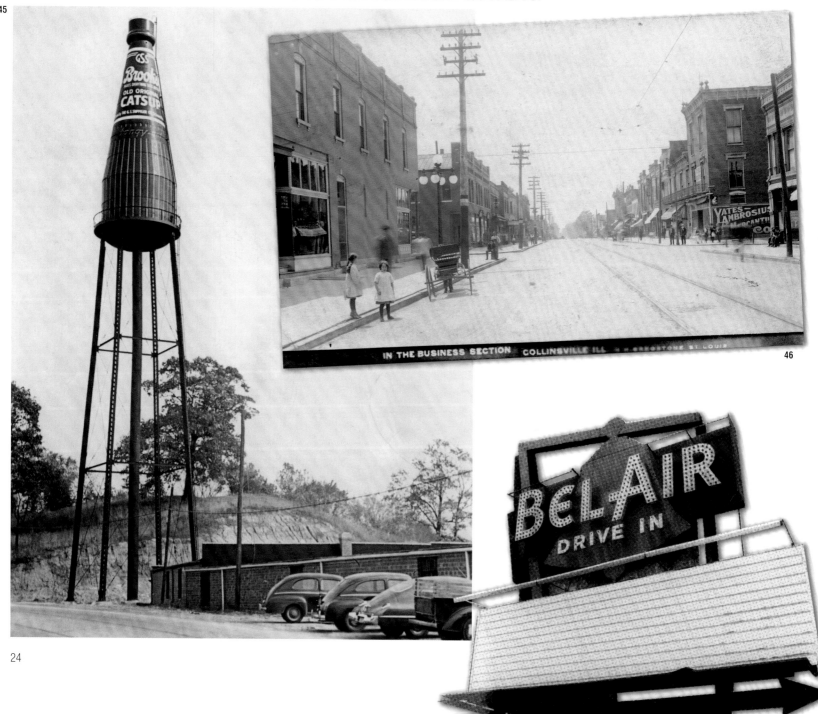

IN THE BUSINESS SECTION COLLINSVILLE ILL

46

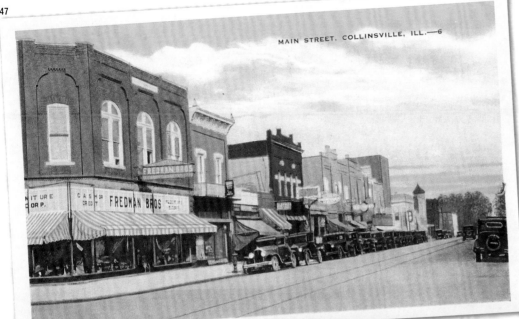

MAIN STREET, COLLINSVILLE, ILL.—6

Route 66 followed a bewildering web of different routes into St. Louis, originally passing through Granite City, Madison and Venice, later through East St. Louis **(49)**. This is not a scenic route today. The recommended route follows the 1936-1955 mainline and 1955-1965 bypass route along Chain of Rocks Road. This route goes through Mitchell, past the Luna Cafe to the Chain of Rocks Bridge. In 1955, Route 66 was shifted onto the newly constructed freeway that became Interstate 55/70. **(48)** This 1966 photo was taken during construction of the maze of ramps that now carry Interstates 55/70 and 64 across the Mississippi.

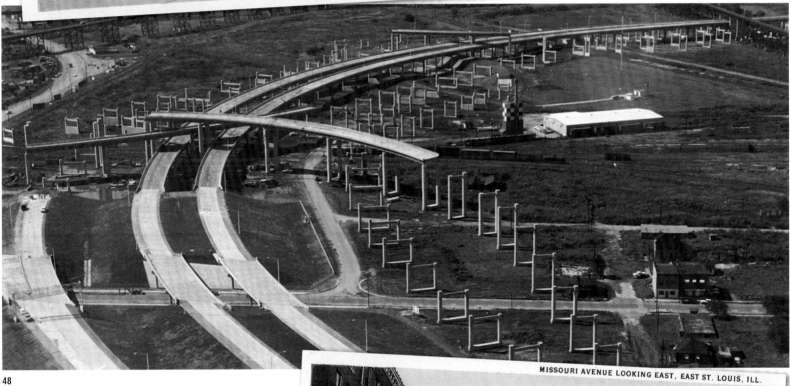

48

STEAKS CHICKEN SEA FOOD
fine drinks pkg. goods
Luna CAFE

MISSOURI AVENUE LOOKING EAST, EAST ST. LOUIS, ILL.

118641

49

MISSOURI The Show Me State

Route 66 in Missouri is a very old road, partly a network of trails used by the Kickapoo and the Osage Indians. After the government erected a telegraph line between St. Louis and Springfield, parts of the route became known as the "Wire Road." During the Civil War, the blue and the gray trudged the dusty path to fight at Wilson's Creek and Carthage. The Old Wire Road became part of the Ozark Trail route in 1917 and was designated as Route 14 when the state highway system was laid out in 1922.

It can be very hard to sort out the web of routes 66 used over the years through the "Gateway to the West." Five different bridges have carried the highway across the Mississippi River. The best-known route leaves downtown on 12th Street, following Gravois and then Watson Road past Ted Drewes Frozen Custard. From 1926 to 1932, original 66 followed Manchester Road, now clogged with traffic and lost amid suburban sprawl. Another route crossed the Chain of Rocks Bridge, skirting north of the city and dropping south on Lindbergh Boulevard through Kirkwood.

No trace remains of the community of Times Beach, west of St. Louis. It was wiped off the face of the Earth by floods and chemical contamination. The cleaned up site is now Route 66 State Park. Billboards and barns advertise Meramec Caverns at Stanton, the "Greatest Show under the Earth," an attraction that retains the good old spirit of roadside hucksterism.

Bourbon provides a popular photo opportunity, with its water towers marked "Bourbon." Cuba is "Mural City USA," with historic murals gracing the buildings. Connie Echols has restored the Wagon Wheel in Cuba, the best preserved 1930s era motel on Route 66. West of Cuba, the world's largest rocking chair sits out front at the Fanning Outpost General Store.

The highway rolls into the Ozark hills west of Rolla and is lined with buildings constructed from distinctive native rock. This is a region of deep forests, sparkling streams, hidden caves and spectacular bluffs. The Interstate blasts through this beautiful country with no regard for the scenery. But Route 66 wound its way down the steep grade at Arlington and into the resort community of Devils Elbow. This stretch is one of the most beautiful anywhere on the route.

After passing through Lebanon, the highway moves well away from the Interstate, past Conway, Marshfield and Strafford before arriving in Springfield, the "Queen City of the Ozarks." The Rail Haven and Rest Haven Motels here are well-preserved.

West of Springfield, the communities of Halltown, Phelps and Avilla were hit hard by the arrival of the Interstate. This segment is known as the "Ghost Highway," due to the numerous roadside ruins. But there is life here, as Route 66 ambassador of goodwill Gary Turner greets travelers at his replica gas station in Paris Springs.

Carthage is next, with its magnificent courthouse and the Route 66 Drive-In theatre west of town. Mark Goodman restored the only survivor of the six drive-in movie theatres that once bore the Route 66 name. Webb City was once the heart of the Tri-State Mining District, but was hit hard when the mines closed.

The City of Joplin was originally two lawless and feuding mining camps, and the highway has been detoured several times over the years due to collapsing mine shafts. Now marked as Missouri Route 66, the highway heads west straight towards Kansas. But a beautiful section of old two-lane awaits at a turn-off just before the state line.

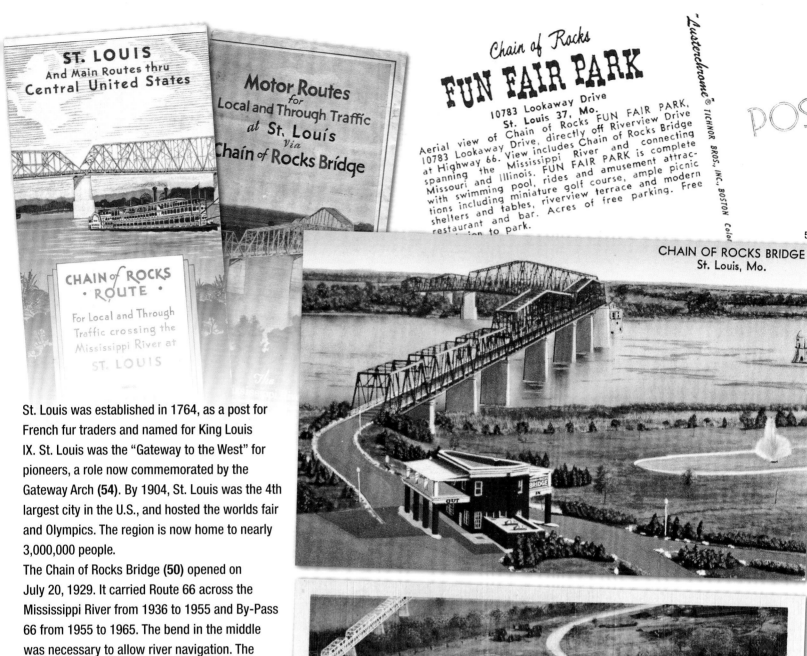

St. LOUIS
And Main Routes thru
Central United States

Motor Routes
for
Local and Through Traffic
at St. Louis
via
Chain of Rocks Bridge

CHAIN of ROCKS
· ROUTE ·
For Local and Through
Traffic crossing the
Mississippi River at
ST. LOUIS

Chain of Rocks
FUN FAIR PARK
10783 Lookaway Drive
St. Louis 37, Mo.
Aerial view of Chain of Rocks FUN FAIR PARK,
10783 Lookaway Drive, directly off Riverview Drive
at Highway 66. View includes Chain of Rocks Bridge
spanning the Mississippi River and connecting
Missouri and Illinois. FUN FAIR PARK is complete
with swimming pool, rides and amusement attrac-
tions including miniature golf course, ample picnic
shelters and tables, riverview terrace and modern
restaurant and bar. Acres of free parking. Free
____ion to park.

POST

50

CHAIN OF ROCKS BRIDGE
St. Louis, Mo.

St. Louis was established in 1764, as a post for French fur traders and named for King Louis IX. St. Louis was the "Gateway to the West" for pioneers, a role now commemorated by the Gateway Arch (54). By 1904, St. Louis was the 4th largest city in the U.S., and hosted the worlds fair and Olympics. The region is now home to nearly 3,000,000 people.

The Chain of Rocks Bridge (50) opened on July 20, 1929. It carried Route 66 across the Mississippi River from 1936 to 1955 and By-Pass 66 from 1955 to 1965. The bend in the middle was necessary to allow river navigation. The bridge closed in 1970. It was nearly demolished and then served as a set for the cheesy film *Escape from New York* in 1981. In 1996, Gateway Trailnet leased the landmark and made it one of the longest bicycle and pedestrian bridges in the world.

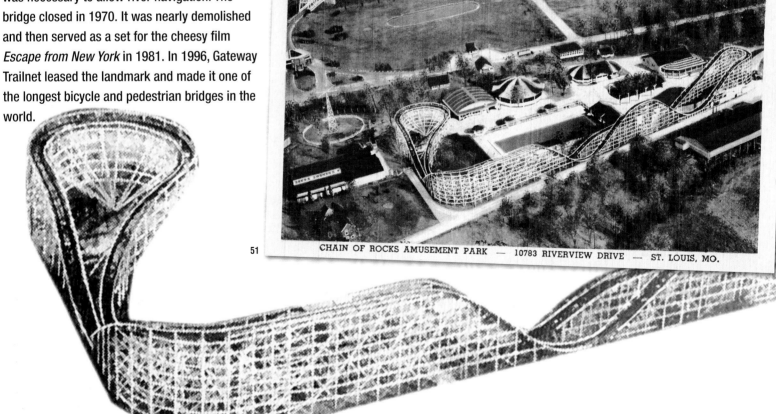

51 CHAIN OF ROCKS AMUSEMENT PARK — 10783 RIVERVIEW DRIVE — ST. LOUIS, MO.

The Chain of Rocks Amusement Park (51) stood on the bluff overlooking the bridge. The Comet roller coaster shown here was torn down in 1958, the same year the park was renamed Chain of Rocks Fun Fair. It closed in 1977 and homes stand on the site today.

The Municipal Bridge (52) opened in 1916 and was renamed in honor of General Douglas MacArthur in 1942. It carried Route 66 from 1929 to 1935 and City 66 from 1936 to 1951. It closed to automobile traffic in 1981 but is still used by trains.

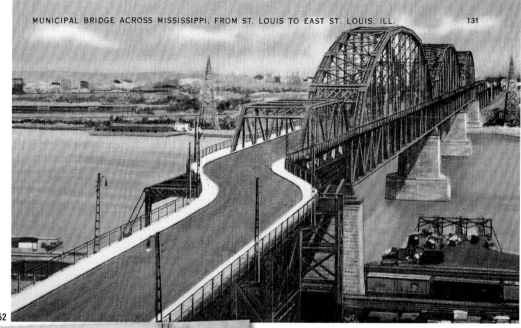

MUNICIPAL BRIDGE ACROSS MISSISSIPPI, FROM ST. LOUIS TO EAST ST. LOUIS, ILL.

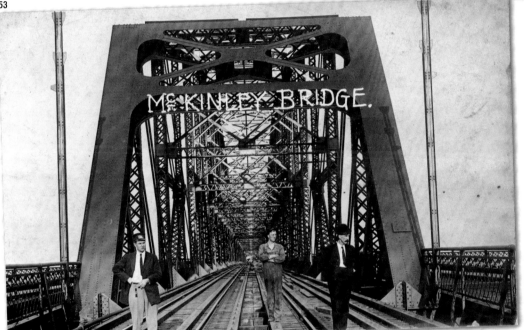

Route 66 originally crossed the Mississippi River on the McKinley Bridge (53), named after Congressman William B. McKinley. Railroad traffic originally used the center, with vehicles on the outside of the superstructure. Today the outer lanes are for bicycle and pedestrian traffic. Route 66 also used the Veteran's (Now Martin Luther King) Bridge from 1955 to 1967 and the Poplar Street Bridge from 1967 to 1977.

From 1940 to 1979 the gleaming *S.S. Admiral* (54) cruised on the Mississippi at St. Louis. She was the largest inland steamship in the U.S., with a ballroom that held 2,000 dancers. The *Admiral* was later converted to a casino but was scrapped in 2010.

ROAD MAP OF METROPOLITAN ST. LOUIS

SHOWING LEADING HIGHWAYS TO, FROM AND THROUGH ST. LOUIS VIA

McKINLEY BRIDGE

St. Louis approach to McKinley Bridge, 3724 North Ninth Street

City Route U.S. 66

OPTIONAL CITY ROUTE U.S. 66 crosses McKINLEY BRIDGE

IS SIX MILES SHORTER THAN REGULAR U.S. 66 ROUTE BETWEEN MITCHELL, ILL. AND KIRKWOOD, MO.

TOLL RATES Car and

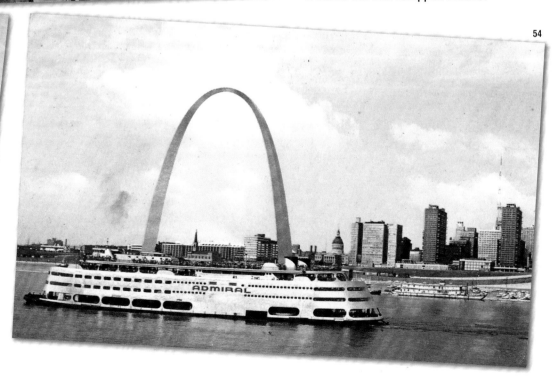

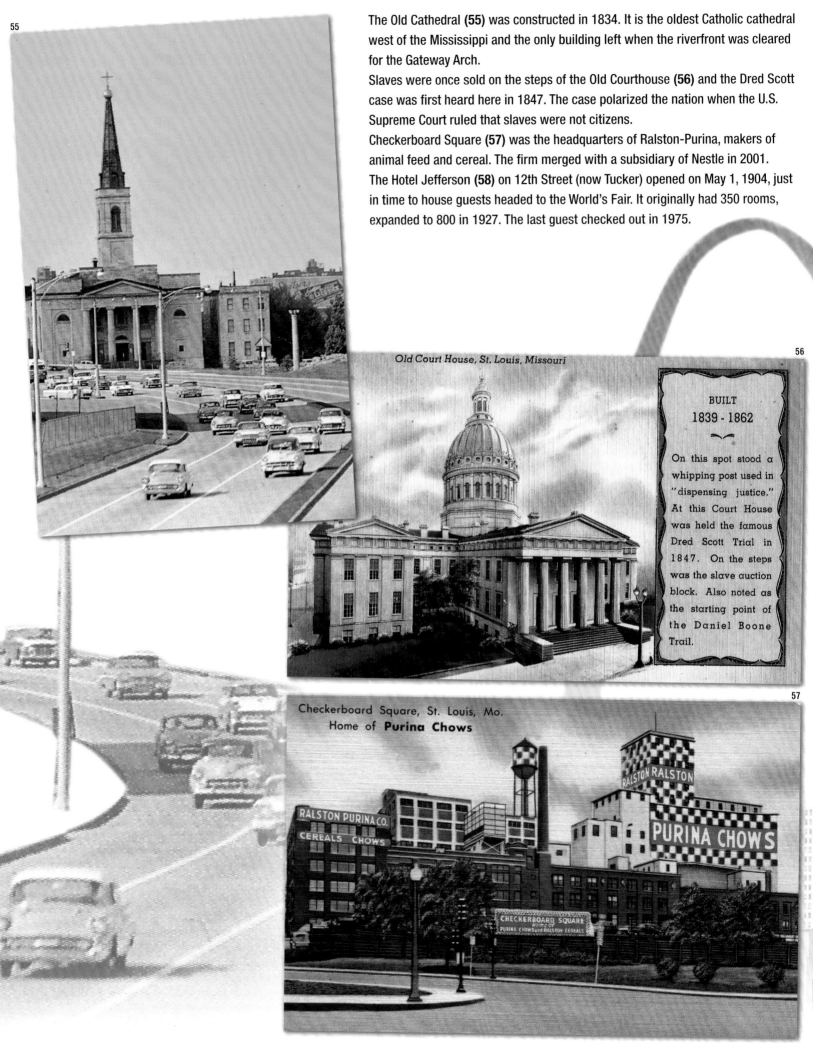

The Old Cathedral **(55)** was constructed in 1834. It is the oldest Catholic cathedral west of the Mississippi and the only building left when the riverfront was cleared for the Gateway Arch.

Slaves were once sold on the steps of the Old Courthouse **(56)** and the Dred Scott case was first heard here in 1847. The case polarized the nation when the U.S. Supreme Court ruled that slaves were not citizens.

Checkerboard Square **(57)** was the headquarters of Ralston-Purina, makers of animal feed and cereal. The firm merged with a subsidiary of Nestle in 2001.

The Hotel Jefferson **(58)** on 12th Street (now Tucker) opened on May 1, 1904, just in time to house guests headed to the World's Fair. It originally had 350 rooms, expanded to 800 in 1927. The last guest checked out in 1975.

Old Court House, St. Louis, Missouri

BUILT
1839 - 1862

On this spot stood a whipping post used in "dispensing justice." At this Court House was held the famous Dred Scott Trial in 1847. On the steps was the slave auction block. Also noted as the starting point of the Daniel Boone Trail.

Checkerboard Square, St. Louis, Mo.
Home of **Purina Chows**

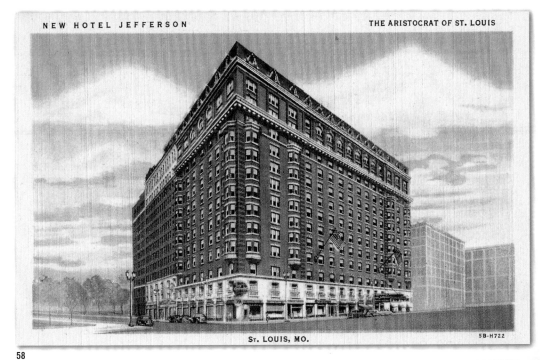

NEW HOTEL JEFFERSON THE ARISTOCRAT OF ST. LOUIS

ST. LOUIS, MO.

5B-H722

58

St. Louis is an avid baseball town and the Cardinals of the National League first played at Sportsmen's Park **(59)**. The Browns of the American League also played here, from 1902 to 1953. The name was changed to Busch Stadium in 1953 and the Cardinals of the National Football League began play there in 1960. The stadium was torn down in 1966.

The first baseball game at Busch Memorial Stadium downtown took place on May 12, 1966. Busch was also the home of the football Cardinals. It was torn down for a new stadium in 2005. The Gateway Arch **(60)**, the nation's tallest national monument, is visible in the view. The Arch is 630 feet tall and is part of the Jefferson National Expansion Memorial. The structure was completed on October 28, 1965.

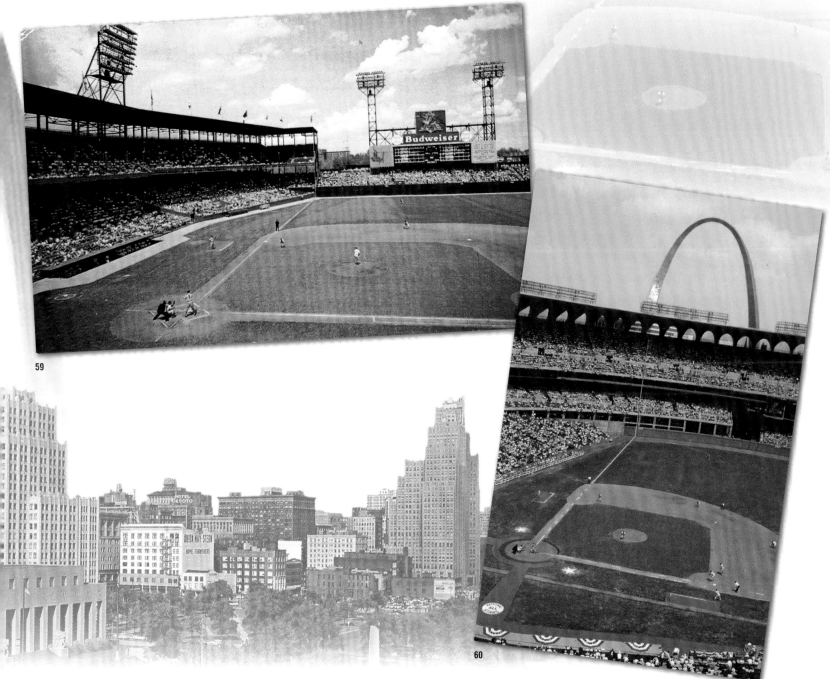

59

60

Union Station **(61)** was the largest depot in the world when it opened in 1894 and once served 100,000 passengers per day on its 32 tracks. The last regular passenger train pulled out in 1978 and the station is now a hotel and retail complex.

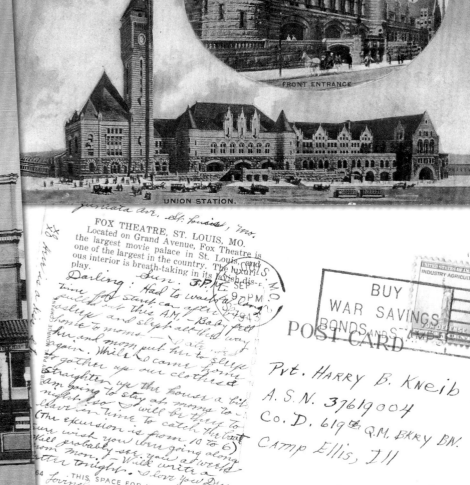

Union Station, St. Louis, Mo.

FRONT ENTRANCE

UNION STATION.

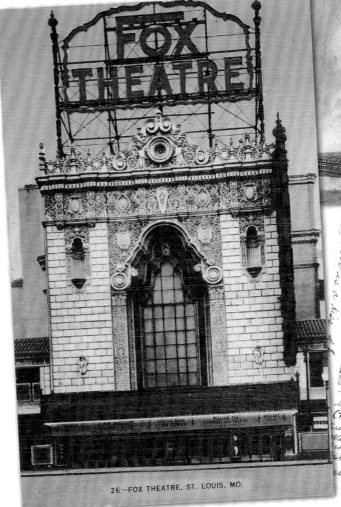

26.—FOX THEATRE. ST. LOUIS, MO.

FOX THEATRE, ST. LOUIS, MO. Located on Grand Avenue, Fox Theatre is the largest movie palace in St. Louis, and one of the largest in the country. The luxurious interior is breath-taking in its lavish display.

Pvt. HARRY B. Kneib
A.S.N. 37619004
Co. D. 619th Q.M. Bkry. BN.
Camp Ellis, Ill

3rd Platoon

THIS SIDE IS FOR THE ADDRESS

The "Fabulous Fox" Theatre **(62)** on Grand Boulevard opened in 1929. The 5,000 seat theater closed in 1978 but was restored in 1982. It is now a venue for concerts and stage productions.

The Automobile Club of America **(63)** originally installed the highway markers, so all four U.S. highways passing through St. Louis were routed past AAA headquarters.

Work on the New Cathedral **(63)** began in 1907 and it was consecrated in 1926. Pope John the Second designated it as the Cathedral Basilica of St. Louis in 1997 and visited during his historic trip in 1999.

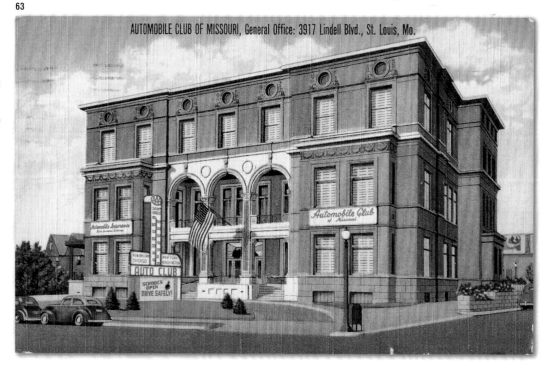

AUTOMOBILE CLUB OF MISSOURI, General Office: 3917 Lindell Blvd., St. Louis, Mo.

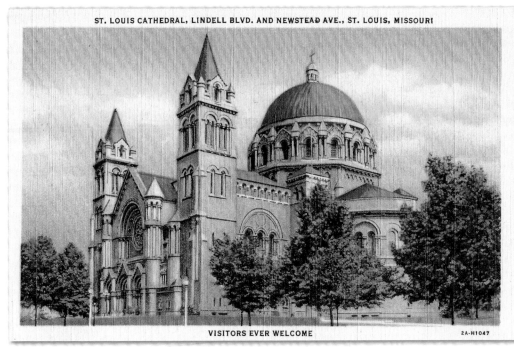

ST. LOUIS CATHEDRAL, LINDELL BLVD. AND NEWSTEAD AVE., ST. LOUIS, MISSOURI

VISITORS EVER WELCOME

2A-H1047

64

The Arena **(65)** opened in 1929 just off Original Route 66 on Oakland Avenue. It was built to house the National Dairy Show, but the Great Depression bankrupted the promoters. The "Old Barn" was the home of the St. Louis Blues of the National Hockey League from 1967-1994 and hosted countless events and concerts. It was imploded on February 27, 1999 for a suburban style office park.

From 1927-1933, Route 66 cut through southern Forest Park, which is 450 acres larger than Central Park in New York. It hosted 20 million visitors during the 1904 world's fair. The nearby Forest Park Highlands **(66)** began as a simple beer garden in 1896 and grew into the premiere amusement park in the city. Most of the amusement park was destroyed by fire on July 19, 1963 and the site is now Forest Park Community College.

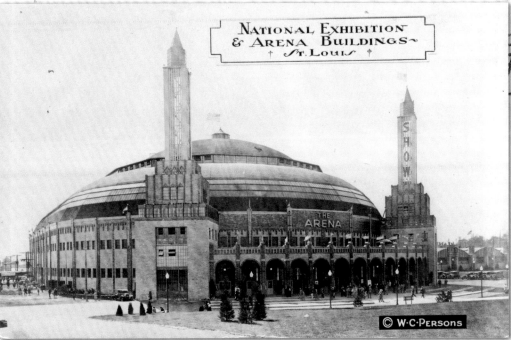

NATIONAL EXHIBITION & ARENA BUILDINGS ST. LOUIS

THE ARENA

© W.C. PERSONS

66

65

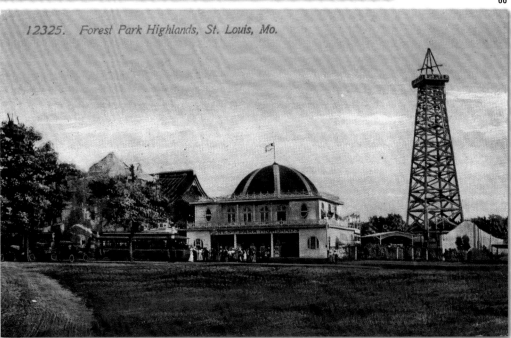

12325. Forest Park Highlands, St. Louis, Mo.

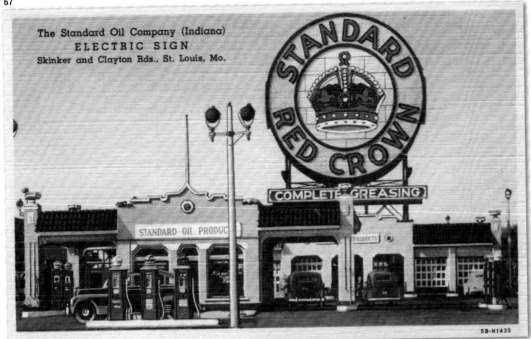

The Standard Oil Company (Indiana)
ELECTRIC SIGN
Skinker and Clayton Rds., St. Louis, Mo.

SB-H1435

The massive sign at the Hi-Pointe Standard **(67)** once helped guide pilots. It was 40 feet wide and 70 feet tall and used as much power as a city of 1,000. It was replaced by a huge plexiglass sign in 1961 and changed to read "Amoco" in 1985.

Original Route 66 followed Manchester Road through Maplewood, passing this Katz Drug Store **(68)**. Brothers Isaac and Michael Katz founded the chain of stores. This building is now a popular restaurant.

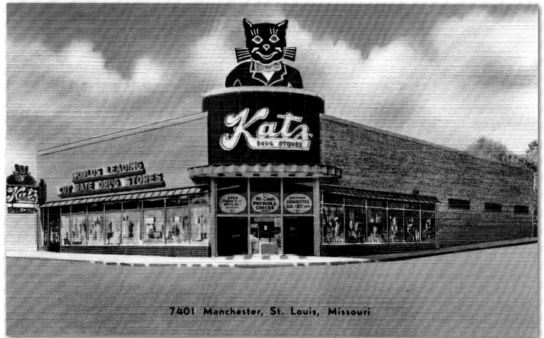

7401 Manchester, St. Louis, Missouri

The 1936-55 mainline and 1955-65 bypass route headed west from Chain of Rocks Bridge and then turned south on Lindbergh Boulevard near the Airport Motel **(70)**. The Ford St. Louis Assembly Plant **(69)** was across the highway. The 3,000,000 square foot plant produced Ford and Mercury automobiles from 1948 until 1984. It later turned out minivans and the Ford Explorer before closing in 2006.

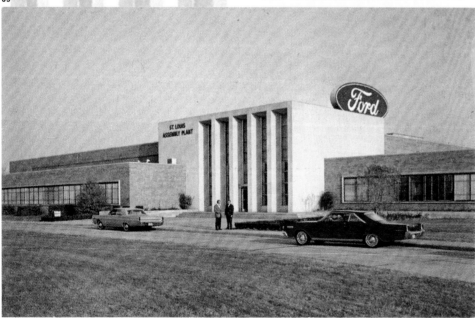

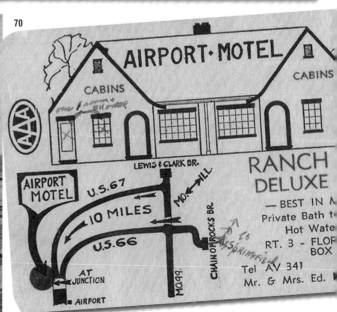

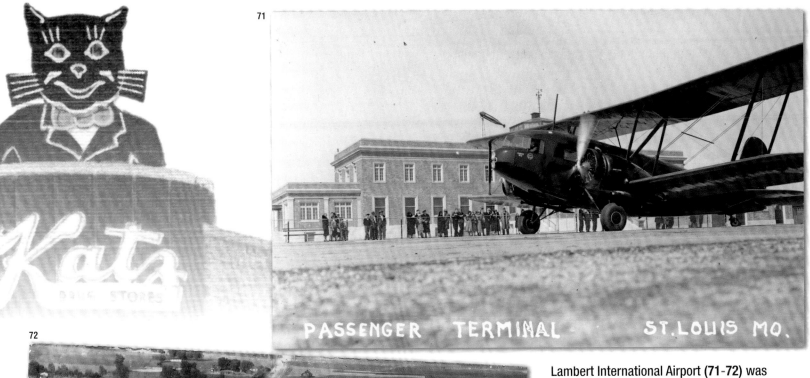

PASSENGER TERMINAL — ST. LOUIS MO.

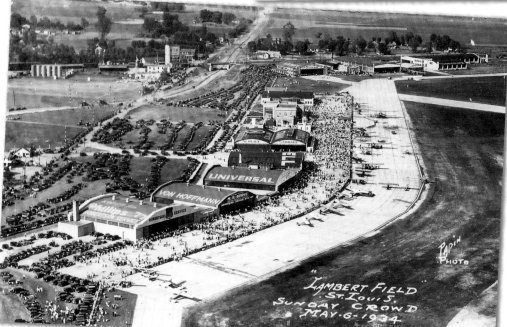

"LAMBERT FIELD"
ST. LOUIS.
SUNDAY CROWD
MAY 6 1934

Lambert International Airport (71-72) was originally a balloon launch site named Kinloch Field, where Teddy Roosevelt became the first president to fly in a plane. Before he made his historic flight in the *Spirit of St. Louis*, Charles Lindbergh flew the mail from the field named for aviation pioneer Albert Bond Lambert. The first terminal on Route 66 could handle four airplanes at a time when it opened in 1933. It was criticized as being too large.

The current Lambert Airport terminal (73) opened in 1956. Minoru Yamasaki, who went on to design the World Trade Center, was one of the designers. The headquarters of the McDonnell Aircraft Company adjoined the airport. McDonnell built military aircraft as well as the Mercury and Gemini space capsules. The firm merged with Boeing in 1996.

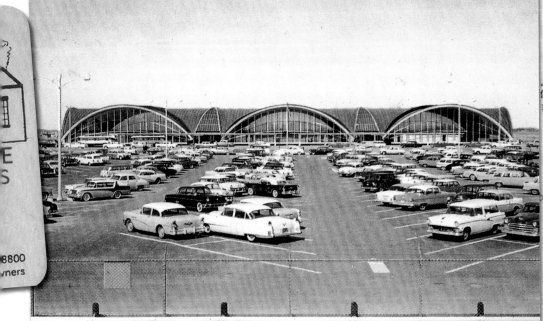

13,885

When you travel, you'll be proud to say –
"I stopped at the new MOTEL ST. LOUIS"
. . . located on Highway 66 & 67, just across
from St. Louis Municipal Airport. Ultra-modern
rooms – Air-conditioned for your comfort –
Television for your pleasure.
MOTEL ST. LOUIS, Phone Avery 7178
Route 1, Box 652, Robertson, Missouri.

May 25, 195

Dear Folks,

Well this is our first stop since we left Chicago this afternoon. We are headed for California. Having a wonderful trip love

Missouri - The Show Me State

35

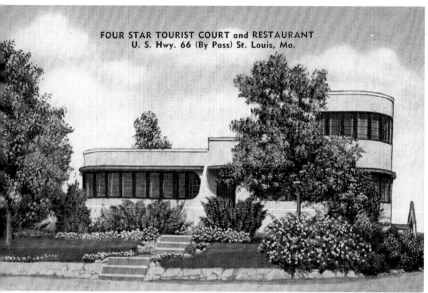

FOUR STAR TOURIST COURT and RESTAURANT
U. S. Hwy. 66 (By Pass) St. Louis, Mo.

74

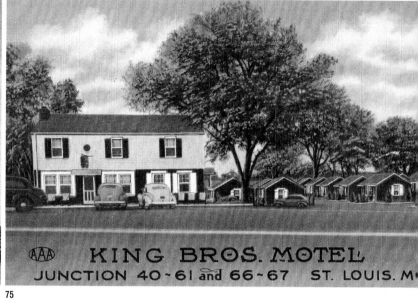

AAA KING BROS. MOTEL
JUNCTION 40~61 and 66~67 ST. LOUIS, M

75

The Four-Star Tourist Court **(74)** in St. Ann had an interesting streamline design. The King Brothers Motel **(75)** could boast of being at the intersection of four U.S. highways. In 1933, Route 66 was moved from Manchester to a route partly using the New Watson Road to Gray Summit. When the mainline moved to the Chain of Rocks Bridge in 1936, the Watson route became City 66.

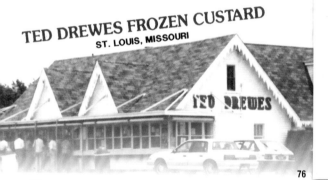

TED DREWES FROZEN CUSTARD
ST. LOUIS, MISSOURI

77

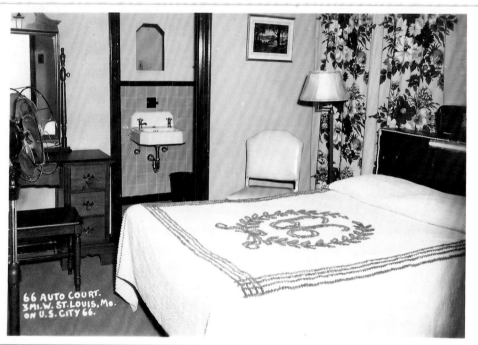

66 AUTO COURT.
3 MI. W. ST. LOUIS, MO.
ON U.S. CITY 66.

76

This is the best known route through St. Louis, once lined with motels like the 66 Auto Court **(76)**. This view shows what $2.50 per night bought for travelers in 1946. The Coral Court **(77)** was the most famous motel on 66. The first units opened in 1941, nestled among the trees. Late in its life, the Coral Court gained a racy reputation, due to its short term rates and private garages. In 1953, the motel's mystique grew when it was connected to the sensational kidnapping and murder of young Bobby Greenlease. Half of the $600,000 ransom was never found. The Coral Court closed in 1993 and was torn down in 1995 to make room for a subdivision. One unit was partly reconstructed at the Museum of Transportation in St. Louis County.

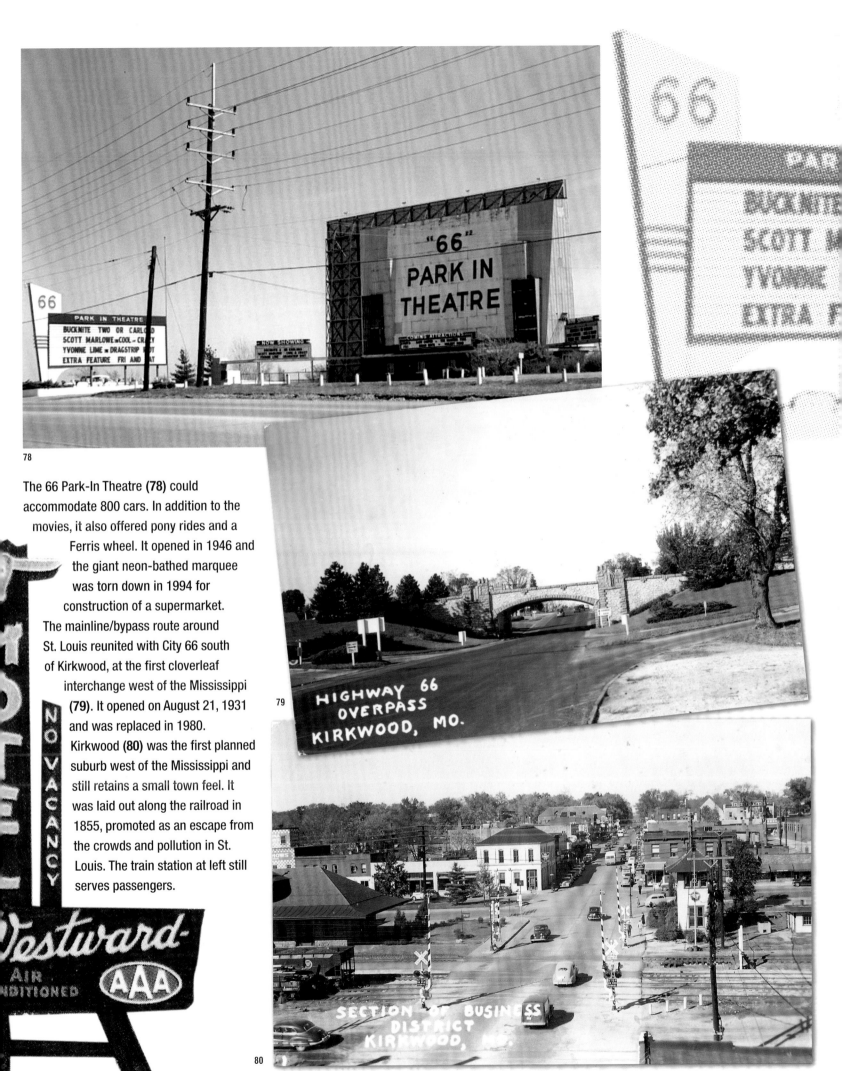

The 66 Park-In Theatre **(78)** could accommodate 800 cars. In addition to the movies, it also offered pony rides and a Ferris wheel. It opened in 1946 and the giant neon-bathed marquee was torn down in 1994 for construction of a supermarket. The mainline/bypass route around St. Louis reunited with City 66 south of Kirkwood, at the first cloverleaf interchange west of the Mississippi **(79)**. It opened on August 21, 1931 and was replaced in 1980. Kirkwood **(80)** was the first planned suburb west of the Mississippi and still retains a small town feel. It was laid out along the railroad in 1855, promoted as an escape from the crowds and pollution in St. Louis. The train station at left still serves passengers.

HIGHWAY 66 OVERPASS KIRKWOOD, MO.

SECTION OF BUSINESS DISTRICT KIRKWOOD, MO.

These Missouri State troopers stopped at Nelson's Café (81), part of the Park Plaza Courts complex on the northwest side of Watson at Lindbergh.

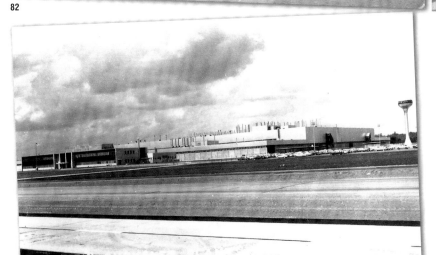

BUSINESS STREET, MANCHESTER, MO.

TRAV-O-TEL AUTO COURT
Valley Park, Mo.

MEMBER NATIONAL
TRAV-O-TEL-SYSTEM Steam Heat Electric Fans

U. S. HIGHWAY NO. 66
11 MILES WEST OF ST. LOUIS

The 1926-1932 route passed through the sleepy village of Manchester (82), now a major suburb.

The attractive Trav-O-Tel Deluxe Court (83) was part of an early chain, but fell victim to the flooding Meramec River.

At one time St. Louis was the second largest producer of automobiles in the nation. The massive Chrysler Plant (84) opened in 1959 but closed in 2009.

Before I-44 was constructed, Sylvan Beach (85) was a popular recreation spot on the Meramec River.

The Bridgehead Inn (86) was a notorious roadhouse until Edward Steinberg took over in 1947 and opened Steiny's Inn. The building served as the EPA headquarters during the controversial cleanup of dioxin in Times Beach and is now the Route 66 State Park visitor center.

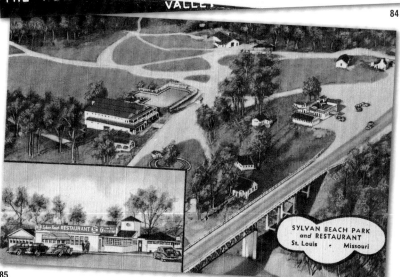

THE NEW CHRYSLER VALLEY

SYLVAN BEACH PARK
and RESTAURANT
St. Louis • Missouri

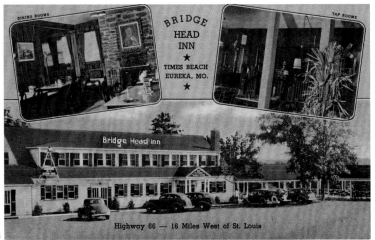

BRIDGE HEAD INN
★
TIMES BEACH
EUREKA, MO.
★

DINING ROOMS TAP ROOMS

Bridge Head Inn

Highway 66 — 16 Miles West of St. Louis

Former bootleggers James and William Smith used cedar logs to construct the Red Cedar Tavern **(87)** in 1934. The business remained in the family until closing in March 2005.

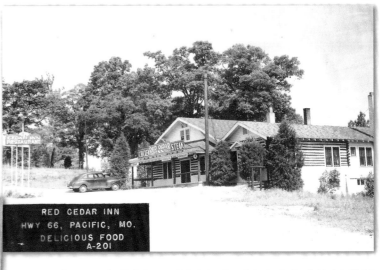

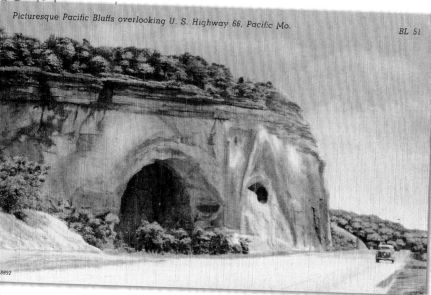

Picturesque Pacific Bluffs overlooking U. S. Highway 66, Pacific Mo.

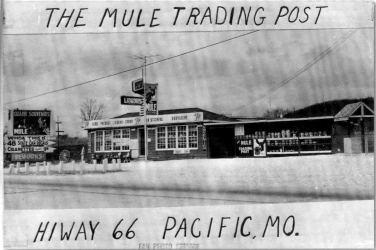

Pacific **(90)** was originally known as Franklin, re-named when the Pacific Railroad arrived. The rebels burned part of the town in 1864. Caves created by silica mining were exposed when the bluff **(88)** was cut back for construction of new Route 66 in 1932-1933.

Frank Ebling founded the Mule Trading Post **(89)** in Pacific in 1946. After I-44 was constructed, Ebling moved it to Rolla, where the mule still greets visitors today.

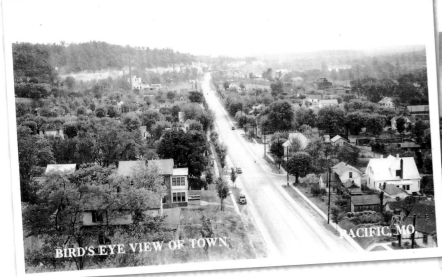

BIRD'S EYE VIEW OF TOWN PACIFIC, MO.

The Lovelace family built the Sunset Motel **(91)** in 1946. Oliver Lee and Loleta Krueger ran it from 1971 to 2006. It is still in the family, and the beautiful sign was restored in 2009.

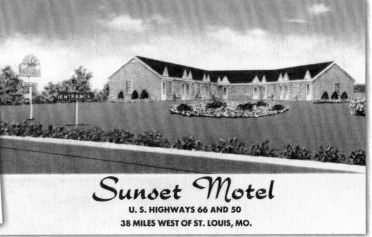

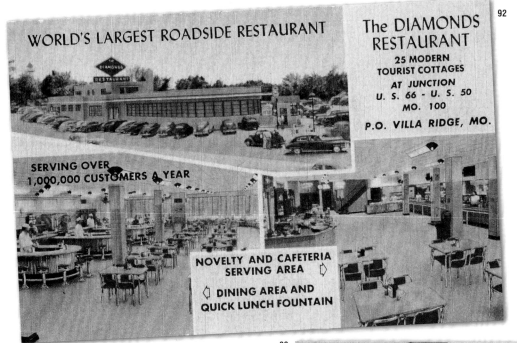

WORLD'S LARGEST ROADSIDE RESTAURANT

The DIAMONDS RESTAURANT
25 MODERN TOURIST COTTAGES
AT JUNCTION
U. S. 66 - U. S. 50
MO. 100
P.O. VILLA RIDGE, MO.

SERVING OVER 1,000,000 CUSTOMERS A YEAR

NOVELTY AND CAFETERIA SERVING AREA

DINING AREA AND QUICK LUNCH FOUNTAIN

In 1919, Spencer Groff set up a stand to sell plums from the family orchard where the Ozark Trail met the Old Springfield Road. Groff opened a more impressive facility on July 3, 1927 and named it after the shape of the property. The Diamonds (92-93) was promoted as "The World's Largest Roadside Restaurant," serving one million customers per year. Restaurant employee Louis Eckelcamp and Nobel Key bought "The Old Reliable Eating Place" in 1935. A fire that closed Route 66 for hours destroyed the original building in1948 and a new streamlined fireproof building opened in 1950. The Diamonds moved to the Interstate in 1967, and this building became the Tri-County Truck Stop, which closed in 2006. Though vacant, the 1950 building still stands. But the Interstate 44 location has been demolished.

93

Ask Anyone Who
TRAVELS
IT'S
"THE DIAMONDS"
RESTAURANT

JUNCTION U. S. HIGHWAY
50 - 66 — MO. - 100

75
COURTEOUS EMPLOYEES
TO SERVE YOU

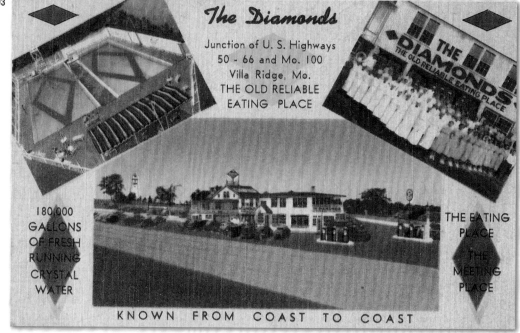

The Diamonds
Junction of U. S. Highways
50 - 66 and Mo. 100
Villa Ridge, Mo.
THE OLD RELIABLE
EATING PLACE

THE DIAMONDS
THE OLD RELIABLE EATING PLACE

180,000 GALLONS OF FRESH RUNNING CRYSTAL WATER

THE EATING PLACE
THE MEETING PLACE

KNOWN FROM COAST TO COAST

94

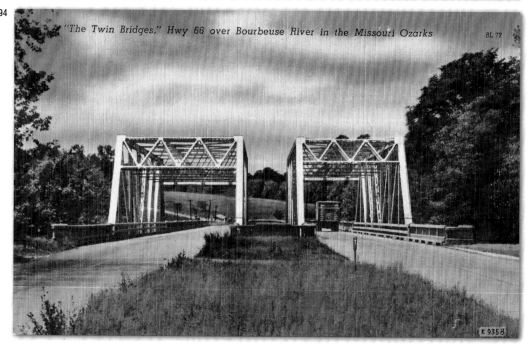

"The Twin Bridges," Hwy 66 over Bourbeuse River in the Missouri Ozarks BL 77

Just before reaching the Bourbeuse ("burr-buss") River, Highway 66 split into dual lanes, and then crossed on identical bridges (94), later replaced by generic I-44 spans.

Bud and Roy's (95), also known as the Oak Grove Café, was originally the 41 Mile Post, a tavern, store and cabins. When the route was known as "The Old Wire Road," it was common for businesses to be named for the distance to St. Louis.

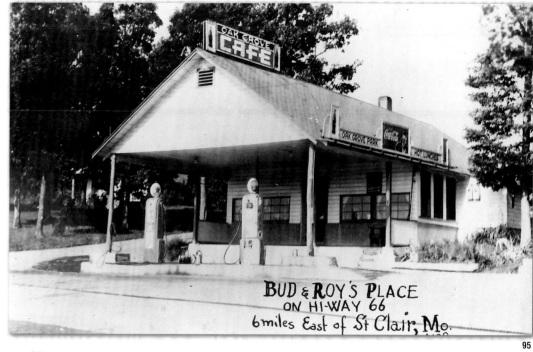

BUD & ROY'S PLACE
ON HI-WAY 66
6 miles East of St. Clair, Mo.

95

Twenty years faithful service. Home cooked meals, ho-made pie, humidor fresh cigars, photo finishing, films, cameras and supplies. SERVING GOOD COFFEE - 5¢

96

Lewis' Cafe, St. Clair, Mo.

Twenty years faithful service. Home cooked meals, ho-made pie, humidor fresh cigars, photo finishing, films, cameras and supplies. SERVING GOOD COFFEE - 5¢

97

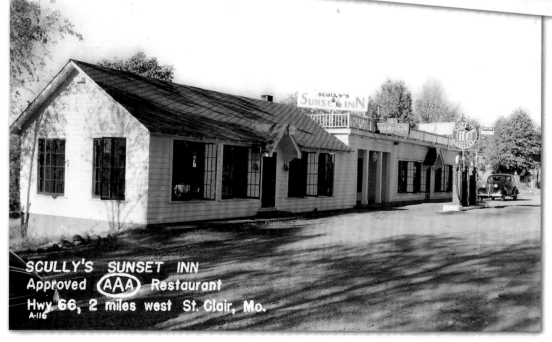

SCULLY'S SUNSET INN
Approved (AAA) Restaurant
Hwy. 66, 2 miles west St. Clair, Mo.
A-116

Arch Bart's service station (97) west of St. Clair developed into Scully's Sunset Inn. Scully was once a chef at the famous Busch's Grove Restaurant in St. Louis. The restaurant moved to the new four-lane 66 in 1952. One day it just closed, and the tables were left set for years.

Virgil Lewis opened his café (96) in the heart of St. Clair in 1938. The café, known for fine steaks, remains in the family.

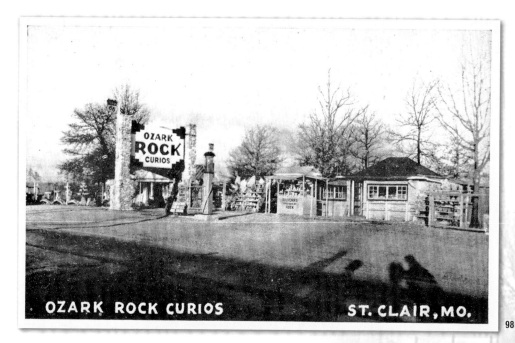

OZARK ROCK CURIOS ST. CLAIR, MO.

98

Paul and Lola May Woodcock ran Ozark Rock Curios **(98)**, offering items from ten cents to hundreds of dollars. The business survived the arrival of Interstate 44, but closed in 1977.

Benson's Tourist City **(99)** belonged to Mr. and Mrs. Lewis Benson. It was later the McGinnis Sho-Me Courts and it was also known as the Del-Crest. Part of the complex still stands.

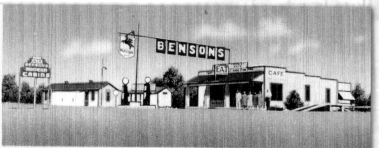

16
All Approved
AAA
Modern
Cabins
24 Hr. Cafe

BENSONS

BENSON'S TOURIST CITY

7 Miles
West
of
St. Clair, Mo.
U. S. Hiway 66

99

Meramec Caverns **(100-102)** is the most famous roadside attraction in Missouri. Lester Dill bought the cave on May 1, 1933. The owner of the "World's Only Drive In Cave" was a promotional genius, credited with inventing the bumper sticker. In the 1930s Dill saw an ad for Lookout Mountain painted on the side of a barn. Soon Meramec Caverns ads were painted on barns across the Midwest. Dill declared his cave as the "World's First Atomic Refuge." Visitors were given cards that guaranteed admission if the bombs fell. He concocted a legend that the outlaw Jesse James had used the cave for a hideout and created a media sensation in 1949, when he claimed to have found the real Jesse James, a 102-year-old man named J. Frank Dalton. Meramec Caverns today retains the atmosphere of a good old fashioned roadside attraction.

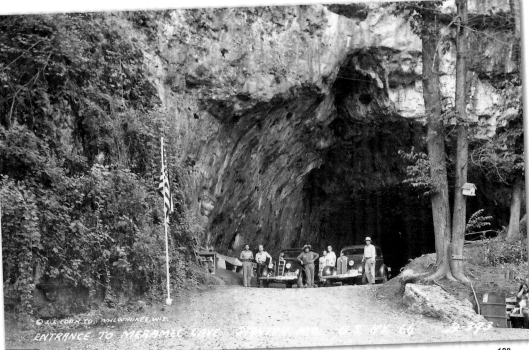

ENTRANCE TO MERAMEC CAVE STANTON MO. U S HY 66

100

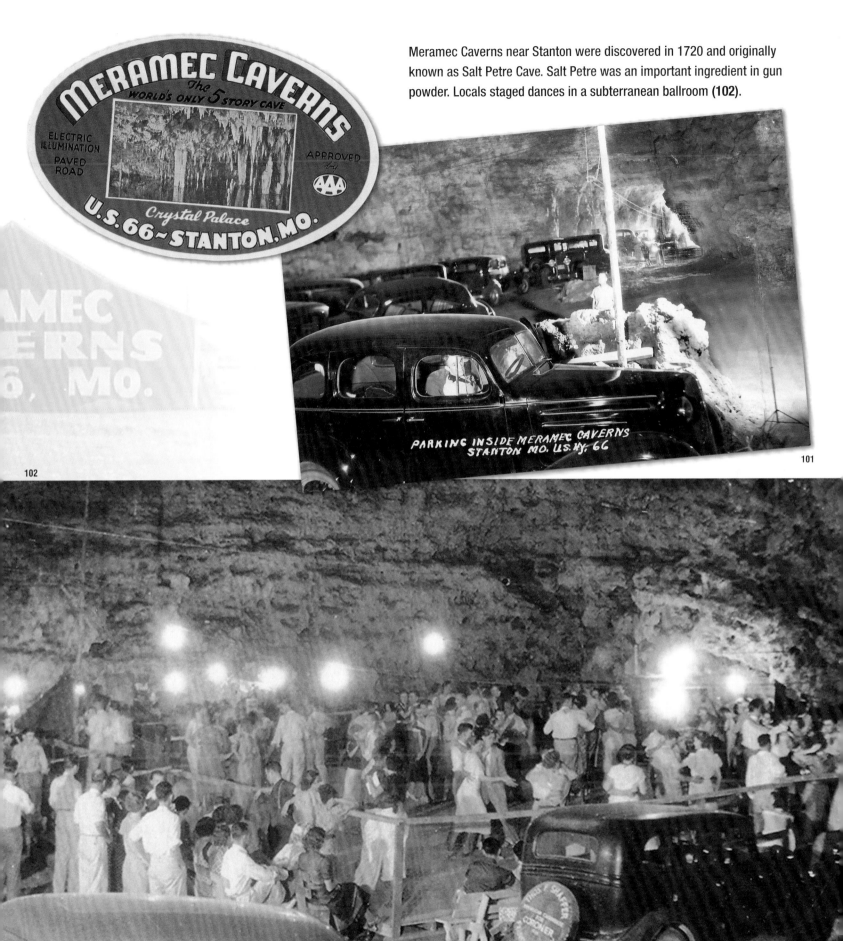

Meramec Caverns near Stanton were discovered in 1720 and originally known as Salt Petre Cave. Salt Petre was an important ingredient in gun powder. Locals staged dances in a subterranean ballroom (102).

MERAMEC CAVERNS
The World's Only 5 Story Cave
ELECTRIC ILLUMINATION
PAVED ROAD
APPROVED by AAA
Crystal Palace
U.S. 66 ~ STANTON, MO.

PARKING INSIDE MERAMEC CAVERNS STANTON MO. U.S. HY. 66

101

102

DANCE IN MERAMEC CAVE STANTON MO. U.S. HY 66.

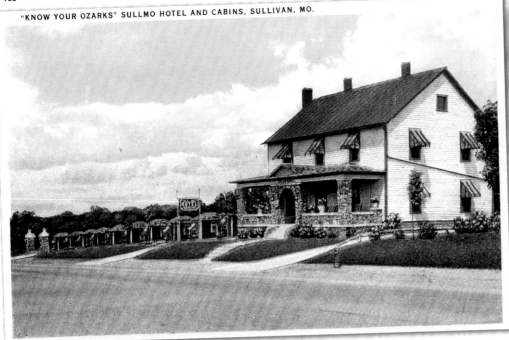

"KNOW YOUR OZARKS" SULLMO HOTEL AND CABINS, SULLIVAN, MO.

At Sullivan, Charles Albrecht converted a home into the Sullmo Hotel and Cabins (103) about 1935. A school was later built on this site

The Shamrock Motel (104) was built for F.E. Dobbs in 1945 and has some of the most beautiful rock work on any motel in the Ozarks. John and Rose Weiland took over in 1953 and the building, now apartments, remains in the family.

Mr. and Mrs. Fred Snell Sr. opened their café (105) in 1949 with the slogan. "Awful Good Food." It later became the Hitching Post Restaurant. The building later housed an antique mall and still stands.

The Bourbon Lodge (106) was opened in 1932 by Alex and Edith Mortenson. The cabins with no plumbing rented for 50 cents per night and a sign out front advertised "Cooked Food." The lodge is now a private home, and the cabins are in ruins.

The Wagon Wheel Motel (107-108) in Cuba is the best preserved of all the classic Route 66 motels. It opened in 1934 as the Wagon Wheel Cabins, operated by Robert and Margaret Martin. John and Winifred Pratt ran the motel from 1947 to 1963, when Pauline Roberts and her husband Hallie took over. After Hallie died, Pauline married Paul Armstrong and they made Wagon Wheel a Route 66 icon.

Connie Echols bought the motel and began renovations in 2009.

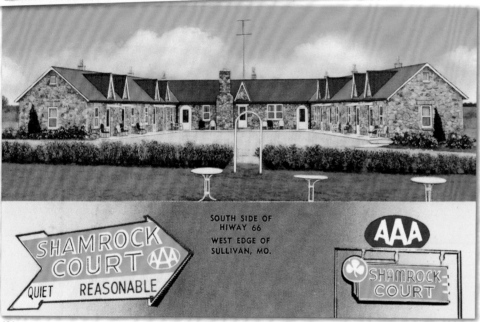

SOUTH SIDE OF HIWAY 66 WEST EDGE OF SULLIVAN, MO.

SHAMROCK COURT QUIET REASONABLE AAA SHAMROCK COURT

104

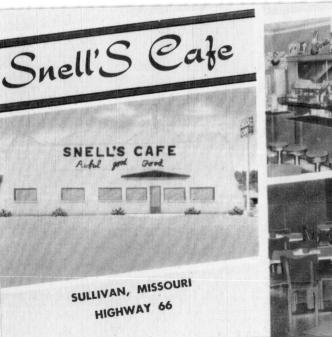

Snell'S Cafe
SNELL'S CAFE
Awful good Food
SULLIVAN, MISSOURI
HIGHWAY 66

105

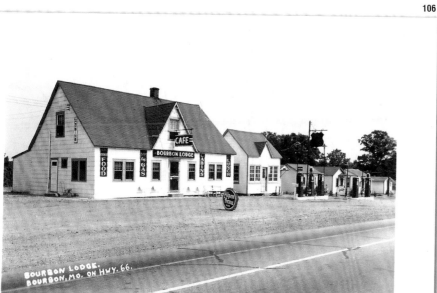

BOURBON LODGE.
BOURBON, MO. ON HWY. 66.

108

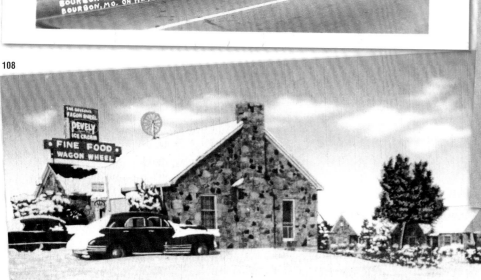

WAGON WHEEL CAFE
HI-WAY U. S. 66, CUBA, MO.

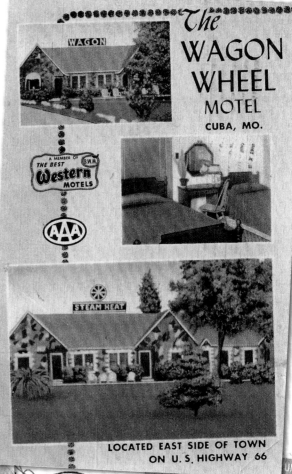

The
WAGON
WHEEL
MOTEL
CUBA, MO.

WAGON

A MEMBER OF
THE BEST
Western
MOTELS

AAA

STEAM HEAT

LOCATED EAST SIDE OF TOWN
ON U.S. HIGHWAY 66

Post Card

CUBA
OCT 30
2 PM
1951
MO

UNITED STATES

1 CENT 1

1 CENT 1

Oct. 29/1951

Wagon Wheel Motel, Cuba, Mo.
"Sleep in safety and comfort without Extravagance, in modern steam heated, fireproof units.
Popular priced dining room, famous for fine
food in connection.
WE RECOMMEND THIS PLACE

12

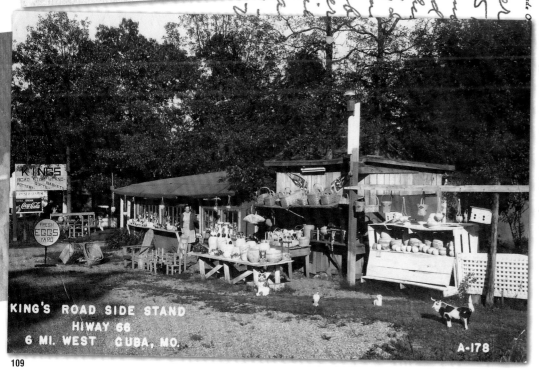

KING'S ROAD SIDE STAND
HIWAY 66
6 MI. WEST CUBA, MO.

A-178

109

Cuba was named by early residents impressed
with tales told by pair of former California
gold miners who had seen the isle. The town
has avidly embraced its Route 66 heritage
and beautiful historical murals adorn several
buildings.
Henry and Elsie Belle King ran this roadside
stand (109) west of Cuba offering a typical array
of Ozark pottery, baskets and souvenirs.

"Pop" Scherer's Café **(110)** in St James later moved to a larger location on the new four-lane Route 66. That building was moved to a golf course in 1964.

Rolla **(111)** was laid out as a railroad supply point in 1855. One of the early residents thought it should be named after his home town of Raleigh, North Carolina, which he pronounced as "Rolla."

SCHERER'S NIGHT AND DAY CAFE, West Side of Town on U. S. Highway 66, St. James, Missouri.

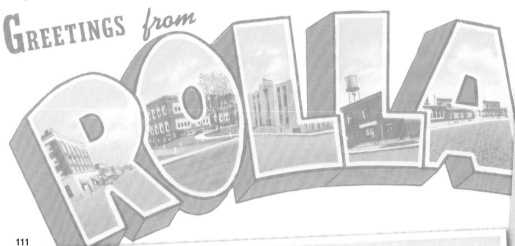

GREETINGS *from* ROLLA

111

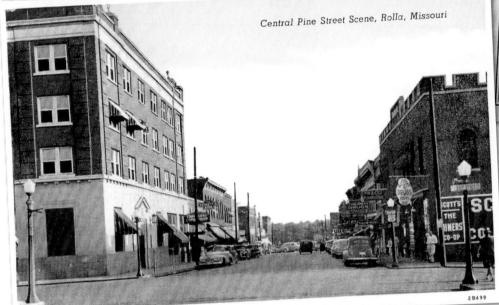

Central Pine Street Scene, Rolla, Missouri

2B499

112

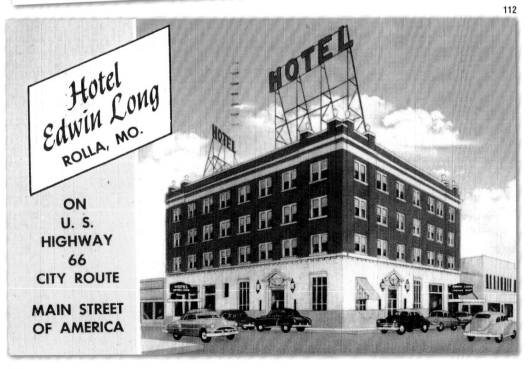

Hotel *Edwin Long* ROLLA, MO.

ON
U. S.
HIGHWAY
66
CITY ROUTE

MAIN STREET
OF AMERICA

TELEVISION LOUNGE

The Hotel Edwin Long **(112)** hosted the huge celebration marking the paving of Route 66 across Missouri just three days after opening on March 12, 1931. It is now a bank headquarters. The Pierce-Pennant Petroleum Company planned a chain of first class facilities every 125 miles, providing the first high class facilities for Ozark motorists. The firm pioneered the use of radio advertising and free maps promoting the Ozarks as a tourist destination. The Pennant Hotel **(113)** at Rolla opened 1929. It later became the Manor Motel and was torn down in 1970.

The Colonial Village **(114)** opened in 1937, owned by Mrs. Lorene Lavery. Later Hull's Colonial Village, it advertised "Food You'll Long Remember." It was known as Frederick's from 1963 to 1976, and torn down in the 1980s.

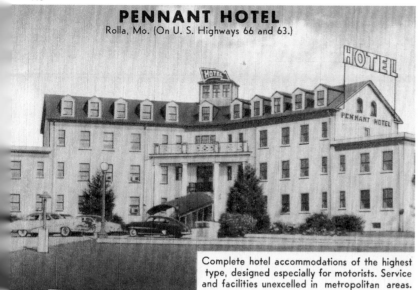

PENNANT HOTEL
Rolla, Mo. (On U. S. Highways 66 and 63.)

Complete hotel accommodations of the highest type, designed especially for motorists. Service and facilities unexcelled in metropolitan areas.

113

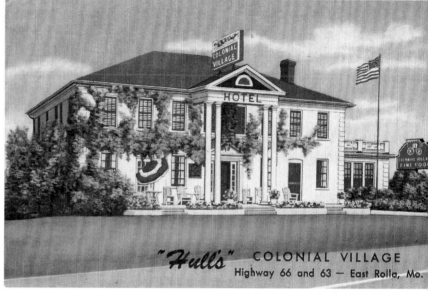

"Hull's" COLONIAL VILLAGE
Highway 66 and 63 — East Rolla, Mo.

114

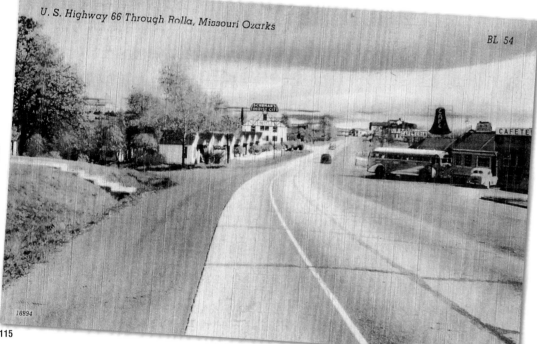

U. S. Highway 66 Through Rolla, Missouri Ozarks

BL 54

115

This 1946 view **(115)** of Rolla looks east from the intersection with City 66, Pine Street. The Bell Café and bus depot is at right. The postcard artist took some liberties with this view, removing wires and poles while adding a nice sunrise.

R.E. Schuman opened his Cottage City **(116)** about 1928, and local lore says some of the 17 cabins were converted chicken coops. It grew into "Tourist City" (later Motor City) with accommodations for over 100 people. The site became the Budget Motel, now the Budget Apartments.

Toky's Bar-B-Q **(117)** was "three miles east of Rolla, opposite the Rolla Airport" and closed in the early 1970s.

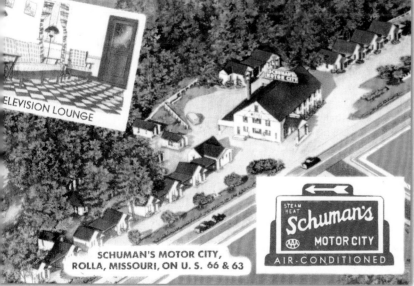

TELEVISION LOUNGE

SCHUMAN'S MOTOR CITY,
ROLLA, MISSOURI, ON U. S. 66 & 63

STEAM HEAT **Schuman's** MOTOR CITY
AIR-CONDITIONED

116

TOKY'S BAR-B-Q
HIGHWAY 66 EAST
Rolla, Mo.

TOKY'S BAR-B-Q

117

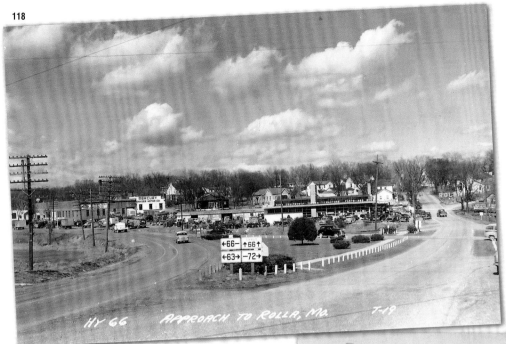

118

HY 66 APPROACH TO ROLLA, MO. 7-19

Entering Rolla from the west (118), Routes 66 and 63 curved to the left. City 66 continued straight on Kingshighway, past the large sign spelling out "Rolla." The city route then met 6th Street, and turned north on Pine Street.

Chuck and Shirley Lammlein's Colonial Lanes (119) advertised 16 lanes with "Modern bowling in early American Atmosphere." Now Coachlight Lanes, it is still owned by the Lammlein family.

In 1957, Zeno Scheffer and his wife Loretta opened the 20-unit Zeno's Studio Motel (120) where the new four-lane met the City Route west of Rolla. They added the steak house in 1959 and the motel was expanded to 32 units. The motel now has 50 rooms and the business is still run by the family.

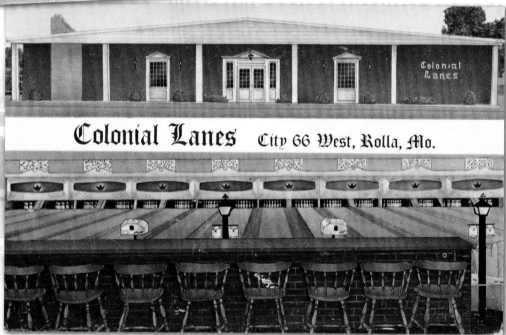

Colonial Lanes City 66 West, Rolla, Mo.

119

120

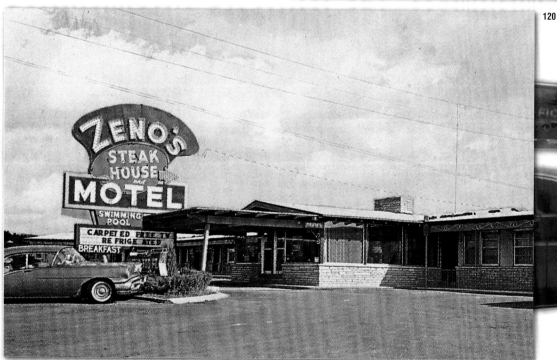

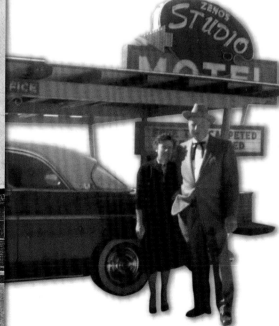

Paul and Gladys Bramwell Bennett's café **(121)**, famous for catfish dinners, opened in 1943 just west of the Newburg Road. (Route T) Paul was an evangelist known as the "The fishing coon-hunting preacher of the Ozarks" and constructed a tabernacle out back. The four-lane construction forced Bennett's to move to Clementine in 1952. That location closed in 1962 due to I-44 construction. Pecan Joe's **(122)** was part of a Texas-based chain. This location near Arlington opened in 1960 and was demolished for Interstate 44 construction in 1967. Note the trademark pecan wearing a cowboy hat.

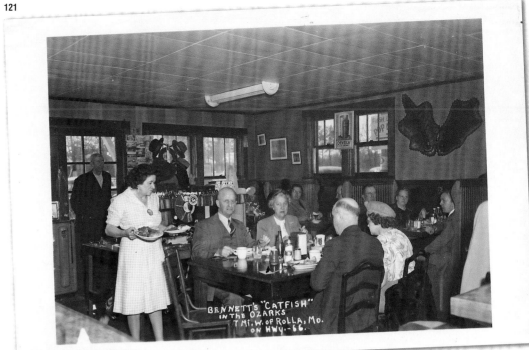

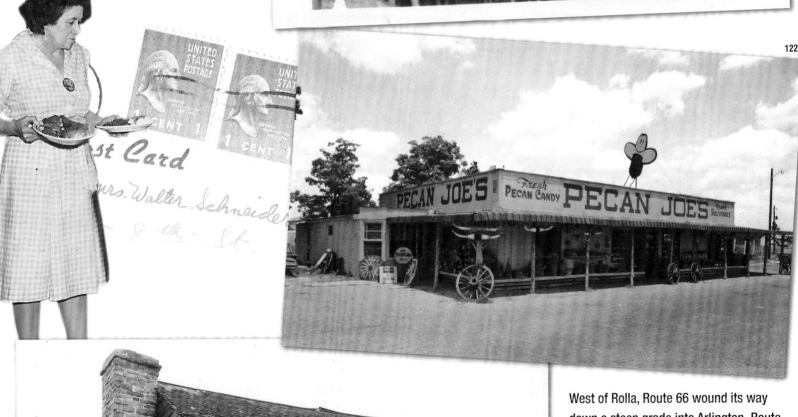

West of Rolla, Route 66 wound its way down a steep grade into Arlington. Route 66 and Interstate 44 were relocated several times in this area and Arlington is now stranded on a winding and narrow dead end service road.

Over the years, Arlington has been part of St. Louis, Gasconade, Crawford, Pulaski and Phelps Counties. It was even the Crawford County seat for a short time. The James Harrison House **(123)** was constructed about 1818 and served as the first Crawford County courthouse. It was torn down for construction of four-lane Route 66.

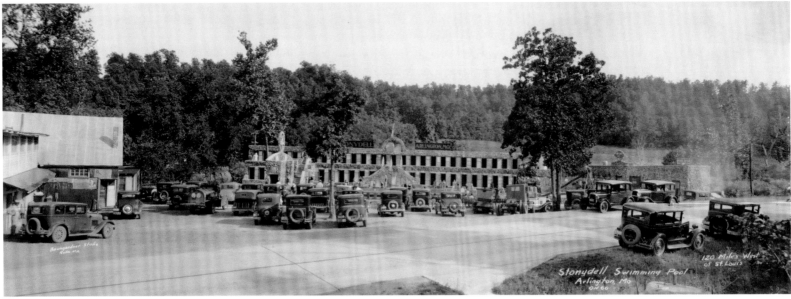

124

Using native Ozark rock, George Prewett constructed the amazing Stoneydell resort **(124)** and its 100 foot long swimming pool in 1932. Stoneydell included ten cabins, a restaurant, and a carp and goldfish pond. Everything in this view was torn down in 1967 for Interstate construction.

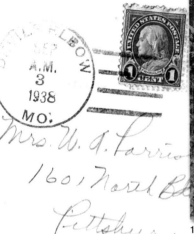

Spectacular bluffs make the winding original alignment of Route 66 through Hooker and Devils Elbow one of the most scenic on Route 66. The two-lane highway couldn't handle the massive increase in traffic when Fort Leonard Wood was constructed in 1940. A new four-lane highway opened in 1942. The new road included a 90-foot-deep rock cut at Hooker that was the largest in the U.S. at the time. The Hooker Cut **(125)** was a popular subject for postcards.

The four-lane alignment crosses this beautiful bridge over the Big Piney River **(126)**. In 1981, this segment became the last section of Route 66 in Missouri to be bypassed.

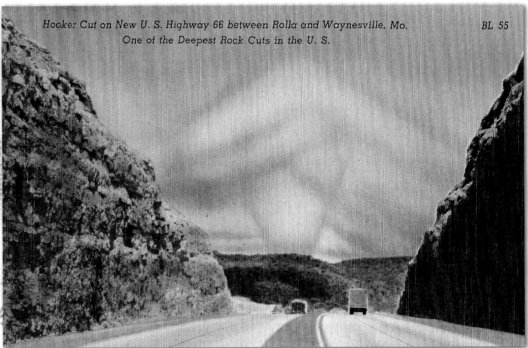

Hooker Cut on New U. S. Highway 66 between Rolla and Waynesville, Mo.
One of the Deepest Rock Cuts in the U. S. BL 55

125

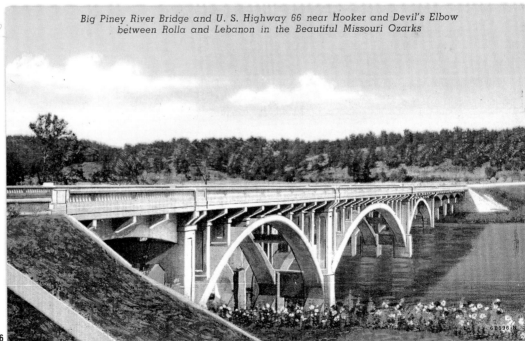

Big Piney River Bridge and U. S. Highway 66 near Hooker and Devil's Elbow
between Rolla and Lebanon in the Beautiful Missouri Ozarks

126

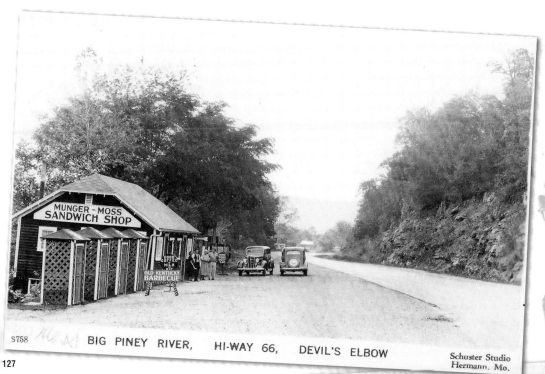

BIG PINEY RIVER, HI-WAY 66, DEVIL'S ELBOW

Schuster Studio
Hermann, Mo.

127

DEVILS ELBOW CAFE DEVILS

S594

In 1929, Howard and Nelle Munger opened a sandwich shop **(127)** just east of 1923 bridge at Devils Elbow. After Howard died, Nelle married Emmett Moss in 1936, and it became the Munger-Moss Sandwich Shop. Later owned by Jessie and Pete Hudson, it is now the Elbow Inn. Dwight Rench constructed this beautiful Ozark rock café **(128)** and Conoco Station just west of the bridge in 1932. The building later became the Hideaway Tavern, but burned to the ground in 1974.

Devil's Elbow, Scenic Spot on U. S. Highway 66

DEVIL'S ELBOW CAFE

DEVIL'S ELBOW
U.S. POST OFFICE

8A869-N

Near Fort Leonard Wood, Missouri

128

state 44 – U. S. Highway 66
in the Missouri Ozarks

The construction of Ft. Leonard Wood triggered a major building boom. Businesses quickly sprang up to serve the soldiers and Route 66 travelers. Tut's Café #2 (129) was on the four-lane east of Waynesville. The original Tut's Café was on the Waynesville Square. James Egan's Wagon Wheel had been in business since the 1920s. The towing business (130) would have been brisk as the stretch between Rolla and Waynesville was among the most dangerous on Route 66. A Ramada Inn was built on this site, but it has also been demolished.

Fort Leonard Wood was named after an Army surgeon who won the Medal of Honor fighting the Indians. Over three million men and women have trained here since the post opened in 1941. The facility is now home to the Army Maneuvers Support Center and training post for the engineer, chemical and military police corps

The Mark Twain Motel (131) six miles east of Waynesville was constructed in the early 1950s and took its name from the nearby Mark Twain National Forest.

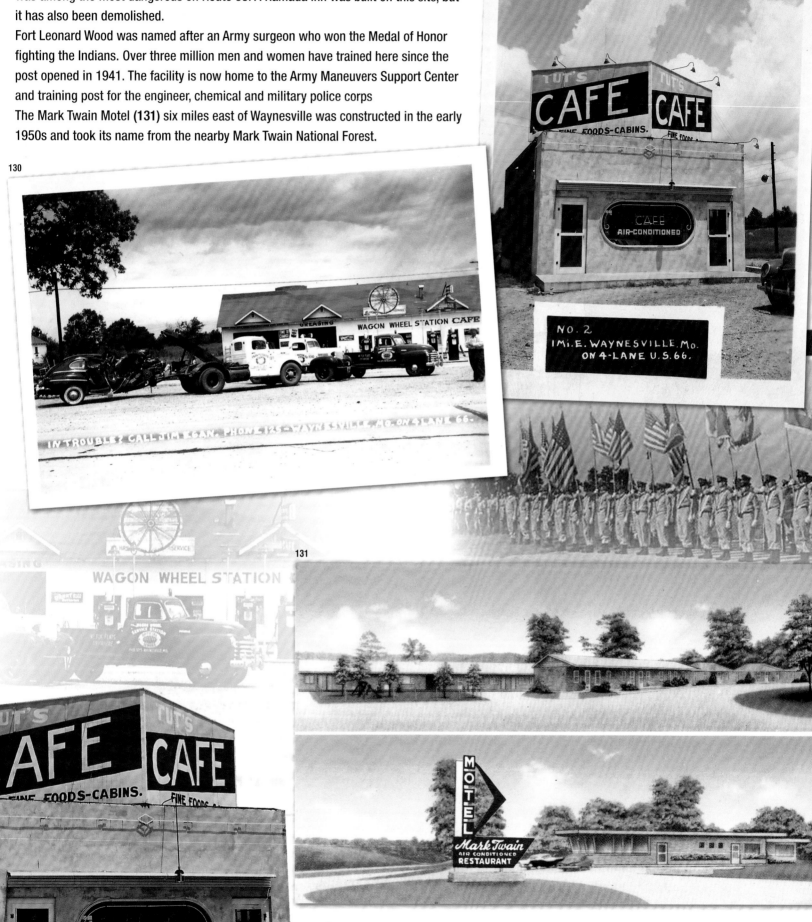

Waynesville **(132)** was laid out in 1839 and named for General "Mad" Anthony Wayne. The Confederate flag once flew from the courthouse. Waynesville was described as having "A leisurely atmosphere, unmarred by the smoke of industry and the impatient panting of trains, and but little jarred by farmer's Saturday night visits." That changed dramatically with the construction of Ft. Leonard Wood.

In the Missouri Ozarks, many businesses and homes are covered in native stone with the joints filled with grout, a style known as "giraffe rock." The Owl Café **(133)** later became Long's Café. The building is barely recognizable today.

Dave Caldwell's complex at Gascozark **(134)** consisted of a gas station and store, with four single cabins. The expanded structure later became the Caldwell-Salsman Truck Stop and still stands as the Gascozark Trading Post.

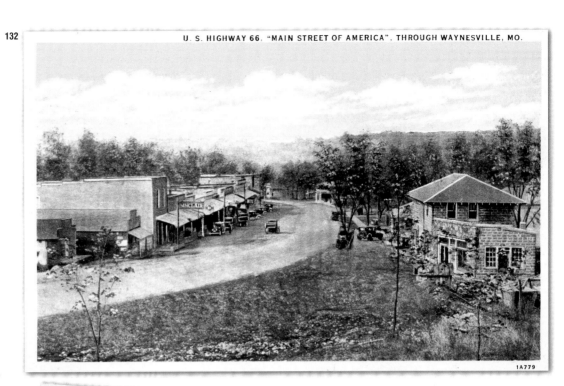

U. S. HIGHWAY 66, "MAIN STREET OF AMERICA", THROUGH WAYNESVILLE, MO.

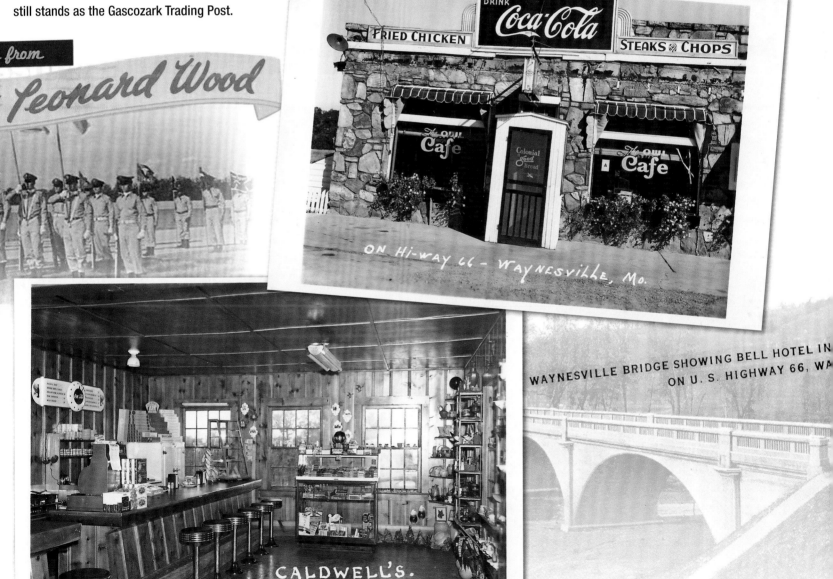

ON HI-WAY 66 - WAYNESVILLE, MO.

CALDWELL'S. GASCOZARK, MISSOURI.

WAYNESVILLE BRIDGE SHOWING BELL HOTEL IN ON U. S. HIGHWAY 66, WA

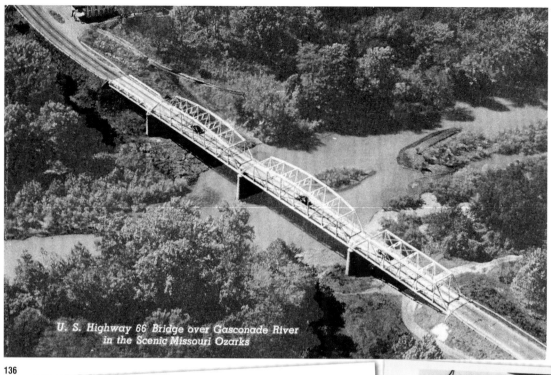

U. S. Highway 66 Bridge over Gasconade River
in the Scenic Missouri Ozarks

At 271 winding miles, the Gasconade is the longest river entirely within Missouri. The old 66 Bridge (135) still carries service road traffic today.

Ray Coleman and Blackie Waters opened the 4-Acre Court (136) in 1939. The remaining cottages are now apartments.

Dennis Scott built Scotty's Tourist City (137) in the late 1940s just east of Lebanon. It consisted of a small café, three cabins, and a Skelly station.

The Motel 66 (138) opened about 1940 and was originally known as Weideman's Court. It was torn down for Interstate 44.

136

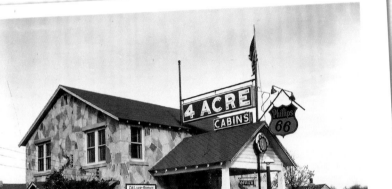

4-ACRE CAMP 4-M&E. LEBANON, MO. ON HWY. 66.

137

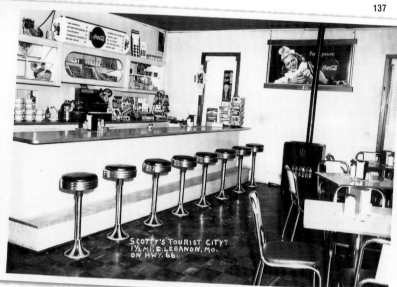

SCOTTY'S TOURIST CITY 1½ MI. E. LEBANON, MO. ON HWY. 66.

"YOUR HOME AWAY FROM HOME"

138

DELUXE-ROOMS
—PRIVATE—
SHOWERS TOILETS
STEAM·HEAT
APPLY-AT-OFFICE

NELSON DREAM VILLAGE
Annex To The FAMOUS NELSON TAVERN
See and hear the Musical Fountain
Cool Nights in the Ozark Mountains
Free Garage Coffee Shop Dining Room
Chicken Dinners A Specialty
Strictly Modern Moderate Prices
The Gateway to the South and West
U. S. Highway No. 66 and No. 5
LEBANON, MO.
Good FISHING AND HUNTING in Season

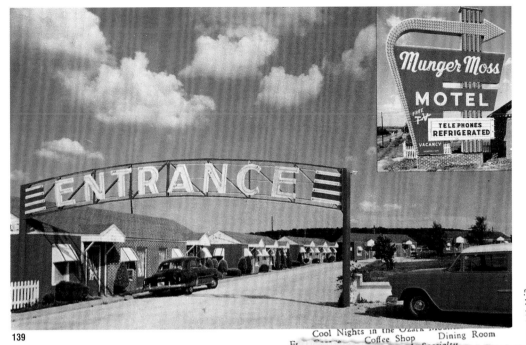

Jessie and Pete Hudson ran the Munger Moss Sandwich Shop **(139)** and moved to Lebanon when Devils Elbow was bypassed. They added a motel next to their Munger Moss Restaurant in 1946. The famous sign was restored in 2010. Ramona and Bob Lehmann have operated this treasure since 1971.

Honorary Colonel Arthur Nelson said the design for his tourist court came to him in a dream after he saw a musical fountain at the Chicago world's fair in 1933. The cabins of the "Dream Village" **(140)** surrounded the fountain, where a light show was presented as music played. It was torn down in 1977.

POST CARD

PLACE
ONE CENT
STAMP
HERE

139

140

Cool Nights in the Ozark
Coffee Shop Dining Room

UNION BUS DEPOT · LEBANON, MO.
The Ozarks Finest
Jct. U. S. Highway 66-64-5-32
Joe Knight, Owner

ELECTRICAL AND MUSICAL FOUNTAIN

NELSON DREAM VILLAGE — U. S. HIGHWAY No. 66 AND No. 5 — LEBANON, MO. 6A-H769

141

BL 60

U. S. Highway 66 Passing Through Lebanon in the Missouri Ozarks

HOTEL
CAFE
LEBANON

Lebanon is the seat of Laclede County, founded in 1849, and originally known as Wyota. Colonel Nelson's Tavern **(141)** is at right in this view. It was demolished in 1957 and the site is now a supermarket. During World War II, one ton of hamburger was reportedly served at the Union Bus Depot **(142)** in 24 hours. It was later known as the Metro Building but was torn down for a Walgreen's.

142

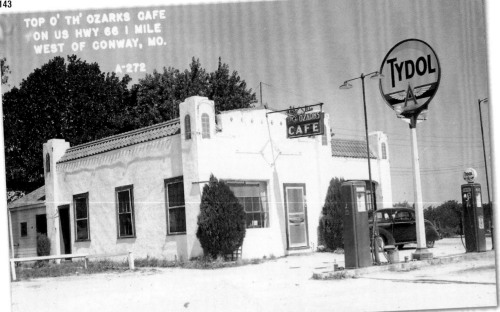

Cassie Warren and his brother John opened the Top O' Th' Ozarks Café **(143)** in 1940. This building burned in 1950.

When Kermit and Letha Lowery opened their café and station in 1952, a friend suggested that the Garbage Can would **(144)** be a memorable name. The café was known for little 10 cent fruit pies, serving up to 400 each day. The abandoned building is crumbling along I-44.

Route 66 headed into Marshfield **(145)** is known as Hubble Drive in honor of local son Edwin Hubble, who first proved the existence of other galaxies. The Hubble telescope sent into orbit in 1990 was named in his honor. Marshfield is the seat of Webster County.

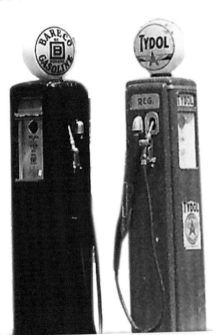

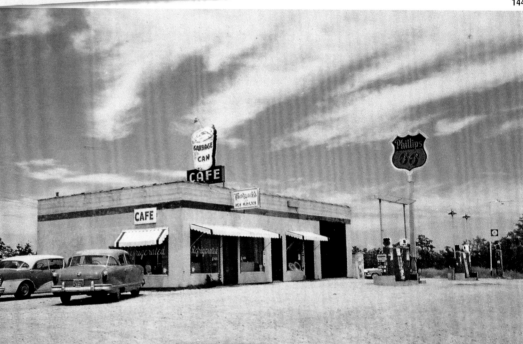

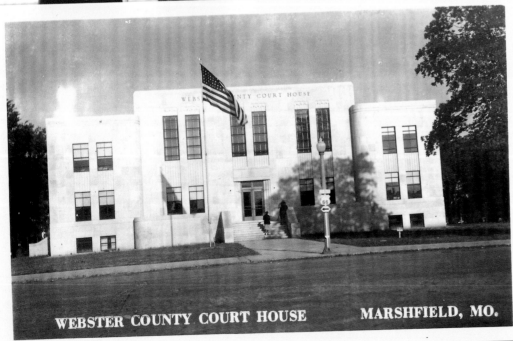

WEBSTER COUNTY COURT HOUSE MARSHFIELD, MO.

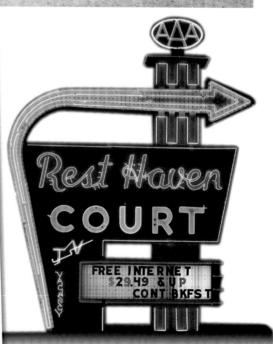

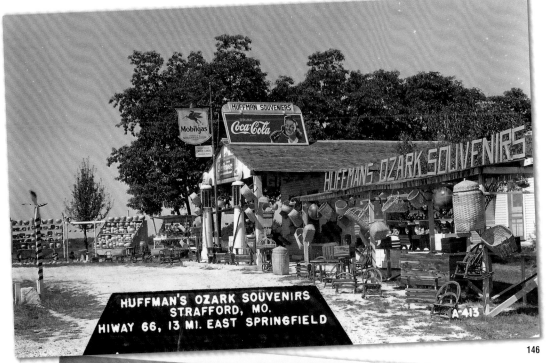

146

Huffman's Ozark Souvenirs **(146)** was located at Strafford, the only town in the U.S. with two main streets and no back alleys, according to Ripley's *Believe it or Not*. Route 66 was built behind the businesses facing the railroad, so the owners simply built new doors facing the highway.

Cain's Café **(147)** offered Bareco "Be Square" Gasoline. Bareco, originally known as Barnsdall, later was sold to a company that rebranded the stations as D-X.

Hillary Brightwell and his wife Mary took over Richard Chapman's gas station and then built the Rest Haven Court **(148)** in 1947. Hillary helped design the sign in 1953, and it provided inspiration for the sign at the Munger Moss Motel in Lebanon. Operated by the Brightwells until 1997, the Rest Haven is still pristine today.

At Kearney Street and Glenstone Avenue in Springfield, Route 66 travelers turned south on Glenstone, and then onto St. Louis Street passing through the Public Square. Bypass 66 continued straight on Kearney before turning south on the West Bypass to meet the main route. The Rock Village Court **(149)** was constructed in 1947 on the southwest corner of Glenstone and Kearney Street. The court featured beautiful native stone construction with nice use of glass accents and evolved into today's America's Best Value Inn.

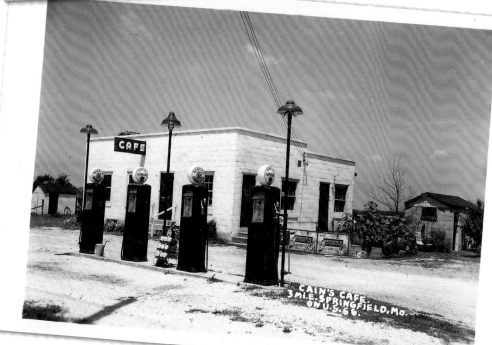

147

148

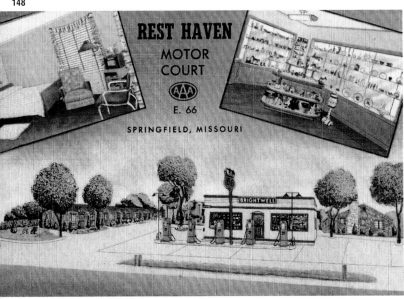

149

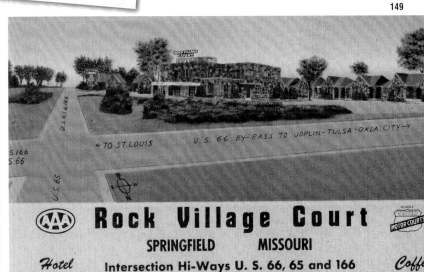

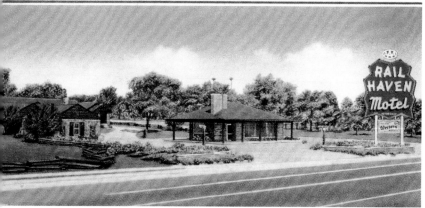

OFFICE and ENTRANCE
Rail Haven Motel
SPRINGFIELD, MO. - PHONE 6-1963, HIGHWAYS 60, 65, 66 & 166

RAIL HAVEN Motel

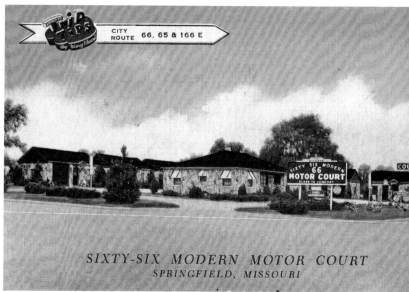

CITY ROUTE 66, 65 & 166 E

SIXTY-SIX MODERN MOTOR COURT
SPRINGFIELD, MISSOURI

150

152

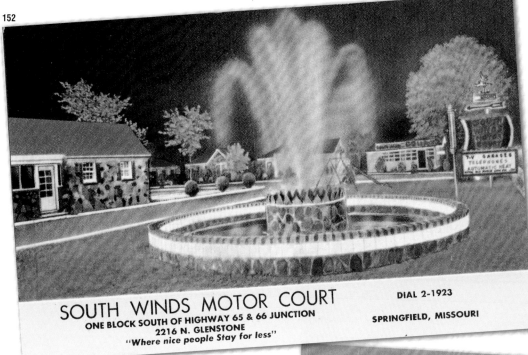

SOUTH WINDS MOTOR COURT
ONE BLOCK SOUTH OF HIGHWAY 65 & 66 JUNCTION
2216 N. GLENSTONE
"Where nice people Stay for less"

DIAL 2-1923
SPRINGFIELD, MISSOURI

Lawrence and Elwyn Lippman's tiny motor court grew into the Rail Haven Motel (150), now the nostalgic yet modern Best Western Route 66 Rail Haven.

Uncle Charlie Haden's Motor Court became the Sixty-Six Modern Motor Court (151) in 1949 and the Heart of the Ozarks Motel in 1954. It was demolished in 1971.

The South Winds Motor Court (152) opened in 1947, became the Roy Rogers Motel in 1961 and was torn down in 1970.

The Rock Fountain Court (153) opened in 1944. Sherman Nutt took over in 1961 and named it the Melinda Court after his daughter. It still stands, but the fountain is gone.

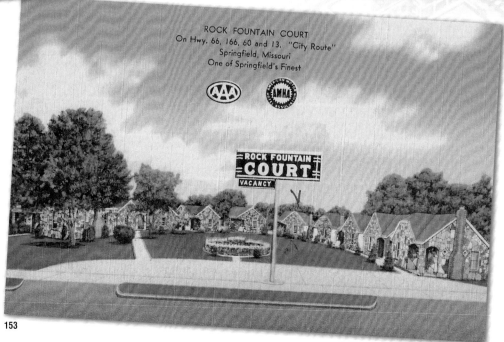

ROCK FOUNTAIN COURT
On Hwy. 66, 166, 60 and 13. "City Route"
Springfield, Missouri
One of Springfield's Finest

ROCK FOUNTAIN COURT
VACANCY

153

Post Card

Fannie.
We are on our way
to St. Louis. Should
be tomorrow evening.
glad I'm getting
home.
Ben needs me either
or telegraph

Mrs. Florence
624 N.
Mac

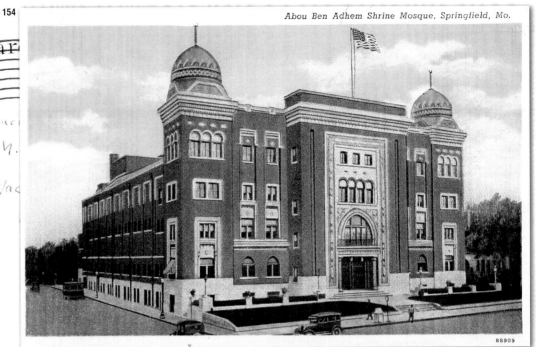

Abou Ben Adhem Shrine Mosque, Springfield, Mo.

154

88909

AERIAL VIEW OF BUSINESS SECTION, SPRINGFIELD, MO.

155

7A78

156

The Shrine Mosque (154) was built by the Abou Ben Adhem Temple in 1923 and designed by Heckenlively and Mark. It has hosted notables such as Presidents Truman, Kennedy and Nixon, as well as Elvis Presley.

Springfield (155) is the third largest city in Missouri. In 1861, Wilson's Creek south of town was the scene of the largest Civil War battle west of the Mississippi. On July 21, 1865, Wild Bill Hickock killed Dave Tutt in a duel on the Springfield Square, the first classic Wild West shootout. Springfield is the birthplace of Route 66, where the number was first proposed for the highway.

The Lily-Tulip Corporation (156) opened its new cup plant in 1952. Solo Cup acquired the plant with its giant "cup" entrance in 2004 and it closed in 2010.

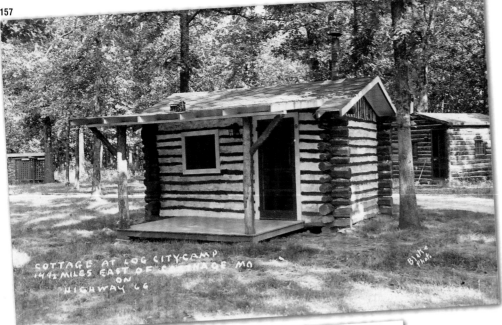

157

COTTAGE AT LOG CITY CAMP
14½ MILES EAST OF CARTHAGE MO
ON
HIGHWAY 66

Route 66 now follows Missouri Route 96 from Springfield to Carthage. Carl Stansbury built Log City **(157)** in 1926 with trees he cut down on the property. The main building became a body shop that now appears abandoned but some of the cabins still stand.

Carthage was established in 1842 and named for the ancient city of North Africa. It was the scene of two battles during the Civil War and rebel guerillas burned the town in 1864. Carthage was also home to the notorious Belle Starr, the "Bandit Queen." The beautiful Jasper County courthouse **(158)** is made of Carthage stone, also used for Missouri's State Capitol. The courthouse was dedicated on Oct. 9, 1895. Architect Maximilian Orlop also designed several other lavish courthouses, notably in Dallas, Texas and New Orleans, Louisiana.

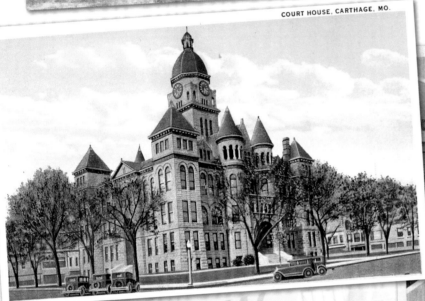

COURT HOUSE, CARTHAGE, MO.

158

C & W CAFE — NORTHSIDE SQUARE — CARTHAGE, MO.

1

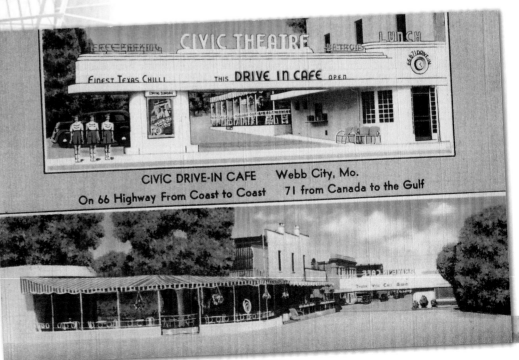

CIVIC DRIVE-IN CAFE Webb City, Mo.
On 66 Highway From Coast to Coast 71 from Canada to the Gulf

The C and W Café **(159)** opened on the square in 1935. At the C and W, and at Red Danner's Café, meat left uneaten on customer's plates was mashed together for the house special meatloaf. Webb City was a mining boom town that fell on hard times when most of the mines closed after World War I. The Civic Drive-In **(160)** was the "Tri-State's only Dry Night Club and Restaurant" and managed by L.P. Larsen.

The side walk café was later enclosed, and the drive-in was converted to an office building.

160

In 1939, Arthur and Ida Boots opened their motel **(162)** at the junction of U.S. 66 and U.S. 71 in Carthage. The rooms originally rented for $2.50 per night. Clark Gable once stayed in room number six. The Boots was nearly demolished in 2003 but was saved following an outcry from preservationists. Arthur Boots designed another deco moderne masterpiece for his drive-in restaurant across from the motel. The Boots Drive-In **(161)** was in operation from 1946 to 1970 and was operated by Arthur's son Bob for many of those years. The altered but still recognizable building still stands today and houses a savings and loan.

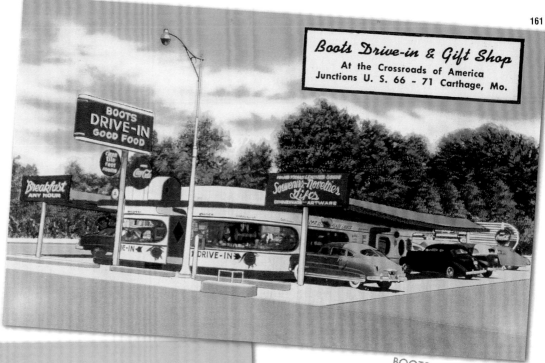

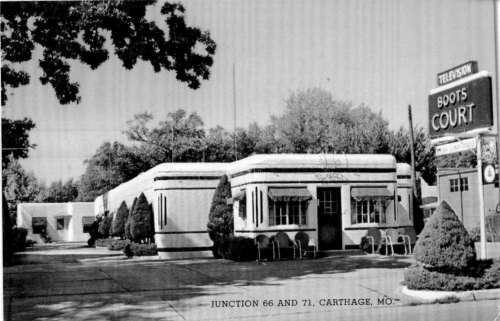

JUNCTION 66 AND 71, CARTHAGE, MO.

The Colonel's Pancake House **(163)** has been in business just south of Route 66 in Joplin for over 50 years.

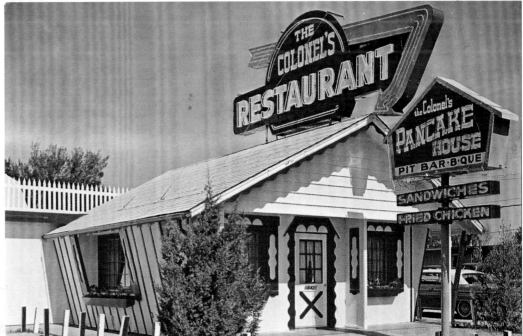

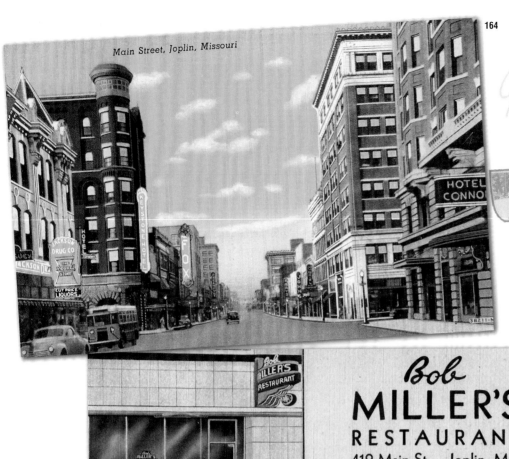

Main Street, Joplin, Missouri

164

Greetings from JOPLIN MISSOURI
"GATEWAY TO THE OZARK PLA[...]"

Bob MILLER'S RESTAURANT
419 Main St. Joplin, Mo.

FOOD YOU WILL REMEMBER

165

166

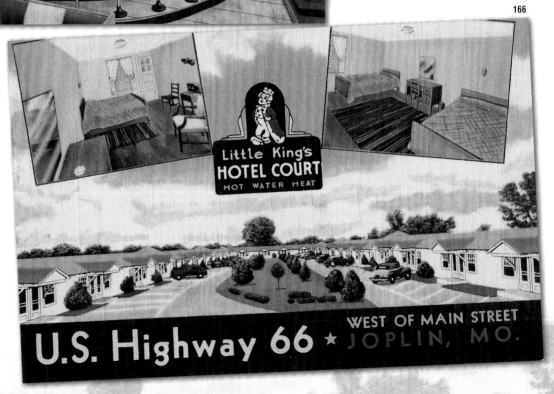

Little King's HOTEL COURT
HOT WATER HEAT

U.S. Highway 66 ★ JOPLIN, MO.
WEST OF MAIN STREET

Joplin is at the center of the Tri-State lead and zinc mining district and was originally two feuding mining towns united in 1873. Main Street **(164)** was once lined with saloons, dance halls and gambling parlors. The Keystone Hotel at left was named for owner E.Z Wallower's home state of Pennsylvania and stood from 1892 to 1968. Its rival, Thomas Connor's Hotel at right, was completed in 1907 and torn down in 1978.

Bob Miller's **(165)** first café was at 609 Main Street. He opened this restaurant at 419 Main on the original site of the Heidelberg Inn after World War II. Ultra-modern pigmented structural glass was used on the exterior facade, the counters and the floors. The restaurant closed in the 1990s.

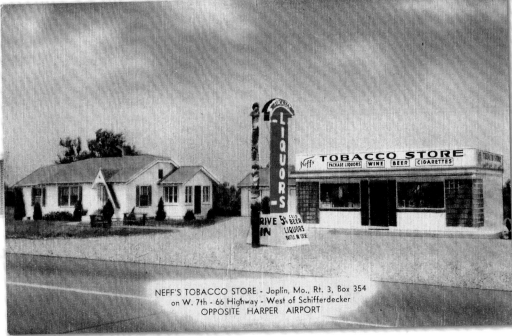

NEFF'S TOBACCO STORE - Joplin, Mo., Rt. 3, Box 354
on W. 7th - 66 Highway - West of Schifferdecker
OPPOSITE HARPER AIRPORT

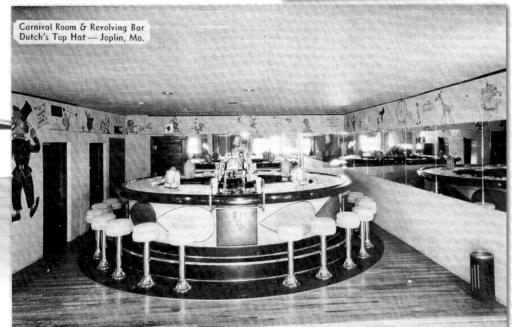

Carnival Room & Revolving Bar
Dutch's Top Hat — Joplin, Mo.

Since Kansas was a dry state, there were plenty of liquor stores, bars and nightclubs on the west side of Joplin. They included Dana's Bo Peep, Dixie Lee's Dine and Dance, Ken's Bar and Dutch's Top Hat, operated by Joe Mertz. Dutch's (168) featured Missouri's only "completely revolving bar," which could seat 27 people. The site is now a used car lot.

W. P. Neff's Liquor and Tobacco Store (167) opened in 1947 across from Harper Airport, the original Joplin Airport. Note the totem pole in front of the sign.

168

169

Route 66 took many paths through Joplin over the years, due in large part to collapsing mine shafts. It originally used Madison Street, Zora Street, Florida Avenue, Utica Street, Euclid Avenue, St. Louis Avenue, Broadway and Main Street to 7th Street. The final route used Range Line Road and then turned west on 7th Street, past the Little King's Hotel Court (166).

Harry M. Bennett's frame and stucco Koronado Kourts (169) were the "Finest and Most Up-to-Date Tourist Kourts in the Entire Southwest on U.S. 66 Highway." The travelers who sent this card commented on a huge slag heap across the street. The Wal-Mart Super Center occupies this site today.

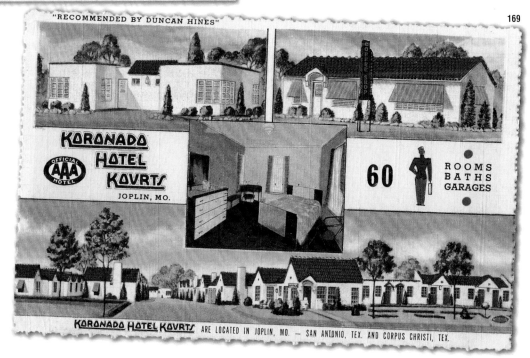

"RECOMMENDED BY DUNCAN HINES"

KORONADO HOTEL KOVRTS
OFFICIAL AAA HOTEL
JOPLIN, MO.

60 ROOMS BATHS GARAGES

KORONADO HOTEL KOVRTS ARE LOCATED IN JOPLIN, MO. — SAN ANTONIO, TEX. AND CORPUS CHRISTI, TEX.

KANSAS *The Sunflower State*

There are only 13.2 miles of Route 66 in Kansas, but every bit is historic. At first, the road passes through a land scarred by lead and zinc mining. At Galena, the "Four Women on the Route" offer a warm welcome at their restored gas station. Out front is the rusty old tow truck that inspired the "Towmater" character in the motion picture *Cars*.

Many buildings are boarded up in the old mining town of Galena, but some are being restored. The old KATY railroad depot is a museum dedicated to the mining industry. Route 66 then crosses the Spring River into Riverton, where the Eisler Brothers Country Store has been in business since 1925. Between Riverton and Baxter Springs, the old concrete truss "Rainbow Bridge" still stands, the only one of its kind remaining on 66.

Baxter Springs is known as the "First Cow Town in Kansas." During the Civil War, surrendering Union soldiers were massacred here by the notorious guerilla, William Quantrill. After the war, the saloons eagerly welcomed the men driving massive herds of cattle up from Texas. The building housing the excellent Café on the Route was once a bank, robbed by Jesse James and his gang in 1876.

The Tri-State area of Kansas, Missouri and Oklahoma is haunted by the mysterious "Spook Light," bouncing along a dusty road. Skeptics say it is caused by headlights on Route 66, which doesn't explain why it has been sighted since the 1830s. There are many more colorful explanations offered, including the spirits of a murdered Osage Chief, a Quapaw maiden, or Cherokee forced from their homes onto the "Trail of Tears."

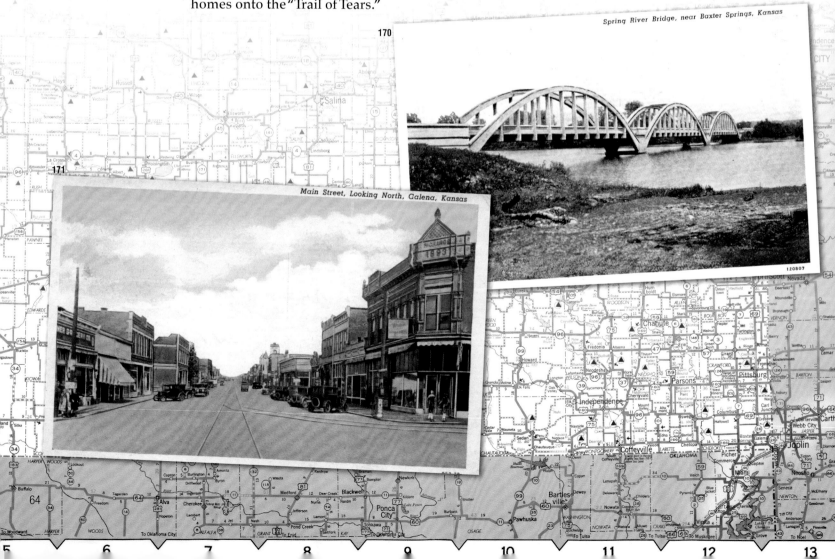

Spring River Bridge, near Baxter Springs, Kansas

Main Street, Looking North, Galena, Kansas

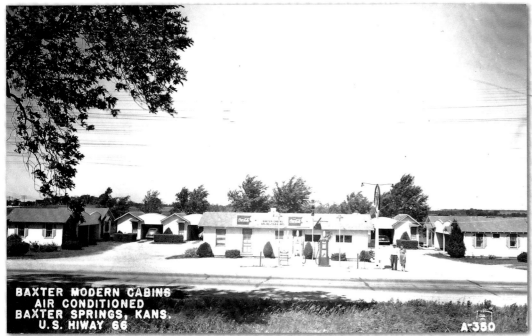

BAXTER MODERN CABINS
AIR CONDITIONED
BAXTER SPRINGS, KANS.
U.S. HIWAY 66

A-350

172

Galena **(171)** and Baxter Springs **(173)** were once wild towns, the main streets lined with saloons, gambling parlors and brothels. Galena was a mining boom town, where the main street was known as Red Hot Street. During the cattle drive days, Baxter Springs was known as the "toughest town on earth." The mayor gunned down the town marshal and 19 men were reportedly hung from Hangman's Elm. The community settled down when the railhead moved further west in the 1880s, and it became a mining center.

173

Main Street, Baxter Springs, Kansas

120806

174

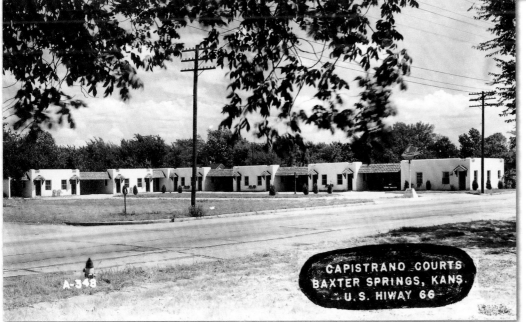

A-348

CAPISTRANO COURTS
BAXTER SPRINGS, KANS.
U.S. HIWAY 66

Nearly all of the motor courts along Route 66 in Kansas have been demolished. The Baxter Modern Cabins **(172)** was located on an S curve just south of downtown Baxter Springs. According to *Route 66 Lost and Found* by Russell Olsen, two illicit lovers are said to have died in their sleep here because of a gas leak. Their spouses were stunned when the bodies were found together in bed the next day. It closed in 1965, and the site is now a Wal-Mart. The Capistrano Motel **(174)** was located at Route 66 (Military Avenue) and 22nd Streets. It has also been demolished.

OKLAHOMA *The Sooner State*

There are plenty of "Kicks on 66" in Oklahoma, the state with the most remaining miles of original route. Route 66 was born here, in the mind of Tulsa businessman Cyrus Avery. Oklahoma is also the birthplace of Will Rogers, the beloved comic and philosopher who never met a man he didn't like.

Route 66 followed the Ozark Trail Highway in eastern Oklahoma and the old Texas Postal Highway in the west. Between Miami and Afton, a precious original section of nine-foot wide pavement can still be driven with care.

The route originally crossed the Canadian River at Bridgeport, on a rickety bridge owned by a politician who charged stiff tolls. Bridgeport became a ghost town when the "El Reno Cut-off" took traffic away in 1934. The Turner Turnpike bypassed the towns between Tulsa and Oklahoma City in 1953 and the Will Rogers Turnpike connected Tulsa and the Missouri line in 1957. Route 66 is still used by locals who avoid the turnpikes.

Early Route 66 used Mingo and Admiral Place into downtown Tulsa, and then shifted to 11th Street after 1932. Phillips 66 gasoline earned its name near here, when a car testing the new fuel hit 66 m.p.h. on Route 66. Other notable landmarks include the Rock Café at Stroud and the Round Barn in Arcadia. In Oklahoma City, Route 66 traveled down Lincoln Boulevard, which was once lined with motels, past the state capitol. A "Beltline" route around the city was added in 1931 and 66 was shifted to present day I-35 and I-44 in 1954.

A great stretch of Old 66 begins west of El Reno. It includes the "Pony Bridge," with its 38 Warren pony trusses. Western Oklahoma boasts two great Route 66 museums, one in Clinton and the other in Elk City. Erick is home to Harley and Annabelle Russell, the "Mediocre Music Makers at the World Class, World Famous Sandhills Curiosity Shop." The ghost town of Texola is at the state line, where a sign on a bar there sums it up nicely, "There's no other place like this place anywhere near this place so this must be the place."

Billed as "Miami's most recommended motor kourt," The Sooner State Kourt **(175)** was constructed with the sandstone slabs so prevalent in the Missouri Ozarks. The Streamline Moderne sign featuring a Conestoga wagon was added about 1960, when Mr. and Mrs. Al Echols owned the motel. The Sooner State Kourt was torn down in 1981.

George L. Coleman made a fortune in mining and built the Coleman Theatre Beautiful **(176)** as a gift to Miami. The $590,000 theatre opened on April 18, 1929. The Coleman family donated it to the city in 1989 and the theatre was restored.

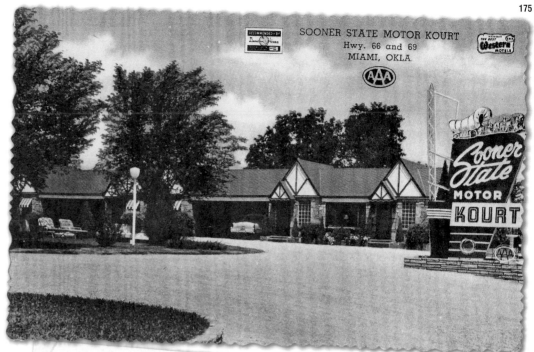

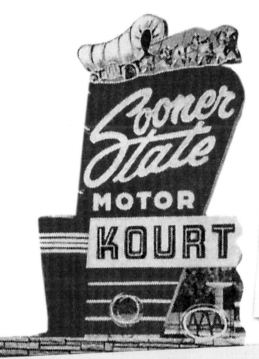

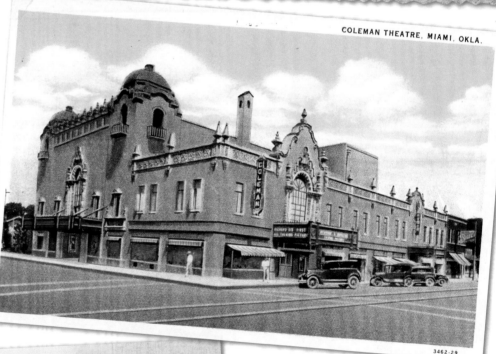

176

Miami, pronounced "My-AM-uh," was the first town chartered in the Indian Territory. It was originally known as Jimtown because four residents shared that name. Jim Palmer established the first post office and named it in honor of his wife, a Miami Indian. Miami grew dramatically after the discovery of lead and zinc in 1905. It is the headquarters of nine Native American tribes. The Hotel Miami **(177)** was constructed in 1918. The building still stands, although the storefronts have been filled in.

177

After passing through downtown Miami (178), early Route 66 travelers followed 15.4 miles of roadway paved just nine feet wide in 1922. Two remnants of the "Sidewalk Highway" can still be driven slowly today. Ben Stanley's Café (179) opened in 1947 in a prefabricated building that came complete with fixtures.

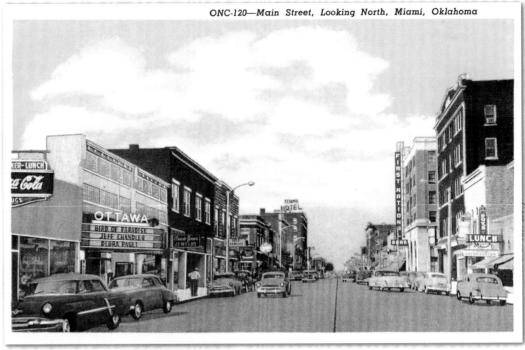

ONC-120—Main Street, Looking North, Miami, Oklahoma

Ben Stanley's
CAFE
Nationally Famous
STEAKS
CHICKEN
SEA FOOD
One Mile South of
MIAMI, OKLA.
on Hi-way 66

Afton was founded in 1886 and named for Afton Aires, the daughter of a railroad surveyor who named her after the Afton River in his native Scotland. Laurel Kane welcomes travelers at her restored gas station in Afton, filled with memorabilia and a collection of vintage Packards.

In 1932, Clint and Lillie Baker took over a small barbeque restaurant that grew into Baker's Café (180), with seating for 120. During the Depression, Clint offered a meal and 50 cents to anyone who would work for an hour. The building later became a day care center

Clint Baker later operated Clint's Café, (183) which later became the Davis Café. The building then housed several other businesses before it burned down in 2009.

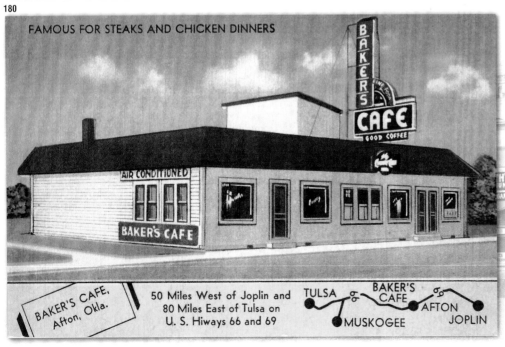

FAMOUS FOR STEAKS AND CHICKEN DINNERS

AIR CONDITIONED

BAKER'S CAFE

BAKER'S CAFE, Afton, Okla.

50 Miles West of Joplin and 80 Miles East of Tulsa on U. S. Hiways 66 and 69

TULSA — BAKER'S CAFE — AFTON — JOPLIN
MUSKOGEE

181

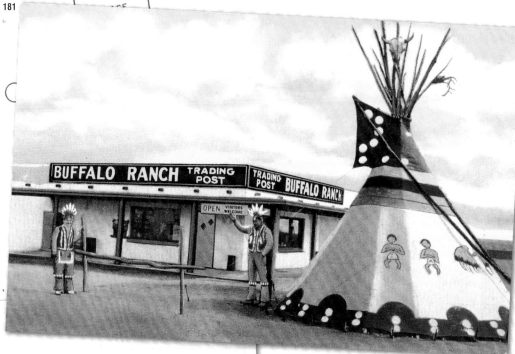

Russell and Allene Kay opened the Buffalo Ranch (181-182) at the junction with U.S. 59 in 1953. The classic roadside attraction closed after Allene died and was leveled in 1998.

Larue Olson and his trained 1,800 pound Buffalo, Pat, performed at the Buffalo Ranch. Olson always said buffalos could be trained but not tamed, and Pat eventually killed him.

182

183

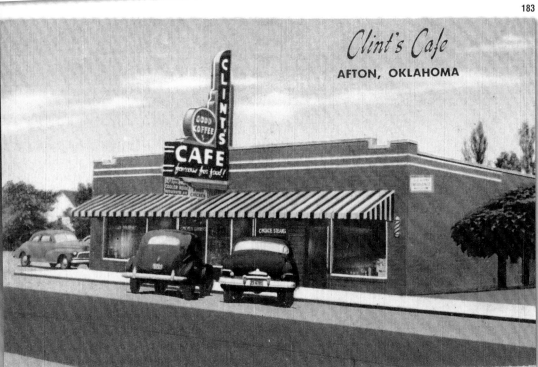

Vinita **(184-185)** is the seat of Craig County, and was originally known as Dowlingville. In 1871, the town was named for Vinnie Ream, the first woman ever to win a commission from Congress for a statue. She created the statue of Abraham Lincoln in the U.S. Capitol rotunda.

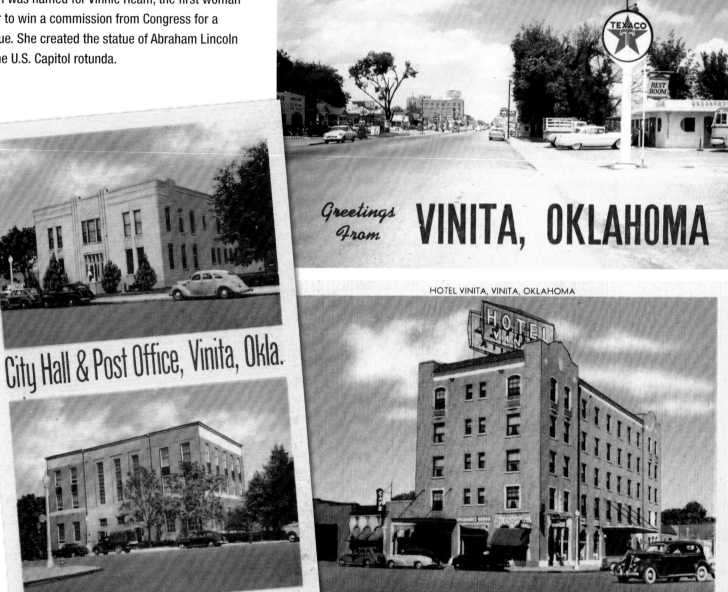

184

Greetings From **VINITA, OKLAHOMA**

185

City Hall & Post Office, Vinita, Okla.

HOTEL VINITA, VINITA, OKLAHOMA

186

When Route 66 was first commissioned, most Oklahoma hotels were designed to serve railroad travelers. The Hotel Vinita **(186)** was constructed in 1930 and oriented to face Route 66. Mont Green originally owned the hotel. The lower level now houses shops.

C.J. Wright's Cafeteria **(187)** is gone now, but Clanton's Café in Vinita has been in business since 1927, and is famous for chicken fried steak.

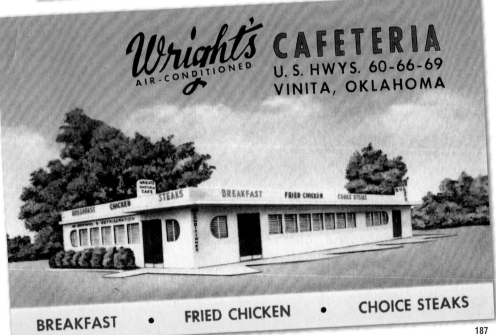

Wright's **CAFETERIA**
AIR-CONDITIONED
U. S. HWYS. 60-66-69
VINITA, OKLAHOMA

BREAKFAST • FRIED CHICKEN • CHOICE STEAKS

187

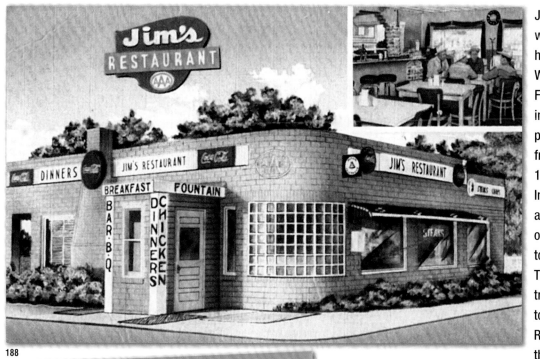

188

Jim's Restaurant (188) opened in 1948 and was located where Route 66 curved to the west headed out of Vinita.

Wood carver Ed Galloway retired to this farm near Foyil in 1937 and began building totem poles, including the largest in the world (190). The poles are made of mortar over a steel and wire framework. His totem pole park deteriorated until 1983, when restoration began.

In the early 20th Century, Claremore was famous as "Radium Town," with bath houses (191) offering a soak in the foul smelling mineral water touted as having healing qualities.

The Southern Café (189) welcomed Route 66 travelers in Claremore, which is also the home town of singing legend Patti Page and Lynn Riggs. Riggs wrote *Green Grow the Lilacs*, the basis for the musical *Oklahoma!*

189

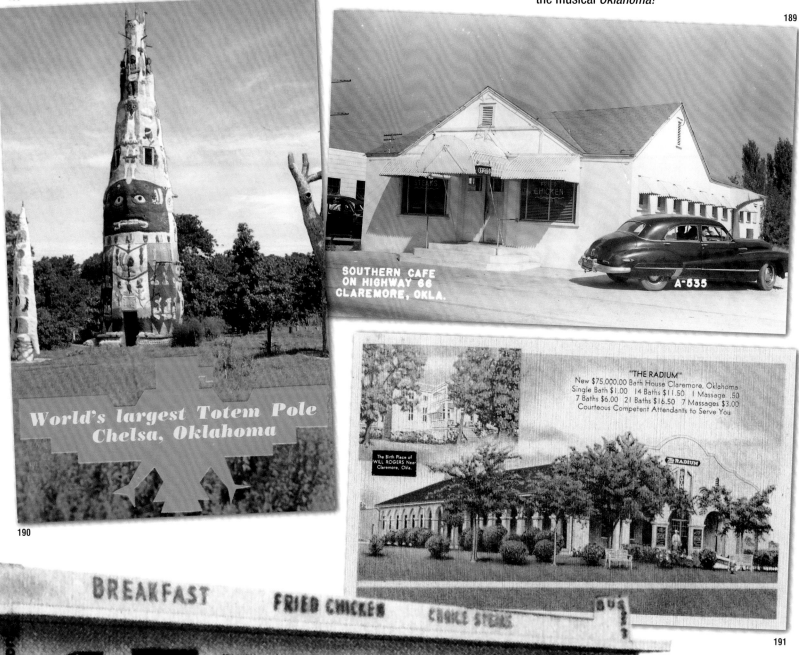

SOUTHERN CAFE ON HIGHWAY 66 CLAREMORE, OKLA.

A-535

World's largest Totem Pole Chelsa, Oklahoma

190

"THE RADIUM"
New $75,000.00 Bath House Claremore, Oklahoma
Single Bath $1.00 14 Baths $11.50 1 Massage .50
7 Baths $6.00 21 Baths $16.50 7 Massages $3.00
Courteous Competent Attendants to Serve You

The Birth Place of WILL ROGERS Near Claremore, Okla.

191

BREAKFAST FRIED CHICKEN CHOICE STEAKS

J. M. DAVIS GUN COLLECTION,
LARGEST INDIVIDUAL GUN COLLECTION IN U. S. A.

MASON HOTEL COFFEE SHOP, CLAREMORE, OKLAHOMA

John Monroe Davis displayed the world's largest private gun collection at his Hotel Mason **(192)** in Claremore. The collection of over 20,000 weapons is now on display at the J.M. Davis Arms and Historical Museum.

Will Rogers was born near Claremore and planned to retire there. After his death, the family donated the land and the state built a memorial museum **(193)**. It was dedicated on the 58th anniversary of Will's birth, November 4, 1938. A sunken garden contains the tomb of Will Rogers, his wife Betty and members of his immediate family. Behind the tomb is a statue of Will atop his favorite horse, Soapsuds.

WILL ROGERS MEMORIAL CLAREMORE, OKLA. L-6

THE TOMB WILL ROGERS MEMORIAL CLAREMORE OKLA. L-12

194

THE HOTEL WILL ROGERS --- Claremore U.S.A. featuring Southern Hospitality" -- Rates $1.00 to $2.50 -- RADIUM WATE...

CLAREMORE is the home of the famous Radium Water Baths, and the sixth floor of this hotel contains the finest Radium Water Bath House in the entire Southwest.

9.15. Tues

Have just finished our breakfast here and are starting for home - today - home via St Louis

Natalie

MADE BY CURT TEICH & COMPANY, INC., CHICAGO, U.S.A.

195

Louis Abraham, Walter Krumrei and Morton Harrison were the builders of the Will Rogers Hotel **(194)**, dedicated on February 7, 1930. It had mineral baths on the top floor, and the sulfurous water ate away the pipes. The hotel closed in 1991. It was restored in 1997 and houses senior citizen apartments.

At Catoosa, Hugh Davis and his wife Zelta's Nature's Acres **(195)** included a small "ark" for the kids to play on, as well as some snakes and alligators. Hugh later turned the pond into a swimming hole, constructing an 80-foot-long concrete whale in 1970. The Blue Whale, restored in 1997, is one of the most beloved landmarks on Route 66.

196

ELECTRIC TOURIST PARK ALL MODERN CONVENIENCES—GAS.

A HIGH GRADE OF GAS AND OILS.

OLD ENGLISH INN, LUNCHES AND DINNERS.

AVERY SERVICE STATION, 6 MI. EAST OF TULSA ON HIGHWAYS Nos. 7—11—12.

Route 66 originally entered Tulsa via 193rd Avenue, 11th Street, Mingo Road, Admiral Place, Lewis Avenue, and 2nd Street. "The Father of Route 66," Cyrus Avery, ran this complex **(196)** at Mingo and Admiral. Route 66 was rerouted to stay on 11th Street west from Mingo in 1932 and Avery's complex was torn down in 1943.

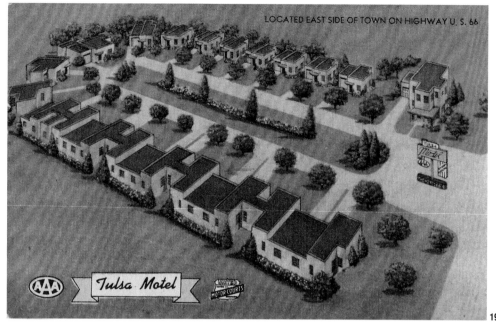

LOCATED EAST SIDE OF TOWN ON HIGHWAY U. S. 66

Tulsa Motel — AAA — MEMBER OF UNITED MOTOR COURTS

197

Tulsa was settled between 1828 and 1836 by Creek Indians driven from their homes in the south by the U.S. Government. They named the settlement Tulasi, which means "old town." The discovery of Oil at Red Fork in 1901 triggered a boom that made Tulsa the "Oil Capital of the World."

"Tulsa's Most Popular Motel," The Tulsa Motel (197) opened in 1941 but no longer stands. It originally had cottages that were entered from the garages to ensure privacy.

The Will Rogers Motor Court (198) opened in 1941 Paul and Dora Johnson took over in 1947, adding the classic neon sign with a rearing horse and its rider in 1951. The court survived into the 2000s, but has been demolished.

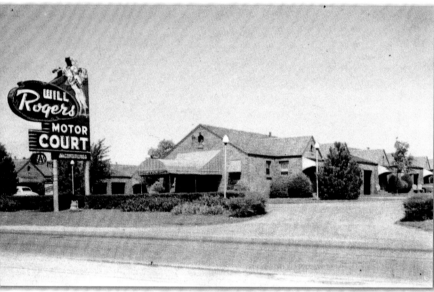

198

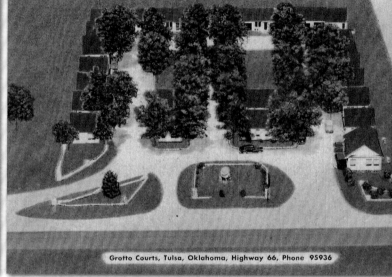

Grotto Courts, Tulsa, Oklahoma, Highway 66, Phone 95936

199

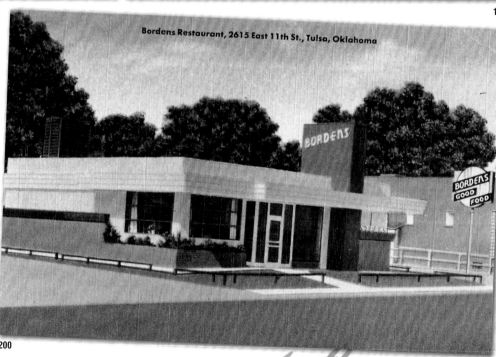

Bordens Restaurant, 2615 East 11th St., Tulsa, Oklahoma

200

Gateway to the Nation's Vacationlands

T.W. Moore and G.L. Chastain operated the Grotto Courts (199). It was torn down many years ago and the site is now a parking lot. Leroy Borden and his brother Richard opened their first restaurant (200) in 1935. They eventually had seven restaurants and cafeterias. The last one closed in 1985.

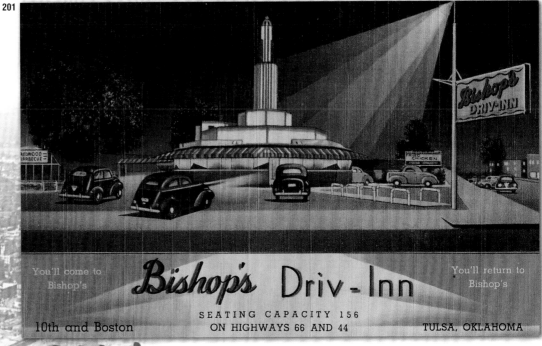

You'll come to Bishop's

Bishop's Driv-Inn

You'll return to Bishop's

SEATING CAPACITY 156
10th and Boston ON HIGHWAYS 66 AND 44 TULSA, OKLAHOMA

Tulsa Oklahoma *Teepees to Towers*

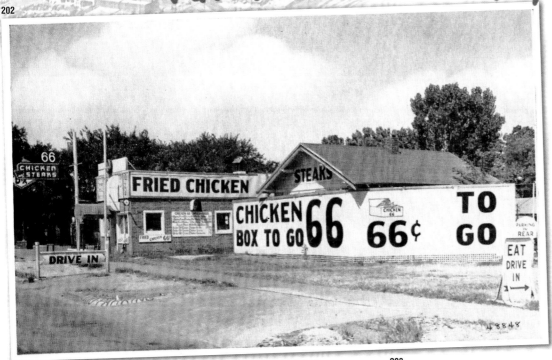

William Wallace Bishop was a very successful restaurateur, owning several eateries in Tulsa and later operating restaurants from Oklahoma City to Hollywood. But Bishop's Drive In (201) was only in business from 1938 until 1942. The site is now a parking lot for Tulsa Community College.

66 Chicken and Steaks (202) was located on South Quanah Avenue, which became Southwest Boulevard in the 1950s.

The highway passes through Sapulpa, Bristow and Stroud before entering Chandler, where Joe Gibson operated Gibson's Court (203). He opened the Lincoln Motel (204) in 1939 and it is still in business today.

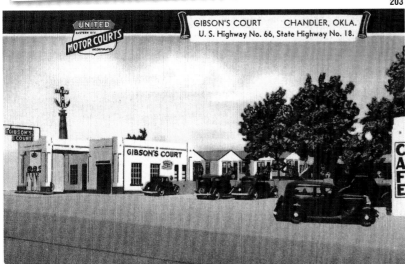

GIBSON'S COURT CHANDLER, OKLA.
U. S. Highway No. 66, State Highway No. 18.

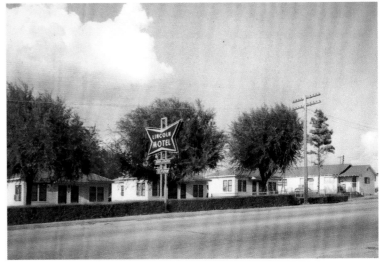

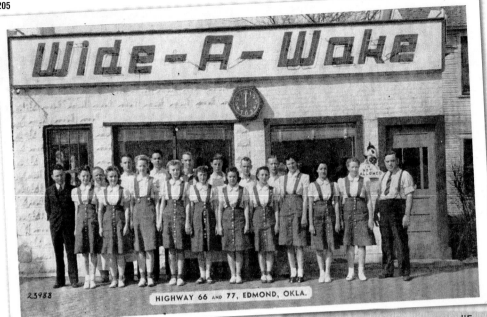

205

HIGHWAY 66 AND 77, EDMOND, OKLA.

23988

Edmond, now a suburb of Oklahoma City, was named for rancher Eddy Townsend. The first schoolhouse in the Oklahoma Territory was erected here in August of 1889.

Originally the Night and Day Café, the Wide-A-Wake Café (205) was opened by brothers Crawford and Gene Noe with their wives Cleo and Essie Mae. The Wide-A-Wake had seating for 31 people and served travelers and locals until 1979. The site is now a parking lot.

Royce Adams was a good friend of Wide-a-Wake Café owner Gene Noe, and opened his own place (206) in 1934. This card said that Edmond had "6,000 live citizens and no negroes."

206

EDMOND

"A GOOD PLACE TO LIVE"

6,000 Live Citizens
No Negroes
Home of
CENTRAL STATE
TEACHERS COLLEGE
Rated as One of the
Nation's Best.
Public School System
Surpassed by None
Eight Active Churches
Seven Attractive Parks
Beautiful Homes with
Ideal Living Conditions
300 Blocks of Paving
Santa Fe Railroad
Hourly Interurban Service
40 Bus and Truck Lines
Municipal Light and
100% Pure Water
Rodkey Flour Mills
Van's Baking Co., - Gins
Ice Plant
Grain Companies
Dairying
Agricultural Center
The Edmond Oil Field,
Three Miles West is one of
the Best in Southwest.

"From Dawn to Dawn We're Never Gone" Air Conditioned

ROYCE B. ADAMSON
OWNER

ROYCE CAFE

ROYCE CAFE Edmond, Okla.

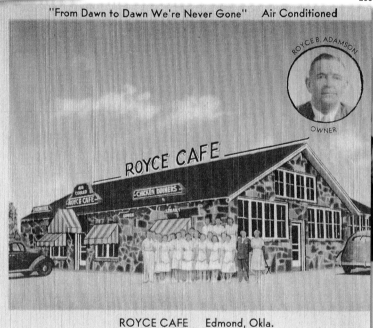

207

TRINITY BAPTIST CHURCH
and a
SUNDAY MORNING CONGREGATION
Oklahoma City, Okla.

TRINITY BAPTIST CHURCH

The caption on this postcard (207) noted that Trinity Baptist Church on N.W. 23rd Street in Oklahoma City had 2,600 members, and 2,000 enrolled in Sunday school. The auditorium seated 1,400.

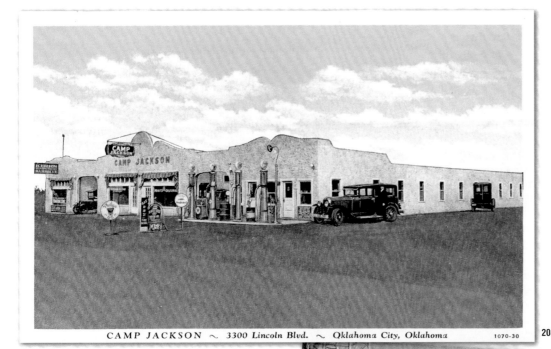

CAMP JACKSON ~ 3300 Lincoln Blvd. ~ Oklahoma City, Oklahoma 1070-30 208

The "Jackson Camp" (208) was one of the first motor hotels in Oklahoma City, opening in 1927 at 3300 N. Lincoln Boulevard, nine blocks north of the state capitol. Operated by Goldie Jackson, it originally had 34 units. Several cabins burned in 1943 and it later became the Jackson Courts.

Route 66 entering Oklahoma City originally used Kelley to Grand and Lincoln Boulevards, turning west at the capitol onto 23rd Street. In 1954, Route 66 was shifted east of Edmond to the path of today's Interstate 35.

Eric Lipper's Clock Inn (210) was located near the intersection of the 1954 alignment with the new Northeast Expressway, now I-35/I-44, and opened the same year. No trace remains today. The sign with its swinging pendulum is now at the Muscle Car Ranch in Chickasha.

The Wilshire Motel (209) opened on August 1, 1954 constructed by Oklahoma City florist J. Wiley Richardson. The $300,000 motel offered a playground, games and Pony rides for the kids.

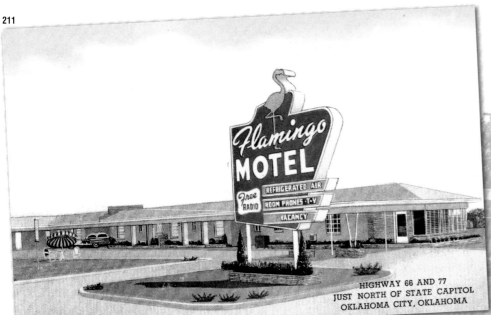

HIGHWAY 66 AND 77
JUST NORTH OF STATE CAPITOL
OKLAHOMA CITY, OKLAHOMA

Colorful motels such as the Flamingo **(211)** once lined Lincoln Boulevard, but most of them deteriorated after the construction of I-44 and were demolished in the 1990s to create a tree-lined boulevard leading to the capitol.

The Palomino motel (212) was constructed by A.M. Collins. The caption on the card called the pony out front "one of the most photogenic horses in Oklahoma" and noted that he "loves to be photographed."

Garland P. Arrington operated Garland's **(213)** from 1939 until 1950. Garland's offered curb service by car hops dressed in sailor outfits with short skirts and white boots.

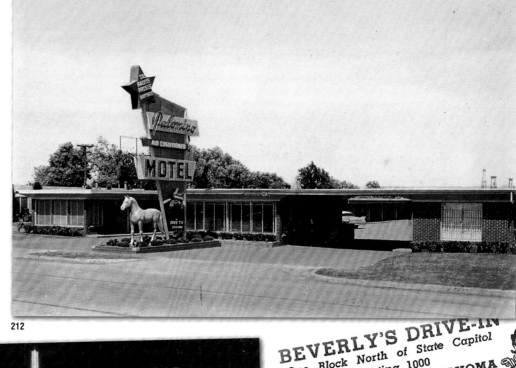

212

213

GARLAND'S
DRIVE-IN
RESTAURANT

OKLAHOMA'S
FINEST

AT THE CROSSROADS
OF U. S. HIGHWAYS
66 AND 77

22nd and Broadway
OKLAHOMA CITY
Phone 5-8811

U. S. HIGHWAY 77 22ND STREET

BEVERLY'S DRIVE-IN
One Block North of State Capitol
Seating 1000
OKLAHOMA CITY, OKLAHOMA

Original home of the nationally famous "Chicken in the Rough."
Franchises in more than 100 cities.
"The Million Dollar Plate"
Mr. & Mrs. Beverly Osborne, Owners.

Dear Dad:
Had a wonderful
+ dinner at this
We sure were tired
nite. Geo is looki
Ma is looking forwa
oming down. Tell
the fellows.

214

The Park O Tell (214) opened in 1930 and included a 68 room hotel, a 68-car garage, a gas station, coffee shop and beauty parlor. Guests could have their cars serviced while they slept. It was demolished when Lincoln Boulevard was routed around the capitol.

The U.S. Government opened the area around Oklahoma City (215-216) for development in 1889. Over 50,000 people gathered on the edge of the territory for a "land rush." Many snuck over at night to get the best sites, and they were known as "Sooners." Built between 1914 and 1917, the Oklahoma State Capitol building is the only state capitol building with a producing oil well on its grounds.

215

217

Beverly Osborne and his Chicken in the Rough Western girls going to the FFA and 4-H Club Live Stock Auction. It is the custom at Beverly's to buy a champion each year.

216

Beverly and Rubye Osborne developed the first franchised fast food in the United States. On a vacation trip in 1936 Beverly hit a bump and Rubye spilled the box of chicken they had packed for lunch. She commented, "This is really chicken in the rough." There were soon over 150 Chicken in the Rough franchises (217), offering one-half of a fried chicken with shoestring potatoes, rolls and honey, to be eaten without silverware.

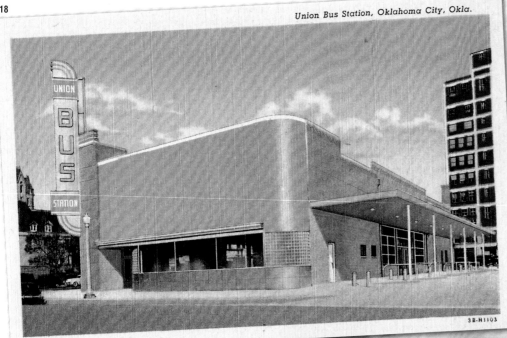

Union Bus Station, Oklahoma City, Okla.

3B-H1103

From 1926 to 1933, Route 66 turned back north from 23rd Street onto Classen Boulevard before turning west again on 39th Street. The Citizen's State Bank **(219)** opened in December, 1958 at N.W. 23rd Street and Classen Boulevard. Designed by local architect Robert Roloff following Buckminster Fuller's patented geodesic design, it was world's first dome made from gold-anodized aluminum. Narrowly saved from demolition, it is now known as the Gold Building and houses a cultural center, offices, and an art gallery in the old bank vault.

219

There were several good tourist courts in a two mile stretch on the west end of Oklahoma City, including the Boyer, Deluxe, Rush, Carlyle, Major, Oklahoma and Hutchison. The Deluxe Courts **(221)** later became the Motel Morocco, but no longer stand. The Lakeview Courts **(222)** offered boat rides on Lake Overholser near the 1925 bridge across the lake. Yukon lies west of Lake Overholser, and the skyline is dominated by the massive Yukon's Best Flour grain elevators.

220

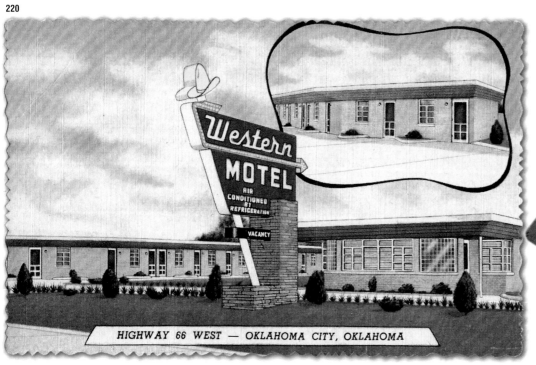

HIGHWAY 66 WEST — OKLAHOMA CITY, OKLAHOMA

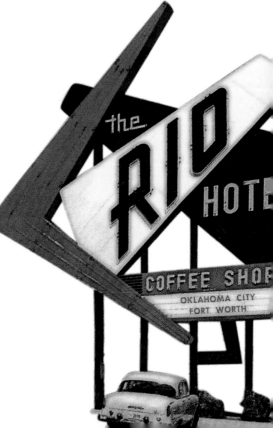

On U. S. Highway 66 *De Luxe Courts* Oklahoma City, Oklahoma
5500 N. W. 39th Street — Phone 9-3027

El Reno was established in 1889 and named for Civil War hero General Jesse Reno. It is located where Route 66 intersects the historic Chisholm Trail. Mr. and Mrs. J.R. Phillips operated the Phillips Motel (223), now the Budget Inn. The Beacon Motel and Café (224) opened about 1940 and later became the Big 8 Motel. The motel and room 117 were featured in the 1988 film *Rain Man*. The sign was altered to read "Amarillo's Finest" for the movie. Sadly, the sign was removed in 1999 and it became the DeLuxe Inn, which was demolished in 2005.

222

221

YUKON'S BEST FLOUR

NO FINER OR MORE MODERN MILLS IN AMERICA

223

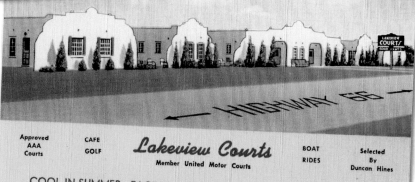

| Approved AAA Courts | CAFE GOLF | *Lakeview Courts* Member United Motor Courts | BOAT RIDES | Selected By Duncan Hines |

COOL IN SUMMER - FACING ONE OF OKLAHOMA'S LARGEST LAKES

8 MILES WEST OF OKLAHOMA CITY LIMITS 3 MILES WEST OF BETHANY 4 MILES EAST OF YUKON ON 66

Phone Bethany 612 and 322 TELEGRAPH Mail Address R. 3, Box 23-A, Yukon

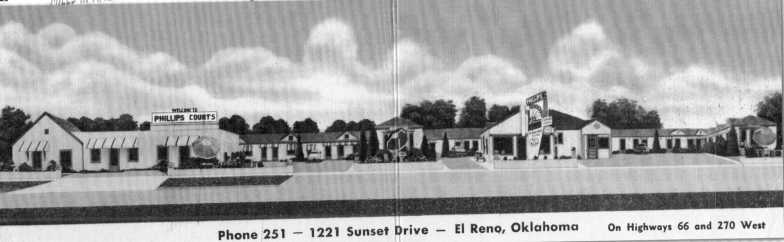

WELCOME TO PHILLIPS COURTS

Phone 251 — 1221 Sunset Drive — El Reno, Oklahoma On Highways 66 and 270 West

224

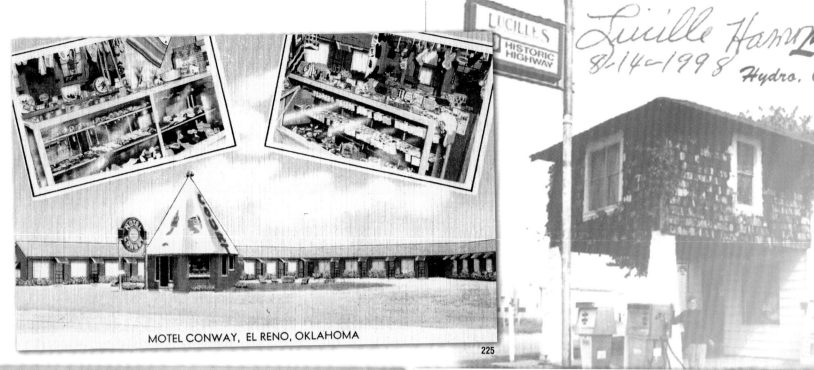

MOTEL CONWAY, EL RENO, OKLAHOMA

225

Howdy from Weatherford, Oklahoma

226

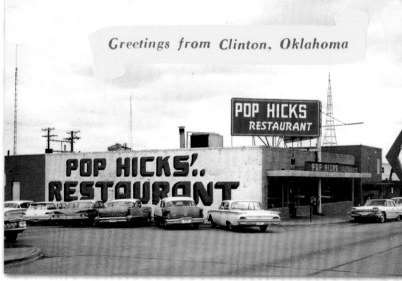

Greetings from Clinton, Oklahoma

POP HICKS
RESTAURANT

POP HICKS!..
RESTAURANT

227

Route 66 is known for motels shaped like wigwams in the west. But Oklahoma had a motel shaped like a teepee. The Motel Conway **(225)** opened in October, 1945 and was full every night for the first three years.

Weatherford **(226)** is part of the area settled in the third Oklahoma land rush and was named for colorful Marshall William J. Weatherford. It is the hometown of astronaut General Thomas P. Stafford, and a museum in town displays his space suit.

Pop Hick's Restaurant was the best known landmark in Clinton **(227)**. Ethan "Pop" Hicks opened his restaurant on January 1, 1936, starting with a 3-booth seven-stool diner and a lean-to kitchen. Howard Nichols was operating the restaurant when it burned on August 2, 1999.

228

Carl Ditmore opened his gas station near Hydro in 1929, adding a motel in 1932. W.O. and Ida Waldroup took over the property in 1934 and named it Provine Station. Carl and Lucille Hamons took over in 1941 changed the name to Hamon's Court. Lucille became beloved as the "Mother of the Mother Road." She died in August 2000. Lucille's Roadhouse in Weatherford pays tribute to Lucille.

"Doc" Mason's Tradewinds Motel (228) in Clinton opened in 1963. Elvis Presley stayed here four times while being driven from Memphis to Las Vegas. The King hated to fly. He stayed in Room 215, which remains much as it was then.

The Home on the Range Motel (229) still stands, and is now the Relax Inn.

Woodrow and Viola Peck were former cotton farmers, who opened the Cotton Boll Motel (230) in Canute in 1960. It is now a private home but the sign remains.

The Motor Inn Courts (231) in Elk City advertised "Where tired tourists meet Good Eats and Good Beds." The Great Plains Regional Medical Center occupies this site today.

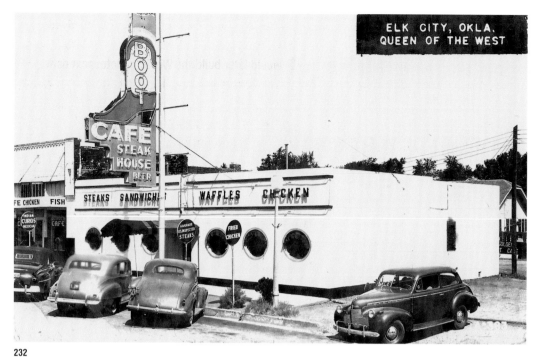

232

The people of Crowe, Oklahoma renamed their town Busch, hoping to impress the St. Louis brewing magnate and perhaps land a brewery. When no brewery was built, residents chose to name the town Elk City, after Elk Creek. The Boot Café **(232)** was originally Campbell's Steak House, offering a "A Meal of Fine Food" for 25 to 65 cents in 1941.

The Monahan's Restaurant **(233)** in Elk City advertised "good food and western hospitality," as well as "Delicious Foods of larger variety properly prepared and courteously served" with an air conditioned dining room and a large banquet room. The site is now a car dealership.

233

Sayre **(234)** is named for railroad stockholder Robert H. Sayre. The Beckham County Courthouse, visible in the background, was featured in the movie *The Grapes of Wrath*, in the montage showing the start of the Joad family's journey. The courthouse was constructed in 1911.

Students at Sayre High School **(235)** reportedly caused a bit of a disturbance on Route 66 when a bridge east of town burned in 1959. They stood by barricades and told out of state motorists that Indians had attacked and burned the bridge.

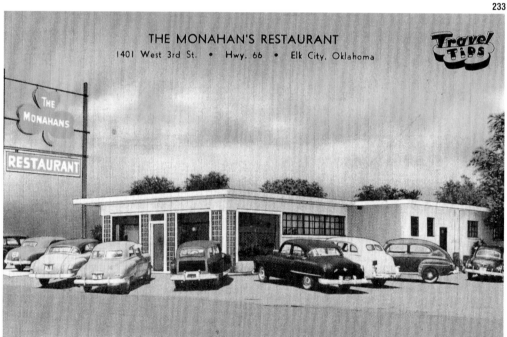

234

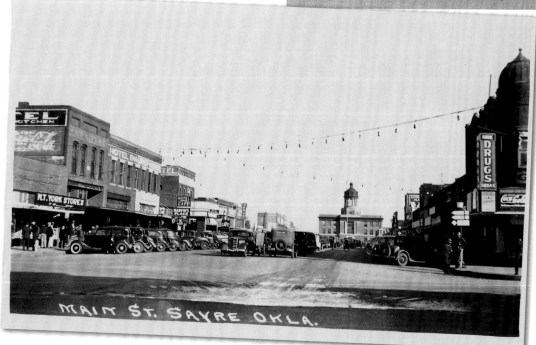

235

HIGH SCHOOL SAYRE OKLA.

Paul and Ruby Mackey built the Sunset Motel **(236)** on the east side of Sayre about 1949. They would later build the Western Motel next door. The Sunset was later owned by Oscar and Grace Dobbins, as well as Anne and Dwight Danberg. The Spence and Russell Standard Station **(237)** opened in 1949. It is no longer in operation, but the building still stands. The station still had new gas pumps and old pumps with Standard crowns on top. Route 66 becomes Roger Miller Boulevard as it passes through Erick, the hometown of the "King of the Road." The ghost town of Texola is at the Texas line.

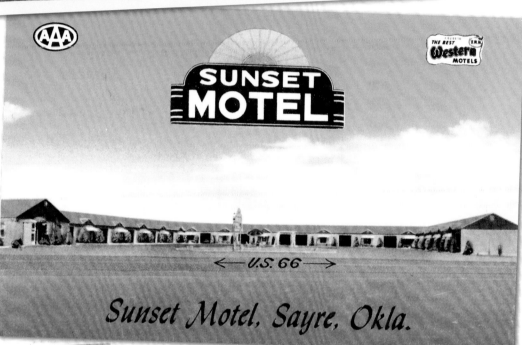

Sunset Motel, Sayre, Okla.

236

237

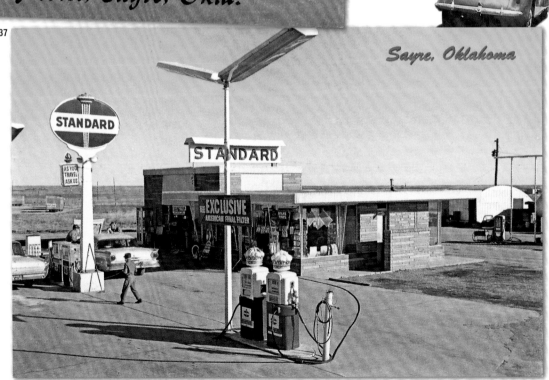

Sayre, Oklahoma

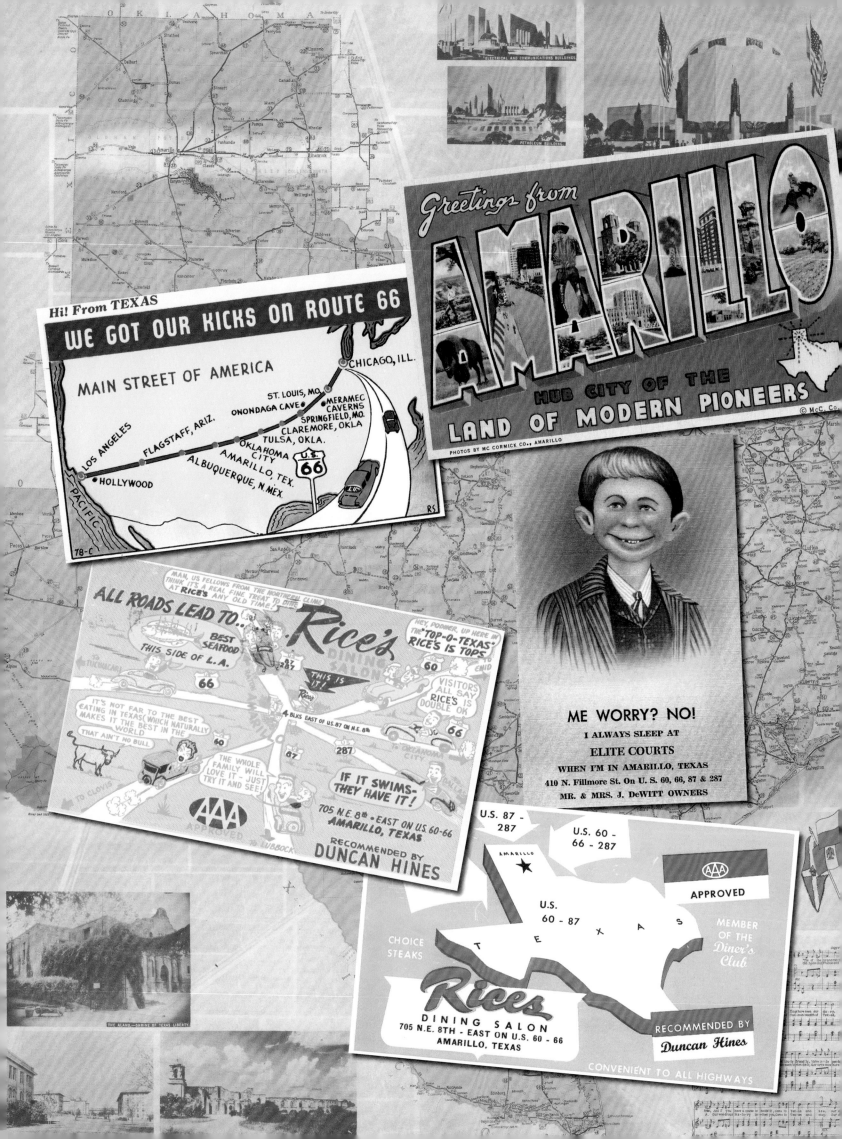

TEXAS The Lone Star State

Route 66 crosses 178 miles of the Texas Panhandle, an area known as the Llano Estacado, or "Palisaded Plains." The name is often mistranslated as "Staked Plain." The early settlers found a featureless terrain, so vast that they drove stakes in the ground to mark their routes.

Route 66 across Texas included the dreaded "Jericho Gap," an 18-mile dirt section between McLean and Groom that remained long after the rest of Route 66 had been paved. Locals raked in cash using teams of horses to pull vehicles from the thick black mud until the gap was finally paved in 1937.

Shamrock was once a busy stop at the intersection with US 83. Many vintage roadside businesses are slowly crumbling and traffic has dwindled, but the glorious neon has been restored at the Art Deco U-Drop Inn. At McLean, a vintage Phillips 66 station has been beautifully restored. The Devil's Rope Museum is a treasure, housed in a former brassiere factory and including exhibits on barbed wire and a section devoted to Route 66. The traveler leaves here with a new appreciation for how barbed wire, known by Indians as "Devil's Rope," tamed the West.

Amarillo is the Spanish word for yellow, a name reflecting the color of the soil along Amarillo Creek and the abundant yellow wildflowers. In the 1890s it was reported that Amarillo had ten times as many cattle as people. Route 66 entered town on 8th Street, today's Amarillo Boulevard. Amarillo Boulevard was known as "Motel Row," but many of the colorfully named motels have disappeared or are crumbling. Past Motel Row, 66 turned south on Fillmore Street through downtown, then headed west on 6th Avenue, Bushland Boulevard and 9th Avenue through San Jacinto Heights.

This little cowpoke posed in the heart of the Amarillo tourist district, the busy intersection of U.S. 60, 66, 87 and 287, Amarillo Boulevard at Fillmore. Many of the establishments on "Motel Row" used western imagery to appeal to the tourists. The cowboy sign shown here still stands in front of the Cowboy Motel.

The Big Texan Steak Ranch, now located on the Interstate, offers a hearty dose of Texas kitsch and the famous 72 oz. steak dinner. It's free for customers who can down it in one hour. Former Cincinnati Reds pitcher Frank Pastore wolfed it down in 9.5 minutes!

West of town, ten vintage Cadillacs are buried in the earth at the Cadillac Ranch. Created by a group of artists for an eccentric millionaire, they now stand as a reminder of the glory days of the American auto industry and Route 66.

Adrian is said to be exactly midway between Chicago and Los Angeles on Route 66, where the Midpoint Café is famous for its "Ugly Crust" pie. Glenrio straddles the state line, a classic Route 66 ghost town devastated by the arrival of the Interstate. Only the occasional stray dog and picturesque ruins greet travelers today. It's a place to pause and reflect on those who came before.

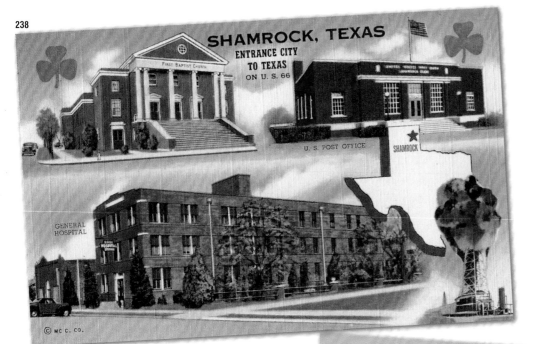

MILEAGE CHART

U. S. HIGHWAY 66
From Shamrock, Texas

EAST		WEST
OKLAHOMA LINE	14	LELA
ERICK	23	McLEAN
SAYRE	38	ALANREED
ELK CITY	56	AMARILLO
CLINTON	88	ADRIAN
WEATHERFORD	103	SAN JUAN
EL RENO	144	TUCUMCARI
OKLAHOMA CITY	173	NEWKIRK
EDMOND	188	SANTA ROSA
CHANDLER	224	ALBUQUERQUE
STROUD	249	LAGUNA
BRISTOW	256	BLUE WATER
SAPULPA	300	GALLUP
TULSA	315	LUPTON
CLAREMORE	344	SANDERS
VINITA	381	HOLBROOK
MIAMI	416	WINSLOW
QUAPAU	422	WINONA
JOPLIN	433	TOWNSEND
CARTHAGE	450	WILLIAMS
SPRINGFIELD, MO.	508	KINGMAN
ROLLA	628	TOPOCK
ST. LOUIS	742	NEEDLES
SPRINGFIELD, ILL.	828	BARSTOW
CHICAGO	1023	LOS ANGELES

Shamrock (238) owes its name to George Nickel, an Irish immigrant who wanted to establish a post office. It was originally known as Hidetown, because the buffalo hunters draped hides over their shelters. Route 66 was once lined with gas stations and motels, but many are now gone or in ruins. John Nunn used an old nail to scratch his vision for a new gas station in the dirt. Architect Joseph Berry put the design to paper, and J.M. Tindall and R.C. Lewis constructed the Tower Station and U-Drop Inn Café (239) at Route 66 and U.S. 83. It opened on April 1, 1936. The U-Drop Inn closed in 1995 but has been restored and serves as a visitor's center. The building was the inspiration for Ramone's body shop in the motion picture *Cars*.

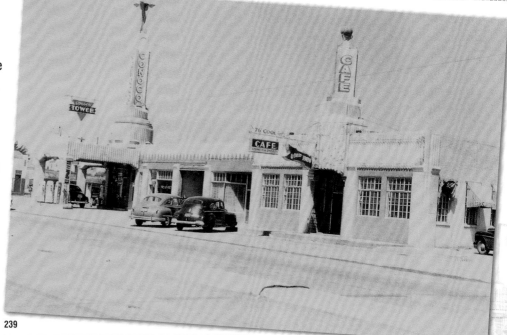

U. S. HIGHWAY 83
From Shamrock, Texas

NORTH		SOUTH
WHEELER	16	WELLINGTON
PERRYTON, TEX.	98	CHILDRESS
LIBERAL, KAN.	147	PADUCAH
McCOOK, NEB.	505	ASPERMONT
NO. PLATTE	581	ABILENE
MISSION, S. D.	778	BALLINGER
PIERRE, S. D.	889	JUNCTION
BISMARK, N. D.	1101	SAN ANTONIO
MINOT, N. D.	1208	LAREDO, TEXAS
CANADA, U. S. LINE	1305	MONTERREY, MEXICO

COMPLIMENTS

DIXIE CAFE
Shamrock, Texas

The Sun n' Sand Motel (240) opened in September 1953 and used the slogan "We Have Everything But You." It later became the Sun n' Sand Motor Inn and is still in business as the Route 66 Inn.

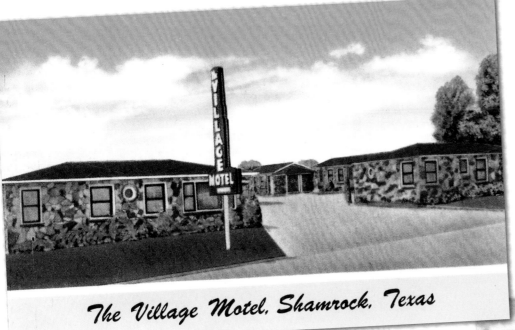

The Village Motel, Shamrock, Texas

241

McLean **(242)** was established around 1900 as a cattle-loading area on the Chicago, Rock Island and Gulf Railway and named for a judge. Alfred Rowe, who owned a 200,000 acre ranch, donated the land. He died aboard the *Titanic*. During World War II thousands of prisoners of war were housed in an internment camp here. McLean had 16 service stations and six motels during the heyday of Route 66. In 1984, it became the last town in Texas to be bypassed by Interstate 40.

The Village Motel **(241)** features a nice rock exterior. It is still standing as of 2011, but apparently no longer operating as a motel. The Ranger Motel **(243)** still survives as the Shamrock Country Inn.

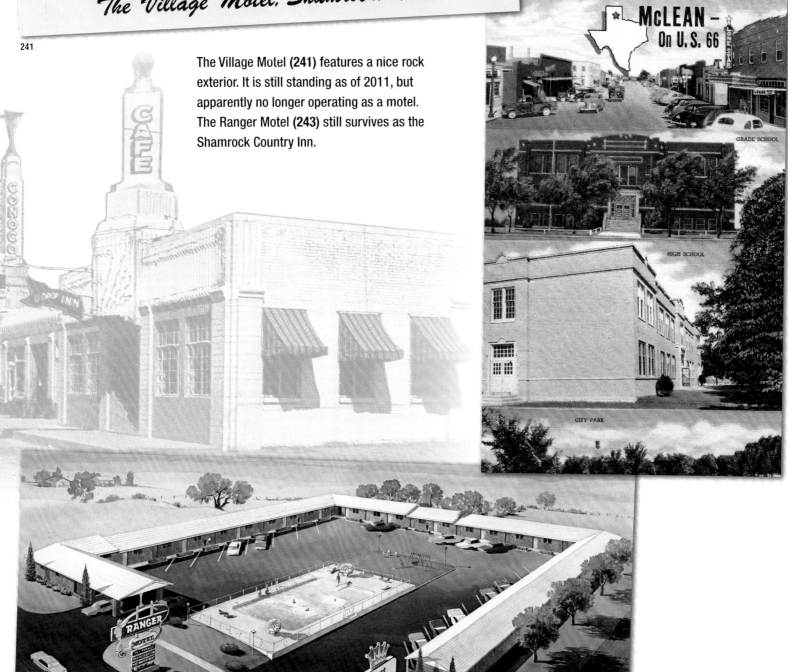

242

243

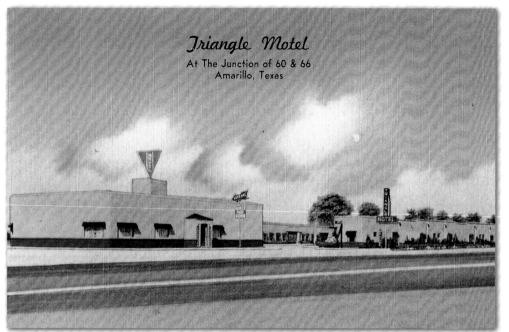

244

Route 66 through Amarillo originally followed Northeast 8th street (Amarillo Boulevard) turning south on Fillmore Street through downtown. The route turned west on 6th Avenue, Bushland Boulevard and 9th Avenue. It was later shifted to remain on Amarillo Boulevard. The former mayor of Borger, Texas, S.M. Clayton, built the Triangle Motel (244), named for the shape of the intersection at Route 66 and U.S. 60. It was cut off by airport expansion in 1955, bypassed in 1968 and closed in 1977. The property is currently being restored.

Vol's (245) was operated by Vol McClanahan, who also owned a couple of other steakhouses in Amarillo. The card noted that they offered "soft organ music" and the finest in foods.

Keith Applebee's Colonial Courts (246) opened in 1952. It later became the Colonial Manor Motel and the Rama Motel, which still stands.

George Pomeroy operated the Redwood Motel (249), which is still in business as the Redwood Motel and Apartments.

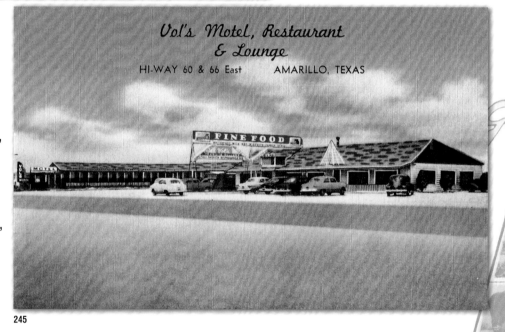

245

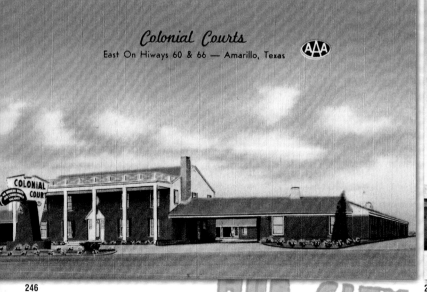

246

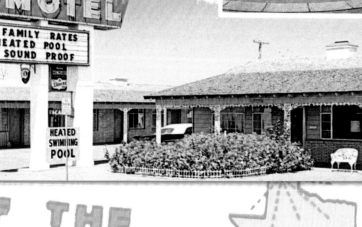

247

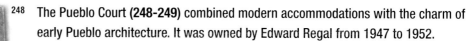

248 The Pueblo Court **(248-249)** combined modern accommodations with the charm of early Pueblo architecture. It was owned by Edward Regal from 1947 to 1952.

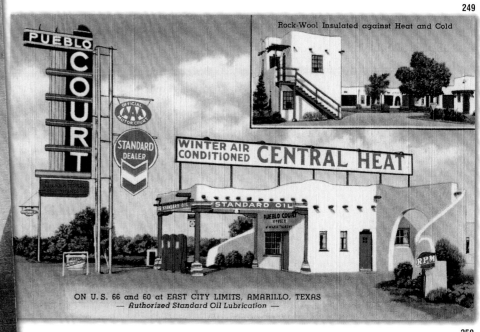

249

Rock-Wool Insulated against Heat and Cold

PUEBLO COURT

WINTER AIR CONDITIONED CENTRAL HEAT

STANDARD OIL

ON U.S. 66 and 60 at EAST CITY LIMITS, AMARILLO, TEXAS
— *Authorized Standard Oil Lubrication* —

Pueblo Cibola

● One of the entrance arches to Pueblo Cibola at Amarillo, Texas, known as the finest tourist court in the Southwest. Located at the east city limits on U. S. Highways 60 and 66, and surrounded by beautifully landscaped grounds. Pueblo Cibola combines ultra-modern accommodations with the charm of early Pueblo Indian architecture and furnishings.

250

RAMADA INN
ROADSIDE HOTELS

The Ramada Inn **(250)** chain started on Route 66 in Flagstaff, Arizona and was once the second largest hotel chain in the U.S.
Colonial architecture made the early Ramada Inns stand out.
Woody's Motel **(251)** still stands today, known as the Estess Motel.

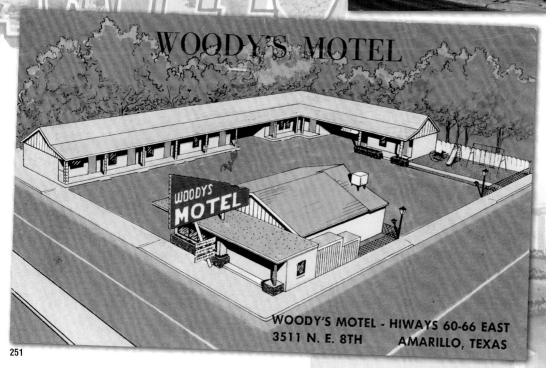

WOODY'S MOTEL

WOODY'S MOTEL - HIWAYS 60-66 EAST
3511 N. E. 8TH AMARILLO, TEXAS

251

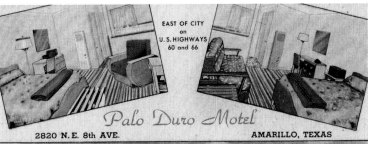

"WHERE THE NORTH MEETS THE SOUTH"

Minnesota Courts
EAST AMARILLO, TEXAS - ON U. S. HIGHWAYS 60 and 66

252

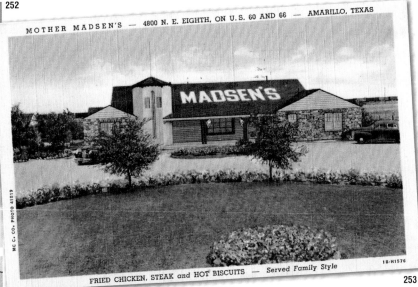

MOTHER MADSEN'S — 4800 N. E. EIGHTH, ON U.S. 60 AND 66 — AMARILLO, TEXAS

MADSEN'S

FRIED CHICKEN, STEAK and HOT BISCUITS — Served Family Style

253

EAST OF CITY on U.S. HIGHWAYS 60 and 66

Palo Duro Motel
2820 N. E. 8th AVE. AMARILLO, TEXAS

254

MARY THOMAS RESTAURANT — 1501 N. E. EIGHTH (Panhandle Highway) — PHONE: 2-4800

Mary Thomas RESTAURANT

STEAKS
SEA FOODS
OPEN

ON U. S. HIGHWAYS 66 and 60 — AMARILLO, TEXAS

255

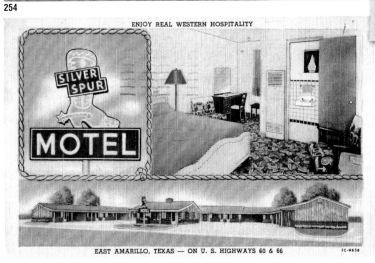

ENJOY REAL WESTERN HOSPITALITY

SILVER SPUR
MOTEL

EAST AMARILLO, TEXAS — ON U. S. HIGHWAYS 60 & 66

256

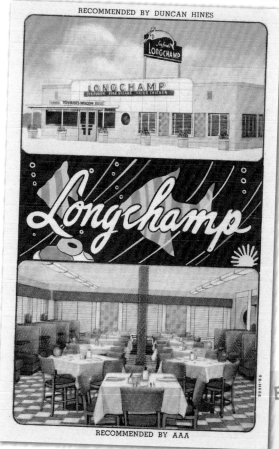

RECOMMENDED BY DUNCAN HINES

LONGCHAMP

Longchamp

RECOMMENDED BY AAA

257

The Minnesota Courts (252) were operated by Arthur J. Johnson, but no longer stand. The Palo Duro Motel (254), constructed by Schuyler Woods in 1952, and the Silver Spur Motel (256) are still in business. Florence "Ma" Madsen's (253) dining room was famous for fried chicken and opened in 1938. It was a tradition here for patrons to pin their name or business card on a big wall map of the U.S. The building that housed the Mary Thomas Restaurant (255) is now a recreational vehicle supply store. Harry Kindig converted an old gas station into the Long Champ Dining Salon (257) in 1945. He specialized in seafood, but found that Amarillo diners preferred steak. He sold to Homer and Auline Rice in 1947 they changed the name to Rice's Dining Salon in 1953. The sign atop Rice's contained 5,000 bulbs, said to be the largest restaurant sign between New York and Los Angeles.

EAST ON HIW

Recommended by

AMARILL

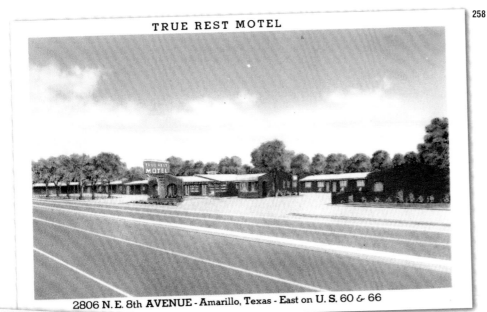

TRUE REST MOTEL

2806 N. E. 8th AVENUE - Amarillo, Texas - East on U. S. 60 & 66

258

259

260

261

262

Had a wonderful time at Rice's; food is delicious—you must try it! Amarillo, pop. 135,000, Elev. 3,676 ft., coolest summer nights in Texas, is trade and amusement center of the Golden Spread region, an area as big as Ohio. Spanish conquestadores searched here for the Seven Cities of Cibola. A noted cow town, Amarillo now is center of world's largest helium supply, rich oil & gas fields, wheat, cattle, cowboys, millions of irrigated acres. City has scores of ultra-modern motels, multimillion-dollar shopping centers, western wear shops. Nearby attractions include Beautiful Palo Duro Canyon State Park, Panhandle-Plains Museum, America's Famous First Boys Ranch on Canadian River at site of Tascosa, ghost town, foot of Boot Hill Cemetery.

O.K. "Cow Waddy" Dunlap, owner of the Grande Tourist Courts (259), said he had spent 40 years in the saddle. The True Rest Motel (258-260-262) is still in business today. It was operated by Frank Hobgood, who once served as president of the U.S. Highway 66 Association. The Plainsman Motel (261) grew from 24 rooms in 1950 to 120 in 1959. The site is now a supermarket.

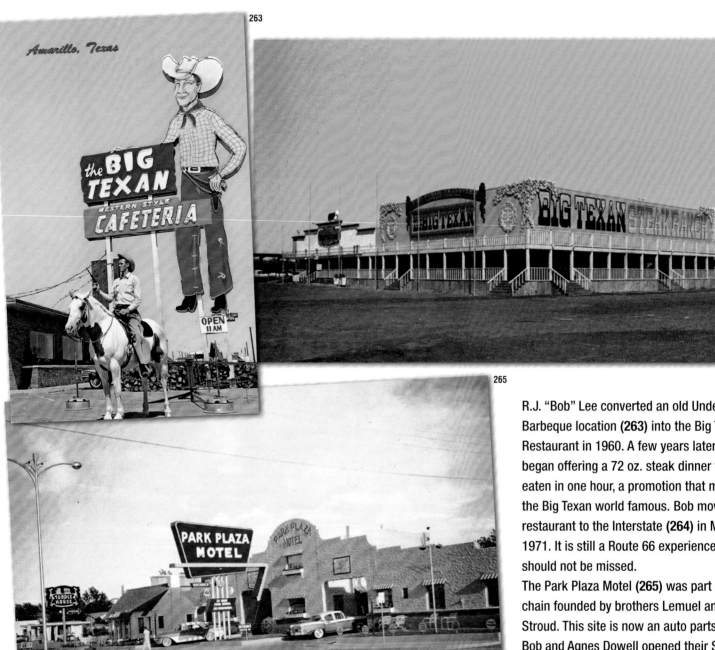

R.J. "Bob" Lee converted an old Underwood's Barbeque location **(263)** into the Big Texan Restaurant in 1960. A few years later, he began offering a 72 oz. steak dinner free if eaten in one hour, a promotion that made the Big Texan world famous. Bob moved his restaurant to the Interstate **(264)** in March 1971. It is still a Route 66 experience that should not be missed.

The Park Plaza Motel **(265)** was part of an early chain founded by brothers Lemuel and Milton Stroud. This site is now an auto parts store. Bob and Agnes Dowell opened their Saratoga Café **(266)** at 5th and North Fillmore in 1948. They owned three other restaurants on Route 66 in Amarillo.

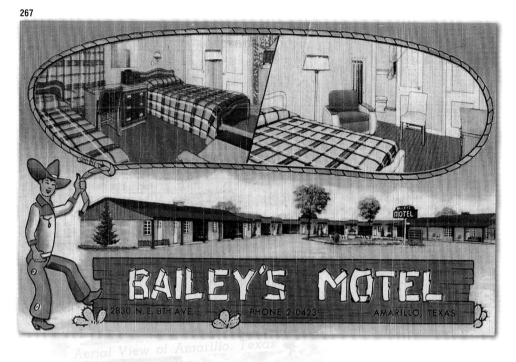

BAILEY'S MOTEL

2830 N. E. 8TH AVE. — PHONE 2-0423 — AMARILLO, TEXAS

Santa Fe Building and Polk Street, Amarillo, Texas

Aerial View of Amarillo, Texas

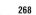

269

Santa Fe Railway Station, Amarillo, Texas

THE ARISTOCRAT — PHONE 23111 — 119 W. SIXTH AVE.

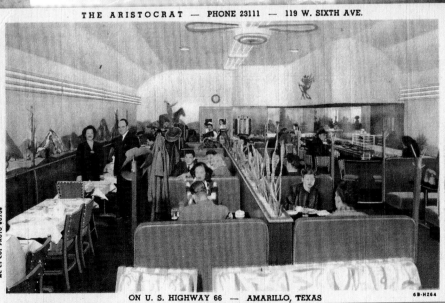

ON U. S. HIGHWAY 66 — AMARILLO, TEXAS

270

James Bailey's Motel (268) opened in 1952 and developed into today's Royal Inn.

The Santa Fe Building (268) was constructed in 1930. At the time, the "Jewel of the Texas Panhandle." was the tallest building between Ft. Worth and Denver. It was narrowly saved from demolition in 1990.

Amarillo's Santa Fe Station (269) was built in 1910. It originally housed a hotel and a Fred Harvey Restaurant. The depot is now used by an auction house.

Owners Mr. and Mrs. Tillman McCafferty are at left in this view of The Aristocrat (270). It was in operation from 1945 to 1957 at 6th Avenue and Tyler.

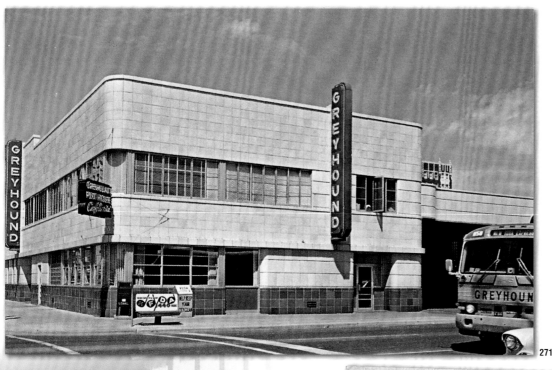

Greyhound Bus travelers stopped at this depot **(273)** in Amarillo.

The Parkview **(274)**, Sunset **(276)** and Skyline **(277)** Motels were clustered around the traffic circle on the west side of Amarillo. The Ranch-O-Tel **(277)** advertised "Your favorite brand of hospitality."

West of Amarillo, a row of ten vintage Cadillacs is buried at the same angle of the Great Pyramid of Cheops. The Cadillac Ranch was created in 1974 by the Ant Farm art collective for eccentric millionaire Stanley Marsh 3. It symbolizes the era when tail finned monsters ruled the road.

271

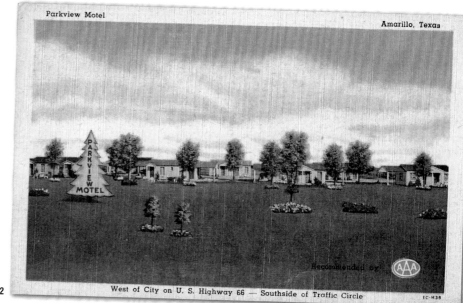

Parkview Motel — Amarillo, Texas

West of City on U. S. Highway 66 — Southside of Traffic Circle

272

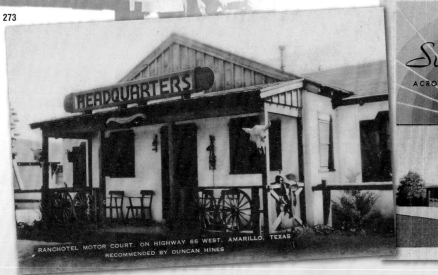

RANCHOTEL MOTOR COURT. ON HIGHWAY 66 WEST, AMARILLO, TEXAS
RECOMMENDED BY DUNCAN HINES

273

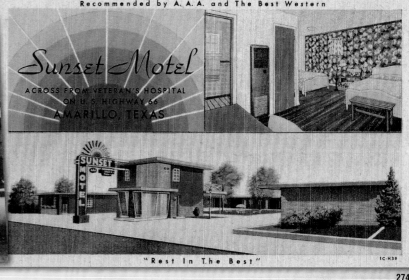

Recommended by A. A. A. and The Best Western

Sunset Motel

ACROSS FROM VETERAN'S HOSPITAL
ON U. S. HIGHWAY 66
AMARILLO, TEXAS

"Rest In The Best"

274

SKYLINE MOTEL

FEATURING TUMBLEWEED CAFE On U.S. Highway 66 AMARILLO, TEXAS West of City

Vega **(278)** means "plain" or "meadow" in Spanish. E.M. and Josephine Pancoast operated the Vega Motel at Route 66 and U.S. 385. It was later owned by Ethridge Betts. Harold and Tresa Whaley bought it in 1988. Adrian lies halfway between Chicago and Los Angeles. Dub Edmonds and former Navy cook Jessie Fincher took over Zella Crimm's Café in 1956. It is now Fran Hauser's Midpoint Café, famous for "ugly crust" pie.

Bob Harris used an old control tower from Amarillo Air Force Base for his cafe. The door was bent to match the sloped windows, so it unofficially became known as the Bent Door. It was later Tommy's Café **(279)**, operated by the Loveless Family.

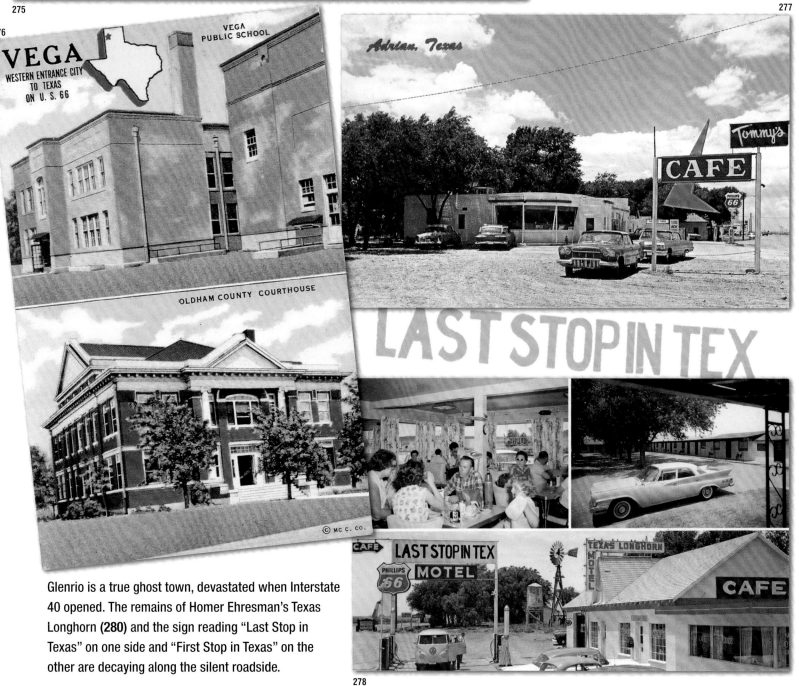

276

VEGA
WESTERN ENTRANCE CITY TO TEXAS ON U.S. 66

VEGA PUBLIC SCHOOL

OLDHAM COUNTY COURTHOUSE

© MC C. CO.

Adrian, Texas

Tommy's CAFE

LAST STOP IN TEX

LAST STOP IN TEX PHILLIPS 66 MOTEL

TEXAS LONGHORN MOTEL CAFE

CAFE

278

Glenrio is a true ghost town, devastated when Interstate 40 opened. The remains of Homer Ehresman's Texas Longhorn **(280)** and the sign reading "Last Stop in Texas" on one side and "First Stop in Texas" on the other are decaying along the silent roadside.

NEW MEXICO Land of Enchantment

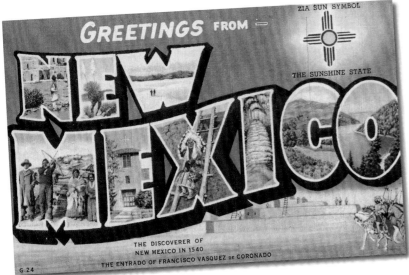

Route 66 across the "Land of Enchantment," presents an amazing variety of culture, history and scenery. The travelers from the East knew they had arrived in the Great Southwest when they entered New Mexico. Part of the route follows the famous Santa Fe Trail and the Spanish El Camino Real. The Camino Real is the oldest road in North America. Highway 66 also passes through Santa Fe, the oldest capital city in North America.

To avoid natural barriers, Route 66 originally turned north past Santa Rosa to Romeroville. The route then headed west into Santa Fe and dropped south, entering Albuquerque on 4th Street and finally turning west at Los Lunas. It was a meandering path of 506 miles.

La Bajada Mesa was the most feared part of the old route between Santa Fe and Albuquerque, dropping 800 feet in 1.6 miles with 23 hairpin switchback curves. The highway was re-routed around La Bajada, Spanish for "the descent," in 1932.

The loop through Santa Fe remained until a ticked off politician entered the picture.

Arthur T. Hannett lost his bid for re-election as governor in 1925. Partly in revenge, he ordered construction of a highway between Santa Rosa and Albuquerque, bypassing the state capitol. Workers pulled double shifts, battling the weather and vandalism to finish the highway in 31 days. It opened just hours before the new governor was sworn in and ordered the work halted. Route 66 would be shifted to "Hannett's Joke" in 1937, cutting the mileage across New Mexico to 399 miles. The new highway entered Albuquerque on Central Avenue. In 1935, there were 16 tourist camps along 4th Street and just three on Central. By 1955, there were 98 motels along Central/Route 66.

Many of the vintage motels are now endangered. But 66 through the Nob Hill neighborhood is now a trendy mix of the old and new and Old Town Albuquerque still retains its Old World charm.

After climbing Nine Mile Hill west of Albuquerque, the highway heads for the picturesque Laguna Pueblo. The "Sky City," Acoma Pueblo, is about 15 miles to the south. It is the oldest continuously inhabited community in the United States, dating back to about 1075 A.D. The Interstate was blasted through the mesas, while Route 66 respects the land, curving around the natural obstacles such as the black lava fields called El Malpais, or "badlands" near Grants.

There were numerous trading posts, animal attractions, snake pits and tourist traps between Albuquerque and Gallup. All sorts of gimmicks were used to lure business, including fake prehistoric monsters. Tourists were fleeced by rigged games of chance at rowdy establishments atop the Continental Divide. The divide marks the point where rainwater on one side flows towards the Pacific Ocean and the other side runs toward the Atlantic Ocean.

Gallup is the "Indian Capital," where a huge gathering of the tribes takes place each year. There are still some vintage motor courts here, but several have been lost, including the distinctive Log Cabin Lodge. El Rancho Hotel, "The World's Largest Ranch House," served as the headquarters for many movies filmed in the area and still offers the "charm of yesterday with the convenience of tomorrow." Route 66 clings to the side of Devil's Cliff near Manuelito, offering a spectacular view of the Rio Puerco, Interstate 40 and the railroad crowded together between the mesas on either side. At the Arizona line, a huge metal arch once spanned the highway and invited travelers to come again. It's just a memory now, obliterated by the Interstate.

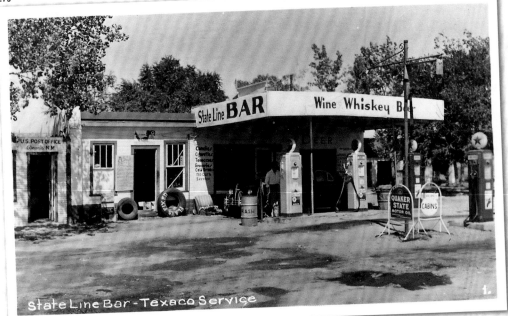

State Line Bar - Texaco Service

279

Homer and Margaret Ehresman's State Line Bar **(279)** was on the New Mexico side of the line at Glenrio because Deaf Smith County, Texas was a dry county. Red billboards reading "TUCUMCARI TONITE!" promoted the town with "2,000 motel rooms," **(280)** including those at the Palomino Motel **(284)**. It opened in 1953.

W.A. Huggins constructed the Blue Swallow Court **(281)** in 1939 and Mr. and Mrs. Ted Jones owned it when this view was made. Floyd Redman gave the motel to his fiancée Lillian in 1958. Lillian made the Blue Swallow a Route 66 icon and passed away in 1999. The motel was restored by Hilda and Dale Bakke and is now owned by Bill Kinder and Terry Johnson.

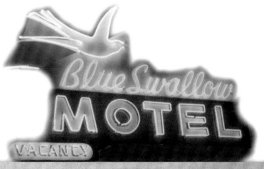

280

AAA U.S. HIGHWAY 66 . . . East Entrance Of . . . TUCUMCARI, NEW MEXICO

281

282

"Recommended by Duncan Hines"
U.S. HIGHWAYS 66 & 54 . . . State Highways 104 & 18 . . . TUCUMCARI, NEW MEXICO
283

La Cita Restaurant **(283)** opened in 1940 and relocated across the highway in 1961.

Only ruins remain at the site of the Frontier Museum **(284)**, between Tucumcari and Santa Rosa

Lettie's Restaurant **(285)** in Santa Rosa was operated by Albert and Ida Jo Campos. It is now the Route 66 Restaurant.

The sign at the Sun n' Sand Motel **(286)** features the symbol of the Zia Pueblo Indians, with four points radiating from a circle symbolizing life.

AAD-1

Tucumcari - Named from the Mountain Tocom-Kari. Whether fiction or fact, the accepted story is that the mountain is named for Kari, the daughter of an Indian Chief, and her lover, Tocom. In Memoriam to their love, Wautonomah, her father, named the mountain Tocom-Kari. Later it was changed to Tucumcari. This legendary mountain is seen in a beautiful view from

TOCOM-KARI COURT - East Entrance on U.S. Highway 66. 19 Modern Air-Conditioned Units with tiled baths - tubs and showers. Locked garages. Vented individual heaters. Some Kitchenettes. Also 2 and 3 bed family units to accommodate 4 to 8 persons

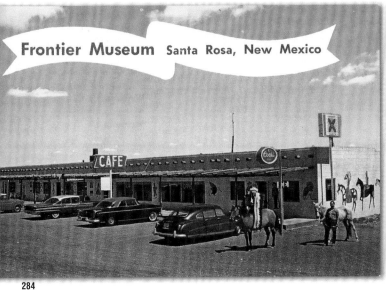

Frontier Museum Santa Rosa, New Mexico

284

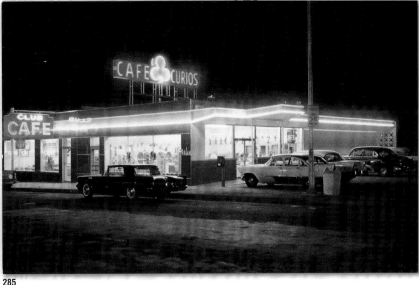

285

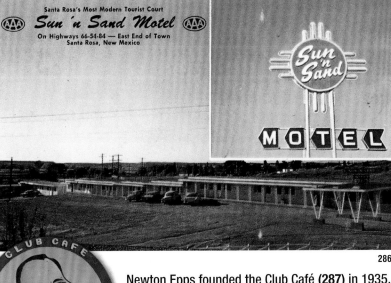

Santa Rosa's Most Modern Tourist Court
AAA *Sun 'n Sand Motel* **AAA**
On Highways 66-54-84 — East End of Town
Santa Rosa, New Mexico

286

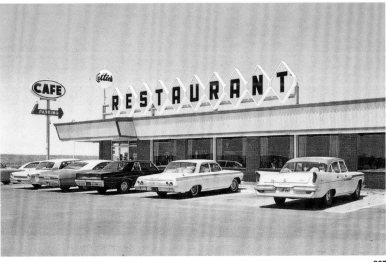

287

Newton Epps founded the Club Café **(287)** in 1935. Phillip Craig and Ron Shaw took over in 1939, erecting billboards featuring a smiling fat man. Ron Chavez took over in 1973 and closed it in 1992. But the Fat Man lives on at Joseph's, just a half block away.

CLUB CAFE SINCE 1935

New Mexico - Land of Enchantment

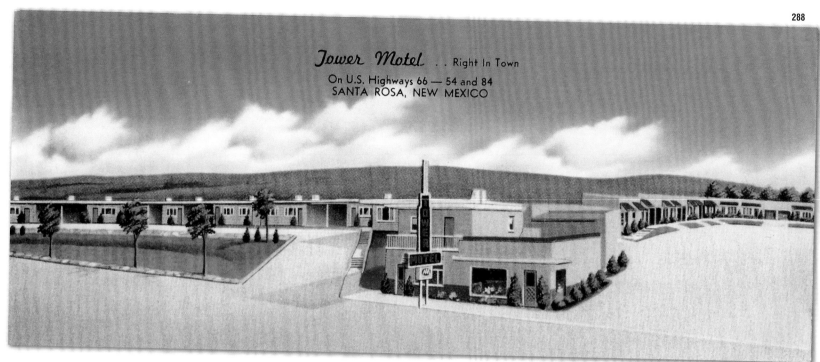

Tower Motel .. Right In Town
On U.S. Highways 66 — 54 and 84
SANTA ROSA, NEW MEXICO

289

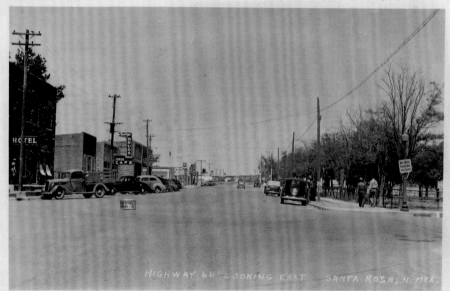

The first Jack's Cafe **(290)** was in Tucumcari and the Santa Rosa location opened about 1940.

There were once over 60 gas stations, 20 motels and 15 restaurants in Santa Rosa **(289)**. The Tower Motel **(288)** is still there.

290

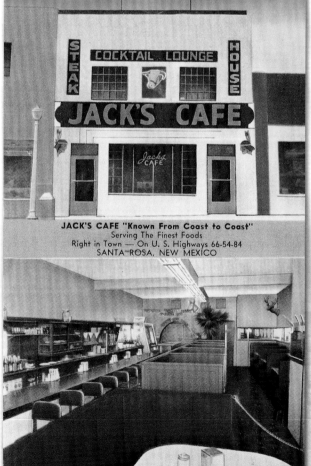

291

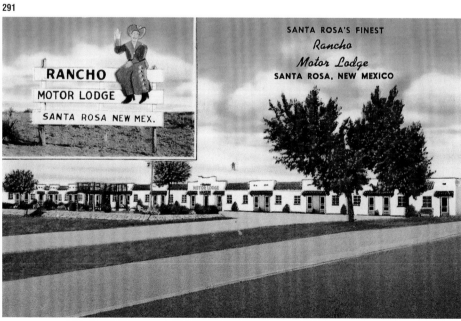

292

Route 66 crosses the Pecos River at Santa Rosa. In *The Grapes of Wrath*, Tom Joad (Henry Fonda) watched a train steam into the sunset on the adjacent railroad bridge (292).

The Rancho Motor Lodge (291) was constructed by H.D. "Mac" McAda and J.M. Fields in 1947. In 1934, Roy Cline moved his gas station to the new alignment of Route 66 at U.S. 285 and convinced Rand McNally to put Clines Corners (293) on their maps. Roy sold the place in 1939, but the name stayed since it was on the maps. Lynn and Helen Smith expanded Clines Corners after WW II, and it remains a popular stop on I-40.

After selling Cline's Corners, Roy Cline opened the Flying C Ranch (294). In 1963, it became Bowlin's Flying C Ranch.

294

Clines Corners on Highway 66, New Mexico

293

GLORIETA PASS—OLD PIGEON RANCH ON SANTA FE TRAIL

Alexander Valle was a Frenchman who spoke poor or "pigeon" English. His Pigeon Ranch (297) was a stage stop on the Santa Fe Trail and a field hospital during the 1862 Civil War Battle of Glorieta Pass. Thomas L. Greer made it a tourist attraction in 1924 and it closed in the 1940s. The main building and the well remain.

295 UNDER MANAGEMENT OF THOS. L. GREER, GLORIETA PASS, N. MEX. 2465-29

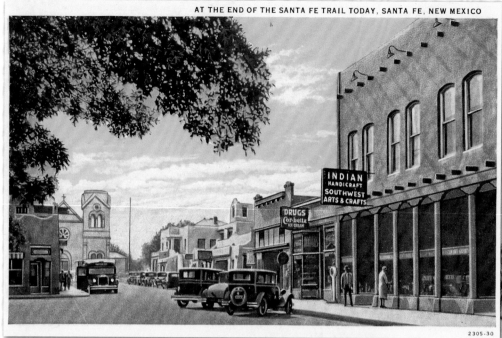

AT THE END OF THE SANTA FE TRAIL TODAY, SANTA FE, NEW MEXICO

2305-30

296

Conquistador Don Pedro de Peralta laid out Santa Fe in 1609. Route 66 originally entered town on the Old Santa Fe Trail **(296)**.

There has been an inn or "fonda" on the plaza since 1610. The current La Fonda **(297)** was built in 1920 and operated by the Fred Harvey Company from 1926-1968.

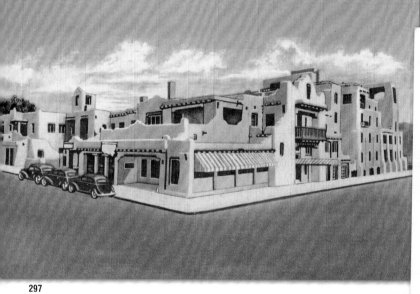

297

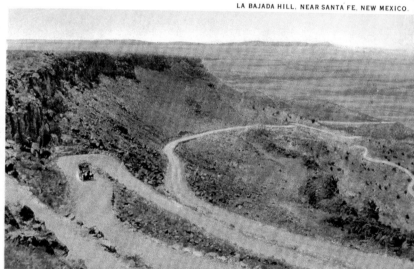

LA BAJADA HILL, NEAR SANTA FE, NEW MEXICO

51346

298

The route over La Bajada Mesa (Spanish for "the descent") **(298)** drops 800 feet in 1.6 miles with 23 switchbacks. A sign at the top warned "This road is not foolproof but safe for a sane driver." La Bajada was bypassed in 1932.

Original Route 66 passed through the "The Big Cut," **(299)** considered an engineering marvel when it was dug out in 1909.

"BIG CUT" ON SANTA FE TRAIL BETWEEN SANTA FE AND ALBUQUERQUE, NEW MEXICO

113379

299

POST CARD

THE SPIRIT OF THE OLD WEST STILL LIVES AT
The Longhorn Ranch

Real Concord Stagecoach used to Haul Mail and
Passengers in the days of Buffalo Bill

Captain Bill Ehret was a former police officer from Endicott, New York and a former Lincoln County, New Mexico Deputy Sheriff. He opened the Longhorn Ranch (300) in 1940. The Longhorn Ranch gave the tourists the old west they had seen in the movies, complete with a saloon, Indian dances and rides in an old Concord overland stagecoach. It closed down about 1977 and almost no trace remains today.

300

301

302

Blackie's Place (301-302) in Moriarty opened in 1945. Hubert Odell "Blackie" Ingram's personality turned it into a into a Route 66 landmark. Blackie died in 1966 and his wife kept the business going until 1975.
The Tijeras Canyon (303) separates the Sandia and the Manzano Mountain ranges. The shape of the canyon resembles a pair of scissors, or "Tijeras" in Spanish.

303

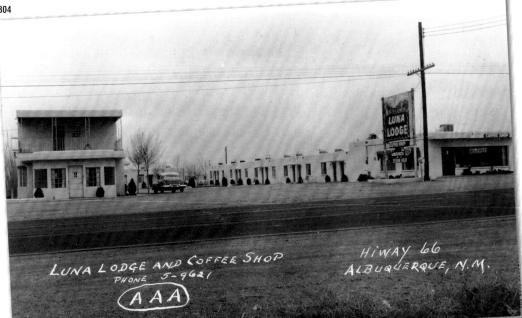

LUNA LODGE AND COFFEE SHOP HiWAY 66
PHONE 5-9621 ALBUQUERQUE, N.M.
AAA

Don Francisco Cuervo y Valdes, interim governor of New Mexico, established La Villa de San Francisco Xavier de Alburquerque in 1706. The villa was named after the viceroy of New Spain, Don Francisco Fernandez de la Enriquez, and 8th Duke of Alburquerque. (The extra R disappeared over the years). Many of the once lovely motels on Central Avenue are endangered.

A-26 GREETINGS FROM ALBUQUERQUE, NEW MEXICO "THE DUKE CITY"

The metropolis of New Mexico, Albuquerque is situated on the Rio Grande at an elevation of 4988 ft., and is approximately the center of the state. The busy city of today was founded by Gov. Cuervo in 1706 and named for the Duke of Alburquerque. Later the first R in the name was dropped, with the coming of the Americans.

POST C

TOMORROW'S HOTEL TO-DAY

The Luna Lodge **(304)**, with its lovely shaded grounds, opened in 1949 and was owned by John Jelso and his wife Dorothy. The Luna is still in business.

Leonard J. Grossman opened Leonard's restaurant **(305)** in 1949, advertising "No Finer Foods Anywhere." The site is now a used car lot.

Leonard's Fine Foods
6616 Central Ave. — East
ALBUQUERQUE, NEW MEXICO

305

TOMORROW'S HOTEL TO-DAY

EL JARDIN LODGE
VACANCY

El Jardin Lodge
Duncan Hines — Recommended
8100 East Central On Highway 66
ALBUQUERQUE, NEW MEXICO

306

David Betten opened the 47 unit El Jardin Lodge **(306)** in 1946 and advertised it as "Tomorrow's Hotel Today." It became the Route 66 Motel before closing in 2004 and being demolished in 2005. They offered "Every Comfort and Service to the Seasoned Traveler" at the Zuni Motor Lodge **(307),** a Spanish Colonial Style motel operated by John A Farr. The Zuni no longer stands.

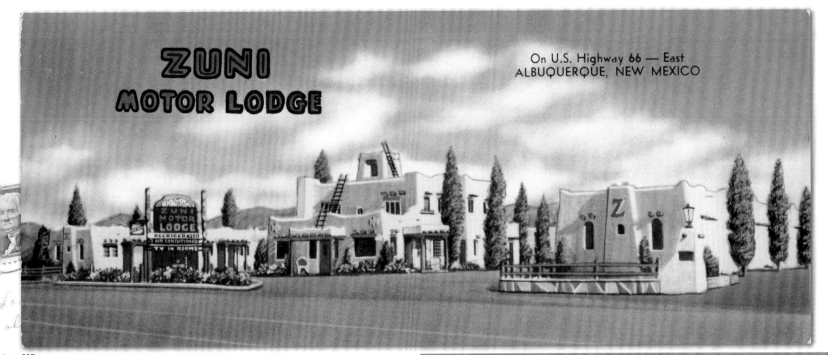

ZUNI MOTOR LODGE

On U.S. Highway 66 — East
ALBUQUERQUE, NEW MEXICO

307

308

TEWA LODGE — ALBUQUERQUE, N. MEX.

309

The Pueblo styled Tewa Lodge (308) opened in 1949, designed by S.V. Patrick and originally owned by H.C. Harvey. It is still in business and the neon sign is one of the prettiest on Route 66

The Bow and Arrow Lodge (309) was originally the Urban Motor Lodge, opened in 1941. It still welcomes travelers today.

The Honey Dew Drive-In (310) specialized in "Steaks - Chicken-in Basket, Hamburger-Supreme" and "Glorified Ham and Eggs." The building no longer stands.

HONEY DEW DRIVE INN
5500 East Central Ave., Albuquerque, N. M. on Highway U. S. 66

310

Calvin and H.B. Horn constructed the $1 million Tradewinds Motel (313) in 1958. It became the Travelodge Mid Town, torn down in 2009.

This cool looking iceberg (311) (note the polar bear above the entrance) originally was a frozen custard stand opened by C.A. McAdams in 1931. It was moved to another location on Central Avenue and became Boren's Iceberg Café. The berg was trucked to U.S. 85 in Bernalillo in 1953 and torn down in the 1960s.

In operation from 1949 to 1958, El Sombrero (312) offered curb service and claimed to serve 250,000 visitors annually.

311

312

313

The Crest Hi Restaurant **(314)** was located across the street from the Hiland Theatre. It advertised "The best cuppa coffee on Route 66."

The DeAnza Hotel **(315)** was built by Zuni Indian trader Charles Garrett Wallace and S. D. Hambaugh in 1939. It was named for Spanish Lieutenant Juan Bautista de Anza, the territorial governor who saved the Hopi pueblo from starvation. The city of Albuquerque purchased the landmark in 2003. But it has yet to be restored.

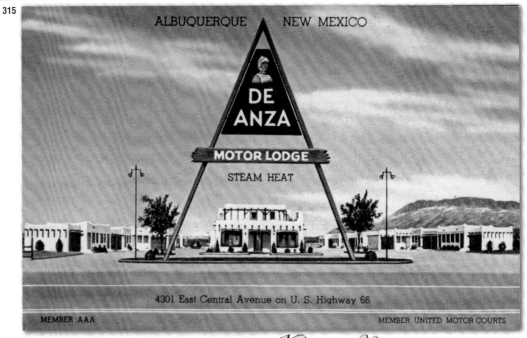

Gwynn and Claudine Hoyt opened the Dinner Bell Restaurant **(316)** in 1943. Charlie Preston and Rob Berg took over in 1974, opening the castle shaped Wellington Restaurant and Lounge. An arsonist destroyed it in 1976.

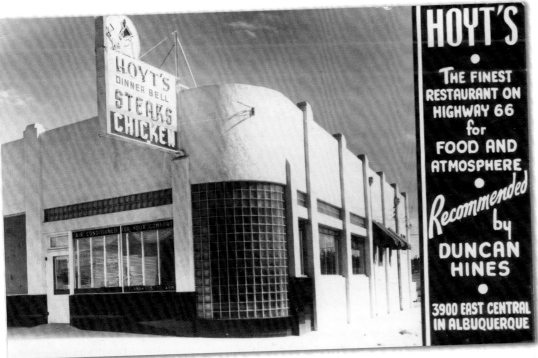

The Aztec (**317**) is the oldest continuously operated auto court on Route 66 in New Mexico. Guy and May Fargo opened it in 1931. Charley's Pig Stand (**319**) opened in 1924 across from the University of New Mexico. The building shown here was constructed in 1935 and closed in 1954. The calf and pig images are still visible on the façade today. Oklahoma Joe's was originally the Dixie Barbecue, opened in 1935 by Alma Patton. Joe Feinsilver changed the name in 1941 and ran Oklahoma Joe's (**318**) until 1956. It evolved into Okie's, a hangout for UNM students known for ten cent beer nights. The site is now a convenience store.

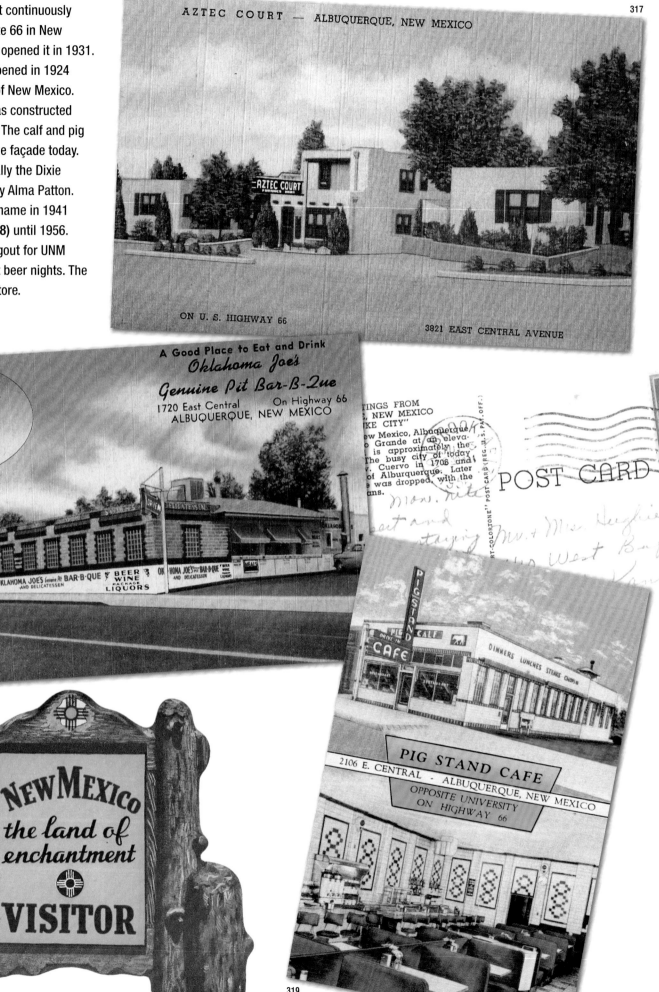

Route 66 originally entered Albuquerque on 4th Street, past the Albuquerque Auto Court (320) operated by C.W. Gruhn. The building that housed L. L. Beck and Carl Romine's Albuquerque Auto Exchange (321) is now the New Mexico Business Resource Center.

Charles Wright's first trading post was on Central Avenue. He opened this Pueblo style building (322) at 4th Street and Gold Avenue in 1917. Wright died in 1938, and his wife sold the business in the 1950s. It evolved into today's Wright's Indian Art. The Gold Building (New Mexico Bank and Trust) stands on this site.

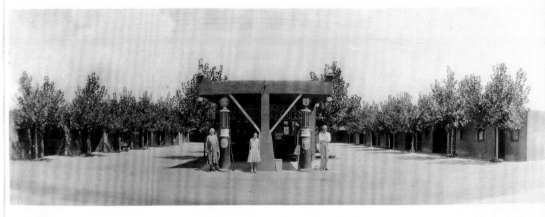

320

ALBUQUERQUE AUTO COURT
C. W. GRUHN, Prop.

2050 North Fourth Street

ALBUQUERQUE · NEW MEXICO

321

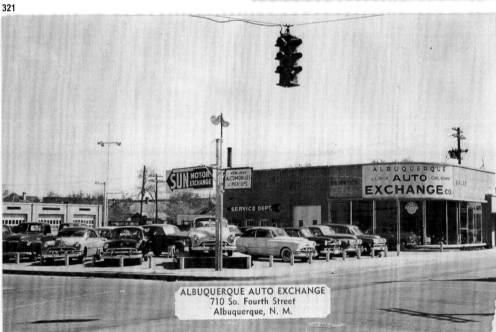

ALBUQUERQUE AUTO EXCHANGE
710 So. Fourth Street
Albuquerque, N. M.

Virgil Katsanis, who later changed his name to Bob Katson, opened the Court Café (323) on November 4, 1925. This jet black carrera glass façade was added in 1935. Elmer and Rosa Lea Elliott operated it from 1945 to 1958. It changed names several times before becoming a gay bar that closed in 2008.

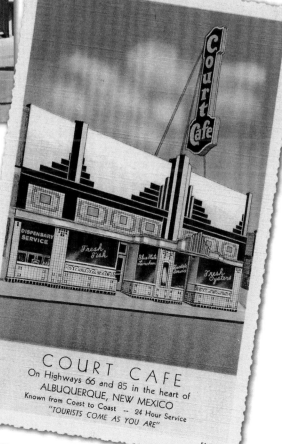

COURT CAFE
On Highways 66 and 85 in the heart of
ALBUQUERQUE, NEW MEXICO
Known from Coast to Coast — 24 Hour Service
"TOURISTS COME AS YOU ARE"

323

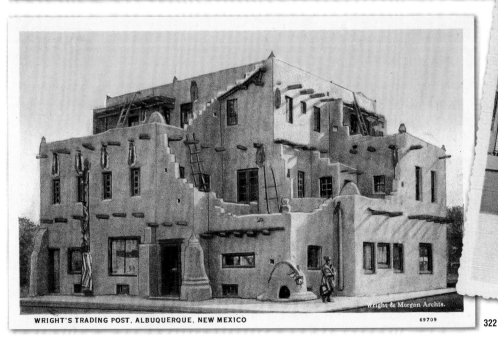

WRIGHT'S TRADING POST, ALBUQUERQUE, NEW MEXICO

322

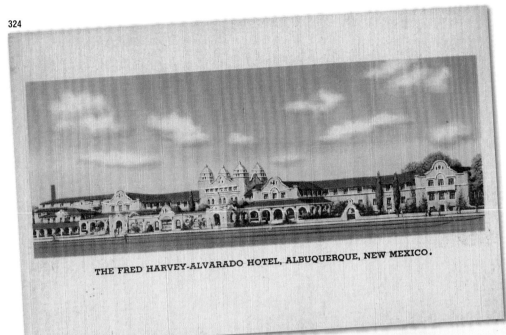

324

THE FRED HARVEY-ALVARADO HOTEL, ALBUQUERQUE, NEW MEXICO.

The "jewel in the Santa Fe's crown," the Fred Harvey Alvarado Hotel (324), opened in 1902. The famous Harvey Girls served travelers at the rambling Mission Revival structure adjoining the depot. Charles F. Whittlesey designed the hotel named for Hernando Alvarado, Francisco de Coronado's commander of artillery.

Amazing Indian arts were displayed at the Fred Harvey Indian Building (325) adjoining the Alvarado Hotel. Craftsmen ready to sell their works greeted tourists. The AT&SF demolished the Alvarado complex in 1970, an appalling loss that spurred a major preservation movement. Today's Alvarado Transportation Center resembles the original complex.

325

A-14 INDIAN BUILDING AND ALVARADO HOTEL, ALBUQUERQUE, N. M.
Connected with the Station at Albuquerque is the Fred Harvey Indian building, famous to travelers the world over for its interesting exhibits of Indian Arts and Crafts as well as relics of the Spanish Conquest. It was established primarily as a diversion for transcontinental travelers and to create a greater interest in the products of the native peoples along the Santa Fe Lines.
All trains stop 10 to 30 minutes at Albuquerque. Conductors give advance notice in the building of the departure of trains.

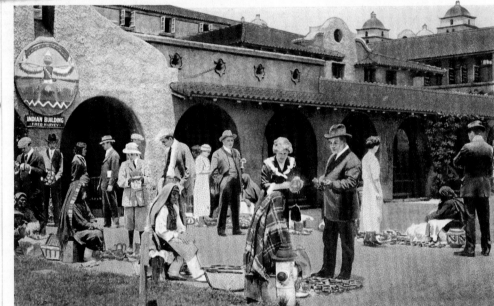

H.1927. ENTRANCE TO THE INDIAN BUILDING, ALBUQUERQUE, NEW MEXICO.

This view looks west on Central Avenue (326) from the Santa Fe railroad overpass. The menu for the Liberty Café on the right said "We will not knowingly serve minors or Indians."

Morris Maisel's Indian Curio Shop (328) opened in 1923 across from the Alvarado Hotel, moving to 510 Central Avenue in 1939. John Gaw Meem designed the façade. Maisel's employed 300 craftsmen on site and was the largest such store in the world before closing in the 1960s. Morris' grandson Skip reopened the store in the 1980s.

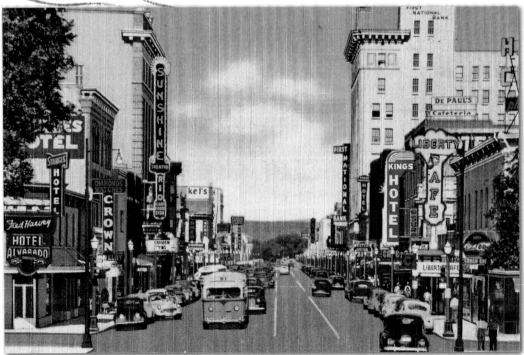

326

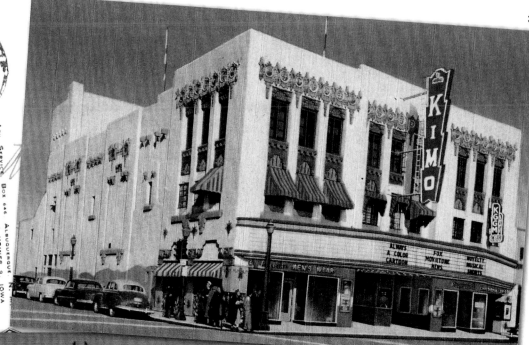

328

The Kimo Theatre **(327)** opened on September 19, 1927, built by Oreste Bachechi and designed by Carl Boller. The name is loosely translated as Tewa for "King of its Kind." The Kimo closed in 1968 and the city began restoration in 1977. The Kimo is said to be haunted by the ghost of six-year-old Bobby Darnell, who died in a boiler explosion there in 1951.

Route 66 actually crosses itself at 4th Street and Central Avenue, **(329)** the intersection of the pre-1937 route through Santa Fe and the post 1937 Central Avenue route. This view looks east on Central from 4th Street. The Woolworth's store was completed in 1941. The tallest structures in this view are the Hilton Hotel and the First National Bank Building. (1922)

MAISEL'S INDIAN TRADING POST — 400 W. CENTRAL AVE. — ALBUQUERQUE, NEW MEXICO

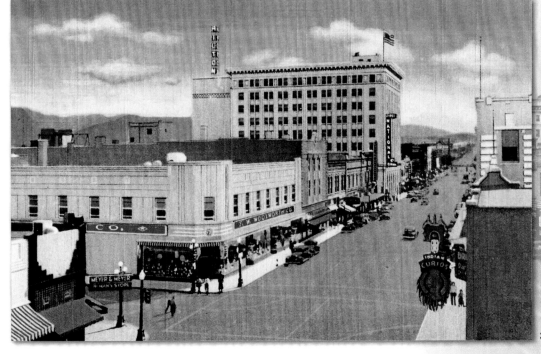

329

330

331

The "Pueblo Expressionist," Franciscan Hotel (331) at Central Avenue and 6th Street opened in 1923, closed in 1970 and was demolished in 1972.

Old Town (332) is where Villa de Alburquerque was established in 1706. Because development shifted east to New Albuquerque with the arrival of the railroad, Old Town kept much of its historic charm. The plaza today houses 130 shops and restaurants.

The Sleepy Hollow Court (330) opened in 1944 and was owned by Mr. and Mrs. Louis T. Higgins when this view was made. The court still stands, but apparently is no longer a hotel.

332

333

334

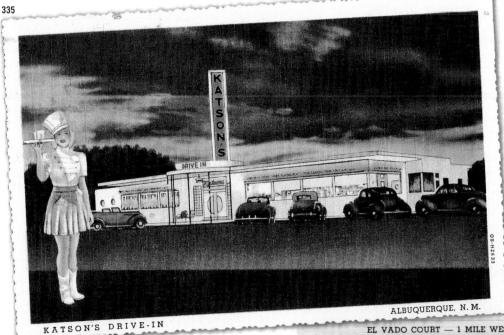

335

KATSON'S DRIVE-IN

ALBUQUERQUE, N. M.

Ben F. Shear constructed the Streamline Moderne Tower Court (333) in 1939. A 30-foot stepped tower served as the office for the motel, but was removed decades ago.

In 1946, Joe Ray Calloway constructed the Texas Ann Motel (334) and named it after a tall blonde Texan he knew with diamonds set in her front teeth. It was featured in a 1955 episode of *I Love Lucy*, which co-starred Vivian Vance of Albuquerque. The motel was demolished in 1976. Bob Katson, owner of the Court Café, opened Katson's Drive-In (335) in May, 1940. Due to wartime shortages, it closed in September 1942 and never re-opened.

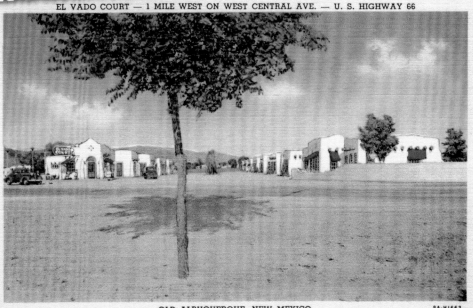

336

EL VADO COURT — 1 MILE WEST ON WEST CENTRAL AVE. — U. S. HIGHWAY 66

OLD ALBUQUERQUE, NEW MEXICO

Dan Murphy, former manager of the Franciscan Hotel, built the El Vado Motel (336) in 1936. Patrick O'Neill operated the motel from 1963 to 1986 and it closed on October 22, 2005. After a battle with a developer who wanted to tear it down, the City of Albuquerque took over the property in 2008.

This view (337) looks east towards the Sandia Mountains from Nine Mile Hill, nine miles from downtown Albuquerque. Eastbound Route 66 travelers at night drove in darkness for many miles until they topped the hill to see the lights of Albuquerque spread out before them.

337

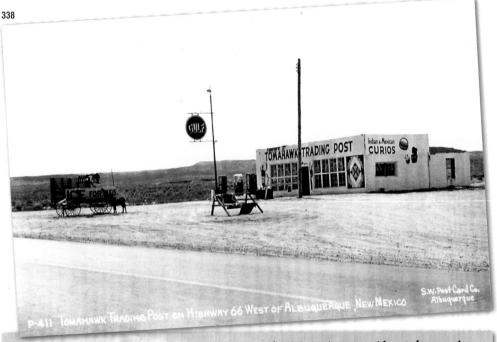

338

P-411 TOMAHAWK TRADING POST on HIGHWAY 66 WEST OF ALBUQUERQUE, NEW MEXICO

S.W. Post Card Co.
Albuquerque

The Tomahawk Trading Post (338) was famous for its Jemez Indian Dances. Owner J.T. Turner stuck ten phone poles made up to look like massive arrows around the trading post.

Route 66 cuts through the Laguna Pueblo lands. About 15 miles to the south, the "Sky City" of Acoma (339) is the oldest continuously inhabited community in the U.S., established about 1075 A.D. For thousands of years it was accessible only by a staircase carved into the nearly 400 foot high sheer mesa.

Grants was originally a railroad camp, established by brothers Angus, Lewis and John Grant. In 1950, rancher Paddy Martinez discovered uranium in the Haystack Mountains west of town, launching a 20 year boom. The Franciscan Motel (340) opened in 1950 and is still there.

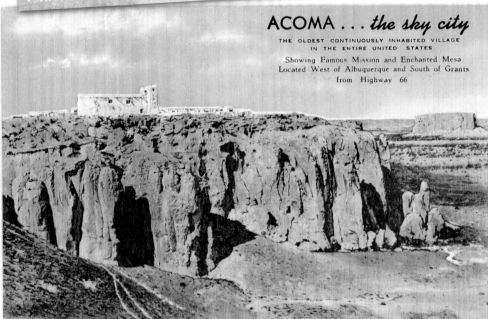

ACOMA . . . the sky city
THE OLDEST CONTINUOUSLY INHABITED VILLAGE
IN THE ENTIRE UNITED STATES
Showing Famous Mission and Enchanted Mesa
Located West of Albuquerque and South of Grants
from Highway 66

339

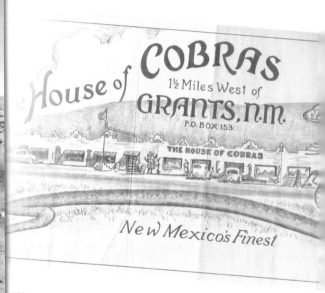

House of COBRAS
1½ Miles West of
GRANTS, N.M.
P.O. BOX 153
THE HOUSE OF COBRAS
New Mexico's Finest

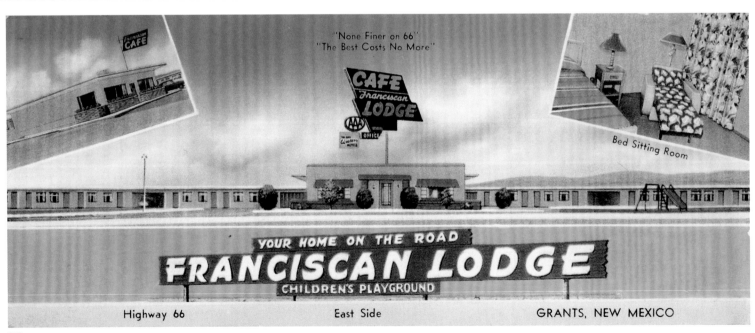

"None Finer on 66"
"The Best Costs No More"

CAFE
Franciscan
LODGE

Bed Sitting Room

YOUR HOME ON THE ROAD
FRANCISCAN LODGE
CHILDREN'S PLAYGROUND

Highway 66 East Side GRANTS, NEW MEXICO

340

Salvador Milan opened the Milan Motel (341) in 1946. Note the inset showing the famous carrot fields of Grants.

There were a string of tourist traps between Grants and Gallup. The Rattlesnake Trading Post (342) advertised a 48 foot long "giant prehistoric reptile." Jake Atkinson's "monster" was made out of cow vertebrae and plaster, with a horn stuck into a cow hip. Jake's brother Herman operated Atkinson's Cobra Gardens (343), with the largest collection of cobras in the U.S. The Atkinsons sold in 1954 and the snakes were moved to the Rattlesnake Trading Post.

Some of the businesses at the Continental Divide (344) fleeced tourists with rigged games of chance. By the 1960s, the area was known for transients, bar brawls and prostitution. Things are much quieter here today.

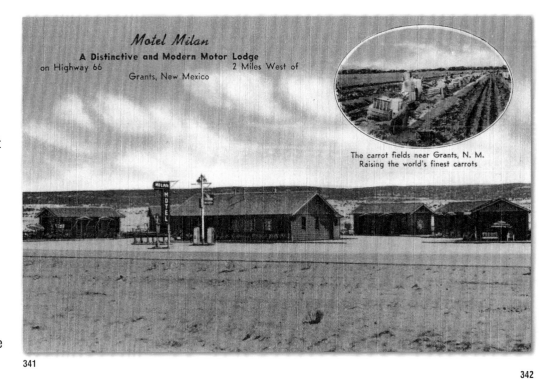

341

342

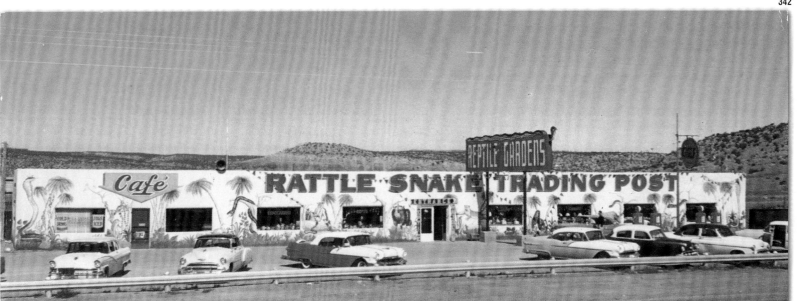

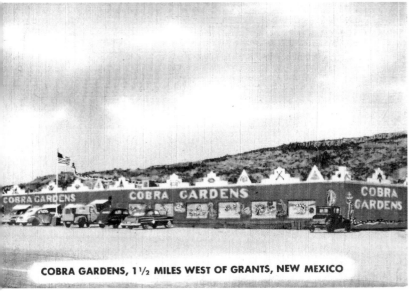

COBRA GARDENS, 1½ MILES WEST OF GRANTS, NEW MEXICO

343

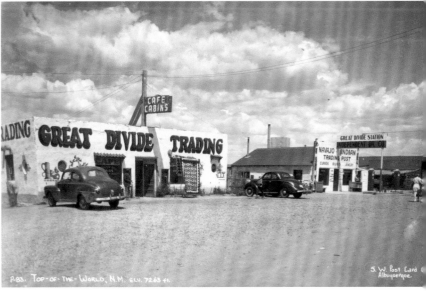

344

At the Navajo Lodge (345), Al and Melvina Lavasek trained a pair of bears to guzzle Cokes bought by tourists. The former trading post is now a bed and breakfast.

Gallup was established in 1881 and named for railroad paymaster David Gallup. Workers would "go to Gallup" for their pay. Gallup is known as "The Indian Capitol of the World" with about 250,000 Navajo, Hopi, Pueblo, and Zuni living in the surrounding area. The local Chamber of Commerce was located in these replica Navajo Hogans (346).

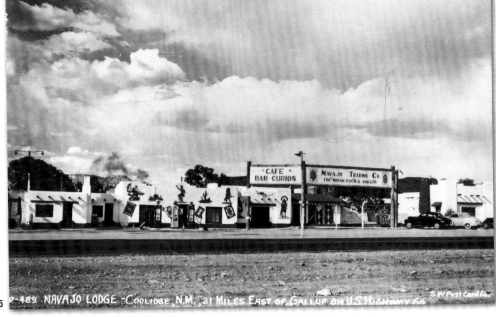

345 P-489 NAVAJO LODGE - Coolidge, N.M., 21 Miles East of Gallup on U.S. Highway 66

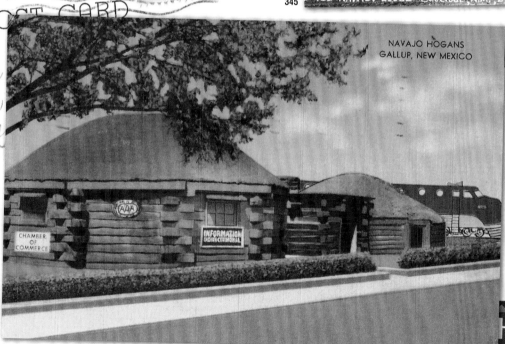

NAVAJO HOGANS
GALLUP, NEW MEXICO

346

347

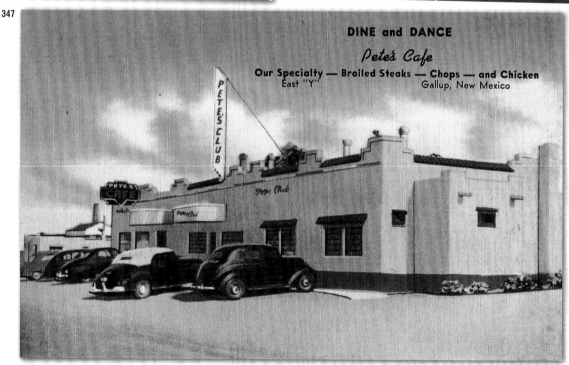

THE SOUTHWEST'S
.....with the Charm of Yeste

INDIVIDUAL— The El Rancho was designed to preserve the atmosphere of western ranch life including all distinctive features of early cowboy days, plus the utmost in modern comfort and luxury. Enter into the spirit of the Old West

ENTERTAINMENT—Ranch life carries on with pleasure and entertaining features, afternoon and night. Stage Coach rides—

Indian, Mexican, Cowb and Cowgirl entertainers Hay rides—Saddle hors and Pack horses available—Fishing and Cou ier trips arranged—Indian Dances and Co boy Rodeos at intervals— Games and Moving Pictures of the Old West nightly— Tea 4 P. M.—Cocktail Hour —Dinner Dancing—Bridge.

Hotel El Rancho • Modern • Di

DINE and DANCE
Pete's Cafe
Our Specialty — Broiled Steaks — Chops — and Chicken
East "Y" Gallup, New Mexico

Several businesses were clustered at the East "Y" where Route 66 meets Railroad Avenue. Pete Hantagos formally opened the new Pete's Club and Café (347) on November 20, 1945. James Theopholis bought it in 1950 and built Pete's Fine Foods here in 1959. Paris "Pete" Derizotis took over in 1960. The building later became a pawn shop.

The Casa Linda Court (348), later the Casa Linda Motel, opened in 1937 and was operated by Evelyn and John Simm for over 20 years. A McDonald's occupies this site today.

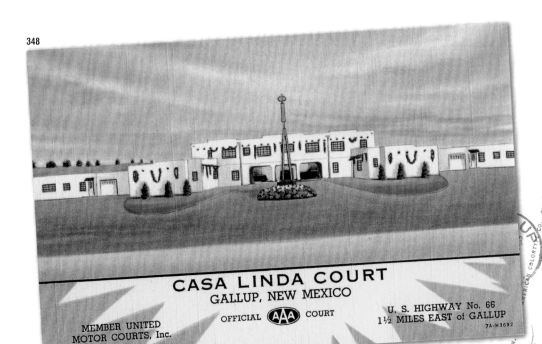

348

CASA LINDA COURT
GALLUP, NEW MEXICO

MEMBER UNITED
MOTOR COURTS, Inc.

OFFICIAL AAA COURT

U. S. HIGHWAY No. 66
1½ MILES EAST of GALLUP

7A-H3692

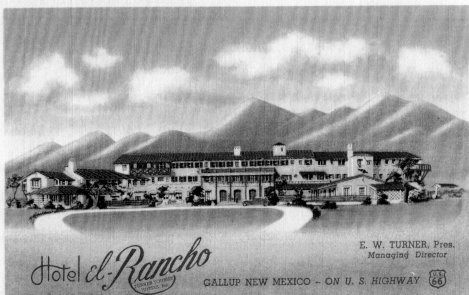

DISTINCTIVE HOTEL

World's Largest Ranch House
Capacity: 400 Guests

d the Convenience of Tomorrow!

UNUSUAL
FEATURES—

Spacious, unique
Galleria, Sun Deck and Solarium,
rrace, Patio, 4 Dining Rooms, Tap
49'er Bar and Chuck House, Ultra
Cocktail Lounge.

OUNDS—Mexican
ian Curio and Gift

Shop, featur-
ing finest ex-
amples of In-
dian - made
Arts and Crafts, together with Mexican im-
portations; El Rancho Dress Shop, showing
latest Hollywood fashions in Women's Wear;
Modern Filling Station and Garage.

For El Rancho Reality credits: Dream—R. E. Griffith;
Architectural Design, Arrangement, Plans, Structural En-
gineering—Chas. S. Dilbeck and Jack M. Corgan; Builder—
Gates Corgan; Furnishings—Fred P. Hoenscheidt.

t Rates Surprisingly Low

Hotel el Rancho
GALLUP NEW MEXICO — ON U. S. HIGHWAY 66

E. W. TURNER, Pres.
Managing Director

7A-H2431

349

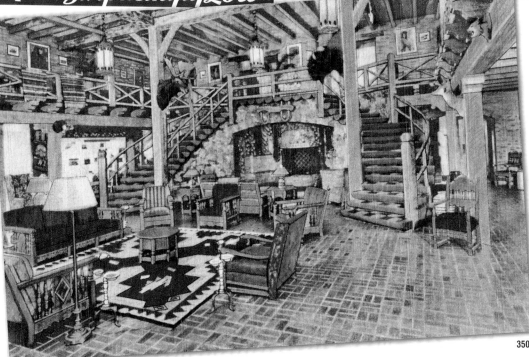

350

Formally opened on December 17, 1937, El Rancho Hotel (349) was built for R.E.Griffith, supposedly the brother of movie magnate D.W. Griffith. It was the headquarters for 18 movies filmed between 1940 and 1964. Stars who stayed at the "World's Largest Ranch House" include John Wayne, Ronald Reagan, Katherine Hepburn and Kirk Douglas. Business dwindled after Interstate 40 opened on October 8, 1980 and El Rancho closed in 1987. It was nearly demolished before Armand Ortega stepped in and restored the property.

The two-story El Rancho lobby (352), with its circular staircase and heavy beams, is filled with Navajo rugs, mounted animal heads and photos of Hollywood stars.

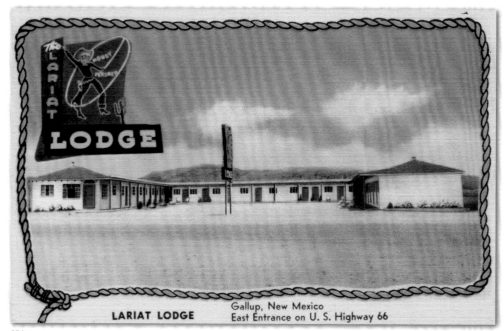

LARIAT LODGE
Gallup, New Mexico
East Entrance on U. S. Highway 66

351

The original Lariat Lodge (351) sign with the cowboy and his lasso was replaced in the 1950s. But the second neon sign is still one of the coolest in Gallup.

The Fred Harvey El Navajo Hotel (352) opened in 1923. A spectacular blend of modern architecture and Native American culture, it closed in 1957 and was demolished.

Charles Garrett Wallace (353) was the largest trader of Zuni jewelry. Much of Wallace's collection was displayed at his De Anza Motel in Albuquerque.

The Avalon Café (354) opened in 1945 and grew into the Avalon Restaurant.

The annual Inter-Tribal Indian Ceremonial (355) has been a major attraction in Gallup since 1922. Native Americans come from all over North America for arts and crafts, sports, parades and dances.

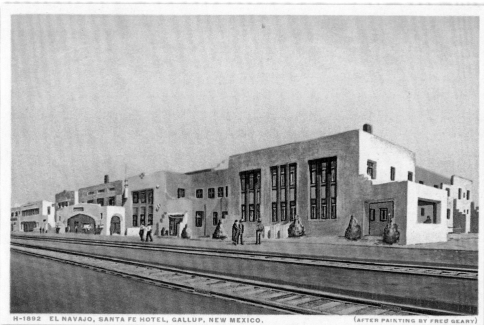

H-1892 EL NAVAJO, SANTA FE HOTEL, GALLUP, NEW MEXICO. (AFTER PAINTING BY FRED GEARY)

352

U. S. LICENSED ZUNI TRADER
SINCE 1928

VISITORS

WELCOME

C. G. WALLACE Indian Trader

GALLUP, NEW MEXICO - HIGHWAY 66 - Across From The El Navajo Harvey House

353

354

355

356

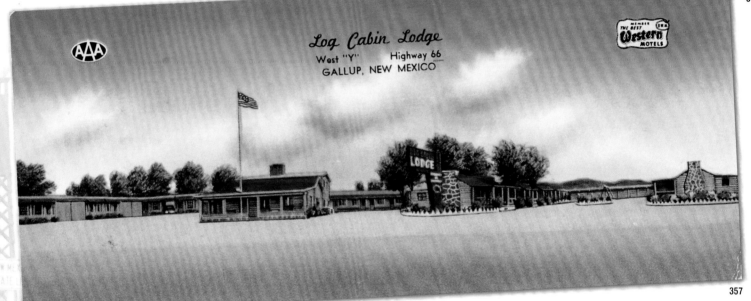

357

This view (356) looks East on Coal Avenue at 3rd Street, U.S. 666. In 2003, Route 666 became U.S. 491, because some associated the number with Satan.

Dan Brunetto and Dominic Bertinetti's Ideal Auto Camp (358) opened in 1928. It became the Ideal Auto Court, ran by Bert Eddies. The site is a used vehicle lot.

359

358

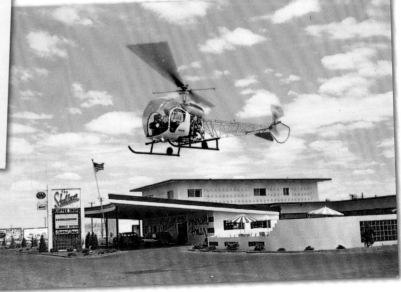

Tony and Francis Leone opened the Log Cabin Lodge (357) in July, 1938. It closed in the 1990s. Much of the complex burned in April, 2004 and the rest was demolished. The Shalimar Hotel (359) opened in April 1960 and was originally owned by Spencer Moss. It closed in 2001 and was torn down in 2006.

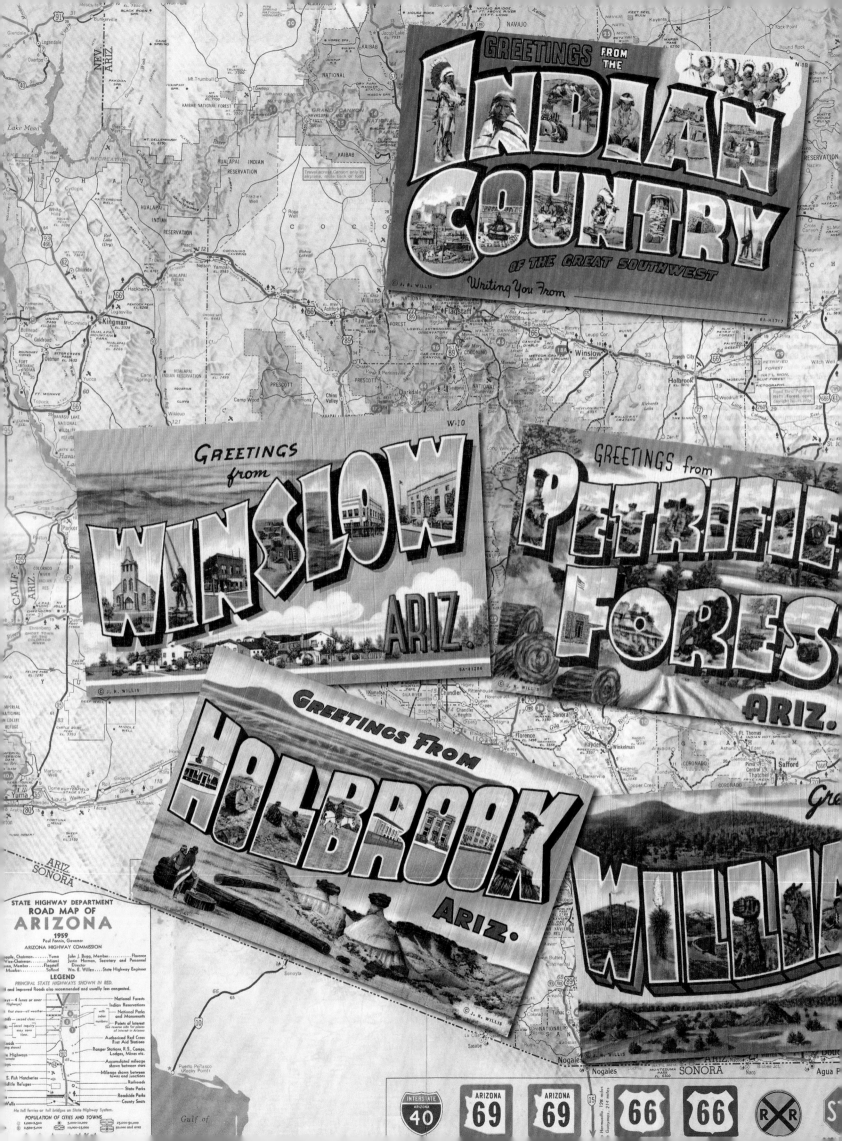

ARIZONA *The Grand Canyon State*

Route 66 in Arizona links spectacular natural attractions such as the Grand Canyon, the Petrified Forest, the Painted Desert and Meteor Crater. The landscape includes vast deserts, snowy mountains and dense pine forests.

In 1857, Lieutenant Edward F. Beale surveyed a wagon road from Fort Defiance, New Mexico to the Colorado River along the 35th Parallel and brought along 23 camels to test their usefulness in hauling cargo. The Atlantic and Pacific Railroad, later the Santa Fe, followed Beale's road and the Fred Harvey Company constructed lavish Harvey Houses along the line. Harvey Houses offered accommodations equal to those in the major cities and were ready to serve motorists when the automobile age arrived.

Route 66 followed part of the National Old Trails Road along the railroad from Lupton to Holbrook. At Kingman, the highway headed west to Oatman, a very important town at the time. This dangerous route was bypassed in 1952 and the new road headed south from Kingman to Topock.

Colorful trading posts offering Native American jewelry, petrified wood and curios are still common in Arizona. Route 66 was lined with billboards featuring shapely cowgirls and big black jackrabbits, blaring promises of killer snakes and prehistoric monsters.

Travelers can still sleep in a concrete wigwam at the Wigwam Motel in Holbrook, see the world's largest petrified tree at the Geronimo Trading post, or sit atop a giant jackrabbit at the Jackrabbit Trading Post in Joseph City. Standing on the Corner Park in Winslow commemorates the classic Eagles song "Take it Easy."

Only ghostly ruins remain where Two Guns once offered a roadside zoo and the infamous Apache Death Cave. Two giant arrows mark the site of the Twin Arrows Trading Post. Many of the old hotels, motels, cafes and interesting shops still remain in Flagstaff, beneath the San Francisco Peaks.

A bittersweet ceremony on October 13, 1984 marked the opening of Interstate 40 around Williams, the last community on Route 66 to be bypassed. Williams still offers plenty of nostalgia, as well as train trips to the Grand Canyon.

A visit to Seligman is like traveling back in time. The Sno Cap Drive-In, Angel Delgadillo's Route 66 Visitor Center and Historic Route 66 Sundries are quirky stops in the town that inspired the fictional Radiator Springs in the motion picture *Cars*. Seligman is part of a 159 mile long stretch of original Route 66 past Grand Canyon Caverns, through Peach Springs and into Kingman. The Hackberry General Store is a great stop along the way for souvenirs and photo ops of old cars, vintage gas pumps and signs. The old powerhouse in Kingman houses a great Route 66 museum and there are several vintage motels. Kingman is also the gateway to Hoover Dam.

Exit 44 on I-40 marks the start of the most scenic stretch of Route 66, a breathtaking run with hairpin curves and steep grades over the Black Mountains, where the classic Cool Springs Camp has been restored. The road then plunges sharply past the ghost town of Goldroads and into Oatman, an old mining town where burros roam the street seeking handouts and leaving their calling card on the sidewalks. Shops, cafes and staged Wild West gunfights cater to the tourists.

Route 66 continues through the harsh desert landscape to the Colorado River. For Dust Bowl refugees such as the fictional Joad family in *The Grapes of Wrath*, it was their first look at the promised land of California. But a long drive through the lonesome desert was still ahead. In the book, Tom Joad declared, "Never seen such tough mountains. This here's a murder country. This here's the bones of a country."

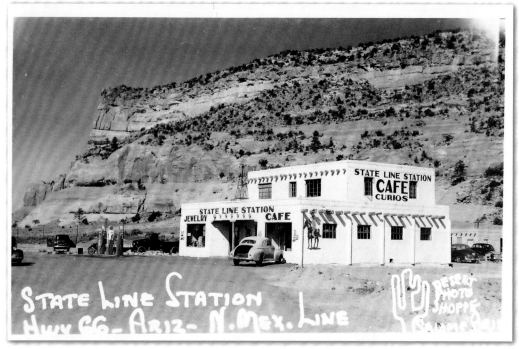

State Line Station Hwy 66 - Ariz - N. Mex. Line

360

The State Line Trading Post (360) was the last stop in New Mexico, opened by Jake and Leroy Atkinson in 1940. For years, no one knew if the post was in New Mexico or Arizona.

Max and Amelia Ortega opened the Indian Trails Trading Post (361) at Lupton in 1946. The Trading Post was demolished for the Interstate 40 service road in 1965.

Navapache (362) was mentioned in Jack Rittenhouse's *Guide Book to Route 66* as a "town" consisting of a tourist court, gas station, garage and store.

Claude and Clara Lee owned the Querino Canyon Trading Post and Big Arrows (363). When Route 66 was relocated in the 1950s, they abandoned Querino Canyon and built a new Big Arrows.

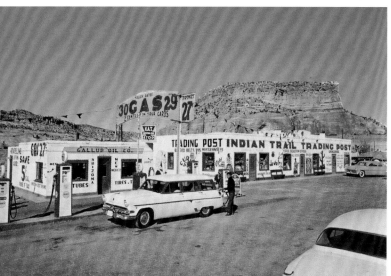

361

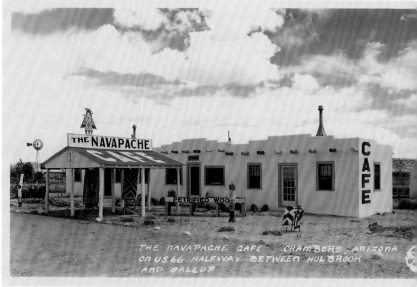

The Navapache Cafe — Chambers — Arizona on US 66 Halfway Between Holbrook and Gallup

362

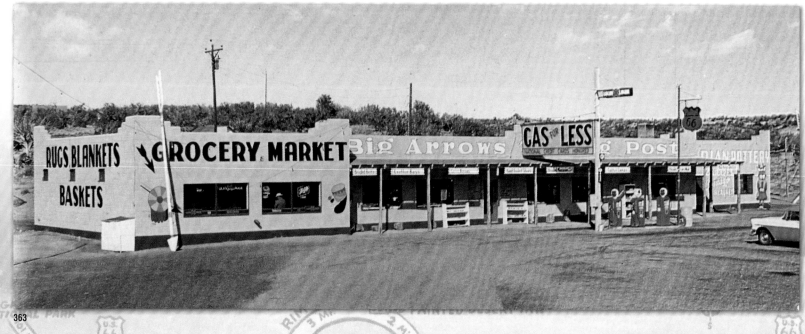

363

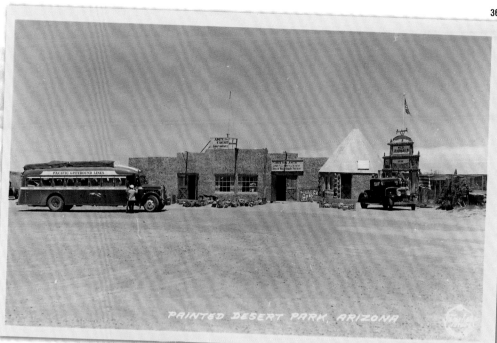

Julia Grant Miller was the sister of Harry "Indian" Miller, owner of Fort Two Guns at Canyon Diablo. Her Painted Desert Park **(364)** offered a spectacular view of the Painted Desert. Julia battled with government officials who believed her post was an eyesore.

Bands of colored sediments and clay of the Chinle rock formation have been exposed by erosion in the Painted Desert. In 1932, 53,300 acres of the Painted Desert became part of the Petrified Forest National Monument, which became Petrified Forest National Park in 1962. The Painted Desert Inn **(365)** was originally the Stone Tree House, built with petrified wood by Herbert D. Lore in 1924. The Civilian Conservation Corps remodeled it into a Pueblo Revival style structure. The Fred Harvey Company ran the hotel from 1947 to 1963 and it is now a museum and visitors center. The Petrified Forest was once a floodplain covered with pine trees. Sand and volcanic ash covered the fallen trees, silica replaced the wood, and erosion exposed the logs **(366)**. The Petrified Forest is the only National Park to include a section of Route 66. Route 66 was busy enough that simple motels surrounded by desert sands could be profitable. The Motel Hiawatha **(367)** was seven miles east of Holbrook.

PAINTED DESERT INN
PETRIFIED FOREST
NATIONAL MONUMENT
A R I Z O N A

TO GRAND CANYON NATIONAL PARK — RIM DRIVE — PAINTED DESERT INN
FLAGSTAFF 60 Mi. · WINSLOW 33 Mi. · HOLBROOK 24 Mi. · 70 Mi. · GALLUP 141 Mi. · ALBUQUERQUE

365

THRU NEW MEXICO to PAINTED DESERT, PETRIFIED FOREST AND GRAND CANYON, ARIZ.

SCENIC HIGHWAY 66

Nez by the Log, Petrified Forest

366

POSTAGE 1¼¢ WITHOUT MESSAGE

The Painted Desert of Arizona—a land of undulating plains and beautifully colored ter. raced cliffs, displaying many contrasting colors and striking hues, combined to make

© BY J. R. WILLIS

MOTEL Hiawatha

367

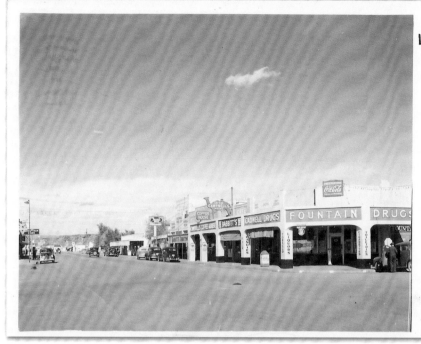

Looking North

on U. S. Highway 66

HOLBROOK ARIZONA

X841

Frasher's FOTOS

Distributed by
Lollesgard Specy. Co.
Tucson, Ariz.

368

Holbrook **(368)** is named for Henry Holbrook, chief engineer for the Atlantic and Pacific Railroad. Chester B. Campbell's Coffee house at right was known for Son-of-a-Bitch Stew, a cowboy dish made with the heart, liver, brains and other calf organs.

Bob Lyall's 66 Steak House **(369)** was located next to the 66 Motel. It later became the Hilltop Café.

Dick Mester operated Campbell's Coffee House **(373)** during World War II, and then opened his own place catering to bus passengers on that site. The building at the southeast corner of Navajo Boulevard and Hopi Drive still stands.

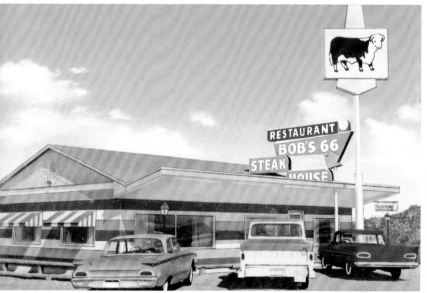

369

370

HOLBROOK, ARIZONA — West Entrance On U.S. Highway 66

371

The Wigwam Motel (372) was one of seven built using a design by Charles Redford. Chester Lewis saw Wigwam Village #2 at Cave City, Kentucky and decided to build one of his own. Wigwam Village #6 opened on June 1, 1950. The motel was vacant from 1974 to 1988, but the Lewis Family restored the 15 steel framed and stucco covered wigwams. The Sundown Restaurant (370) is still standing next to the Sundown Motel, although the sign has been covered in white paint.

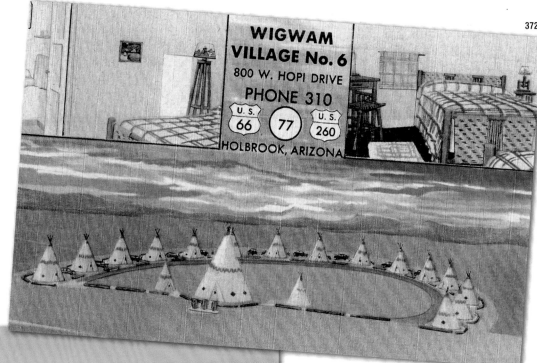

In 1956, the Whiting Brothers DeLuxe Motel was expanded to become the Whiting Motor Hotel (371) with the Kolob Restaurant next door. The Whiting Motor Hotel later became the Sun N' Sand Motel. Holbrook was the headquarters for the Whiting Brothers chain of gas stations, which once had over 100 locations in the southwest. The company also operated about 15 motels, including two in Holbrook. The Desert View Lodge (374) was owned by Ruby and Jim McDermott and later by Mr. and Mrs. Norm Hormandl. It was the first motel in Holbrook with a swimming pool and later became the Star Inn.

Arizona - The Grand Canyon State

375

This Arizona Department of Agriculture and Horticulture Inspection Station (375) was on Route 66 just west of Holbrook.

Established by "Doc" Hatfield about 1950, the Geronimo Trading Post (376) is the home of the world's largest petrified log. It weighs 89,000 pounds.

Frederick "San Diego" Rawson was enslaved by the Indians as a child and became a scout, poet, and author. He opened San Diego's Old Frontier Trading Post (377) in 1927. Ray Meany took over a few years after Rawson sold in 1947 and the trading post was awarded to his wife Ella Blackwell when they divorced. Ella talked to mannequins and claimed the post was established in 1873. It was abandoned when she died in 1984.

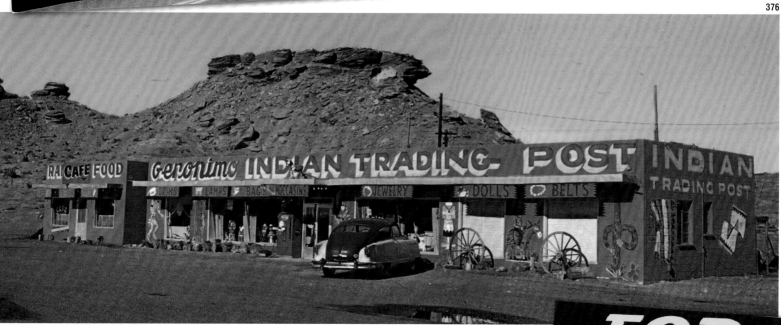

376

377

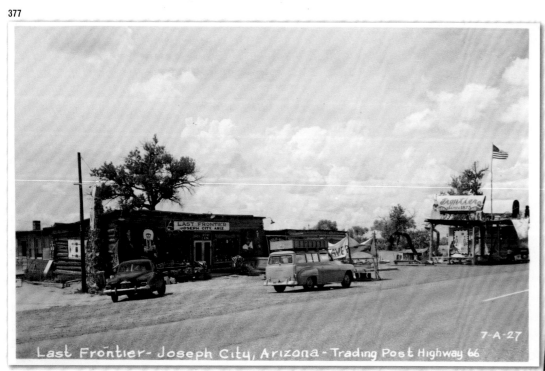

Last Frontier- Joseph City, Arizona - Trading Post Highway 66

378

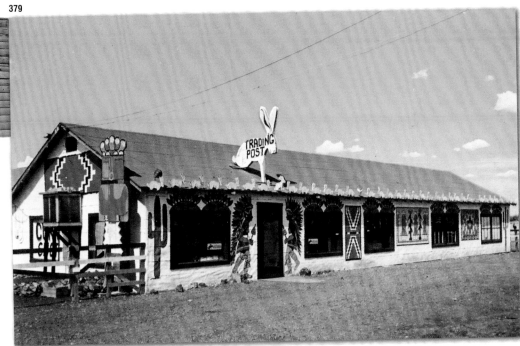

HERE IT IS

This landmark **(379)** formerly housed the Arizona Herpetorium. In 1949, Jack Taylor opened the Jack Rabbit Trading Post. It has been operated by the Blansett family since 1961. Taylor and his friend Wayne Troutner posted billboards for their businesses as far away as New York. Troutner's Store for Men billboards were adorned with a curvaceous cowgirl **(378)** while the Jackrabbit boards still feature a black bunny on a yellow background. Standin' on the Corner Park now occupies the site on the far left **(380)**. It features a two-story mural by John Pugh and a life-size sculpture of a musician by Ron Adamson illustrating the Eagles song "Take It Easy." The mural was saved when the old J.C. Penney building burned in 2004.

Former Hawaiian band leader Ray Meany and his wife Ella Blackwell owned the Hopi House **(381)** at Leupp Corner and the Old Frontier in Joseph City. When they divorced, Ray got the Hopi House, which was killed off by Interstate 40.

380

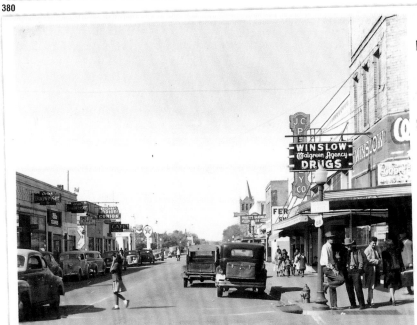

Looking West
on
Second Street

WINSLOW
ARIZONA
X821

381

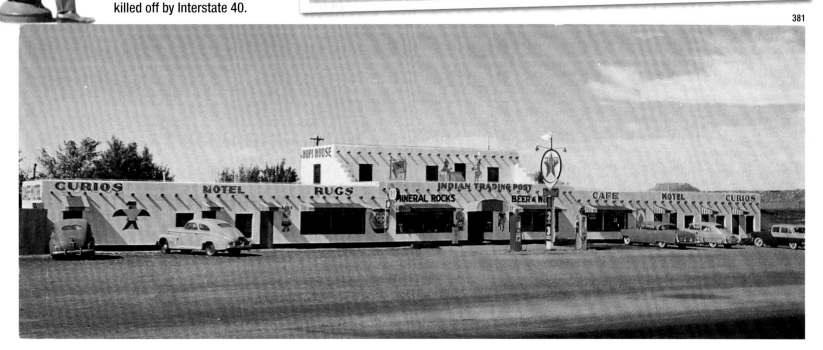

La Posada (382) was the last of the great Fred Harvey hotels to be constructed, opening in 1930 and closing in 1959. Restoration began in 1997. Harry Locke lost his Meteor Crater Observatory to foreclosure and Dr. Harvey Nininger opened the American Meteorite Museum (383-384) here in 1946. The museum closed in 1953, a few years after Route 66 was moved away. Only ruins remain. Meteor Crater (385) is 4150 feet across, three miles around the top and 570 feet deep. The Hopi believed it was caused by a god cast from heaven. Daniel Barringer set up mining equipment at the crater and was ridiculed when he said it was caused by a meteor. The theory was accepted after he died in 1929.

H-4224 LA POSADA, FRED HARVEY HOTEL, WINSLOW, ARIZONA

382

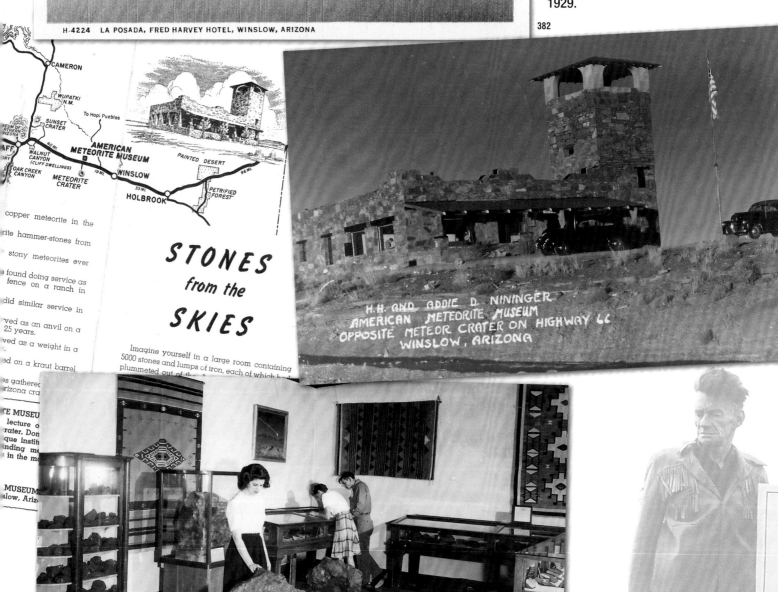

STONES
from the
SKIES

H. H. AND ADDIE D. NININGER
AMERICAN METEORITE MUSEUM
OPPOSITE METEOR CRATER ON HIGHWAY 66
WINSLOW, ARIZONA

383

CORNER IN AMERICAN METEORITE MUSEUM
OPPOSITE METEOR CRATER ON HIGHWAY 66 IN ARIZONA

384

METE
POPU

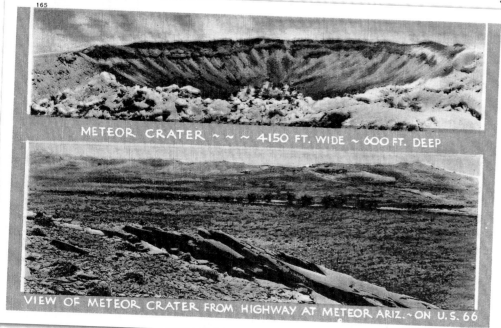

METEOR CRATER ~ ~ ~ 4150 FT. WIDE ~ 600 FT. DEEP

VIEW OF METEOR CRATER FROM HIGHWAY AT METEOR ARIZ.~ ON U.S. 66

9-2103

Earl Cundiff's Canyon Lodge store and camp was located at the National Old Trails Road Bridge over Canyon Diablo. In 1925, he leased it to the mystical Harry "Indian" Miller, who had lived among headhunters and starred in silent films. Calling himself "Chief Crazy Thunder," he named the complex Fort Two Guns after a film.

In 1878, Navajos trapped 42 murderous Apache in a cave near Canyon Diablo, filled the entrance with brush and set it on fire. The Apache died horribly. Harry Miller built fake Indian ruins and made the "Apache Death Cave" **(386)** part of his attraction. In 1926, Miller killed his landlord, Earl Cundiff. Cundiff was unarmed, but Miller claimed self defense and was acquitted.

This view shows the zoo at Two Guns **(387)**. Many locals never forgave Harry Miller for shooting Earl Cundiff and Miller was convicted of defacing Cundiff's tombstone, which read "Killed by Indian Miller." He left in 1930 to open a business at the Cave of the Seven Devils, on Route 66 at the New Mexico-Arizona state line.

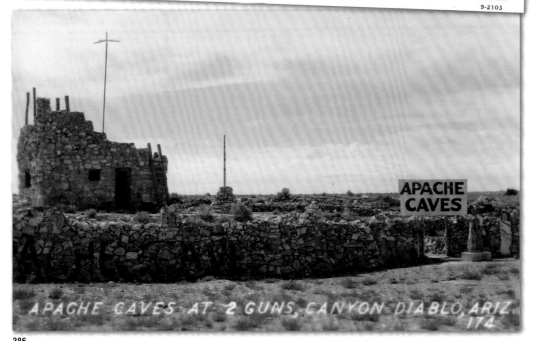

APACHE CAVES

APACHE CAVES AT 2 GUNS CANYON DIABLO, ARIZ. 174

386

CITY 2

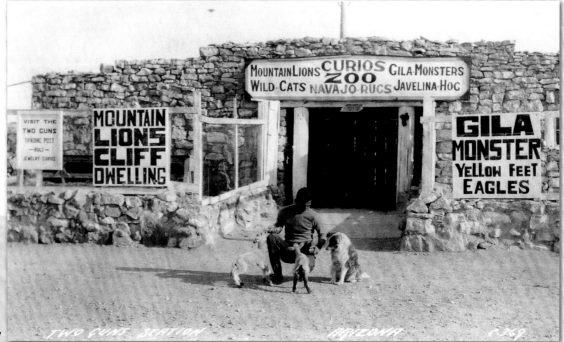

VISIT THE TWO GUNS TRADING POST - RUGS - JEWELRY CURIOS

MOUNTAIN LIONS CLIFF DWELLING

MountainLions WILD-CATS CURIOS ZOO NAVAJO RUGS GILA MONSTERS JAVELINA-HOG

GILA MONSTER YELLOW FEET EAGLES

TWO GUNS STATION ARIZONA C-269

387

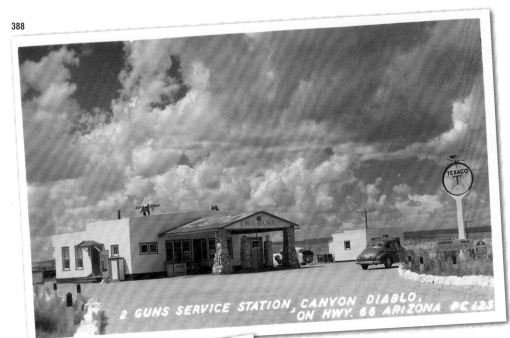

388

2 GUNS SERVICE STATION, CANYON DIABLO, ON HWY. 66 ARIZONA PC 125

Earl Cundiff's widow, Louise, married Phillip Hesch in 1934. Route 66 was relocated in 1938 and Hesch built this store (388) and station, re-opening the zoo behind the store. Benjamin Dreher built a modern motel and station at Two Guns in 1963 that burned spectacularly in 1971. Only ghostly ruins remain today.

To raise money to build his Meteor Crater Observatory, artist Harry Locke leased his station to "Rimmy Jim" Giddings (390) in 1933. Giddings posted cartoons (389) by Locke, warning that he kept a graveyard for salesmen. He placed an intercom beneath the outhouse seats to startle unsuspecting travelers.

389

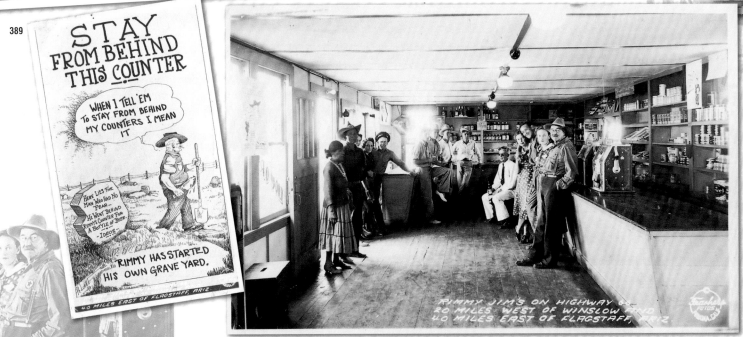

STAY FROM BEHIND THIS COUNTER

WHEN I TELL 'EM TO STAY FROM BEHIND MY COUNTERS I MEAN IT

HERE LIES THE MAN WHO HAD NO FEAR — HE WENT BEHIND RIMMYS COUNTER FOR A BOTTLE OF BEER — IDEOS

RIMMY HAS STARTED HIS OWN GRAVE YARD.

40 MILES EAST OF FLAGSTAFF, ARIZ.

RIMMY JIM'S ON HIGHWAY 66 20 MILES WEST OF WINSLOW AND 40 MILES EAST OF FLAGSTAFF, ARIZ.

390

A town "wilder than Tombstone" sprouted when construction of the Atlantic and Pacific Railroad was halted at Canyon Diablo due to financial difficulties in 1881-1882. Canyon Diablo's Hell Street was lined with 14 saloons, ten gambling dens and four brothels. The first marshal was killed five hours after being sworn in and only one lawman survived as long as 30 days. The town died when the bridge (391) was finished.

391

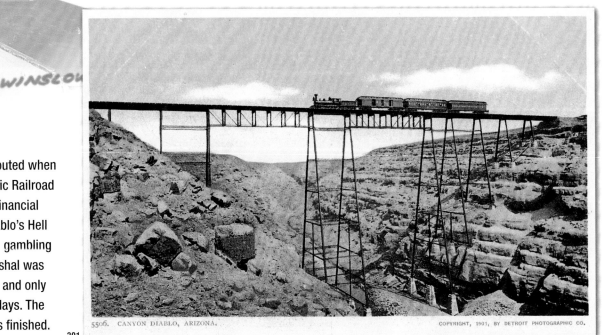

5506. CANYON DIABLO, ARIZONA.

COPYRIGHT, 1901, BY DETROIT PHOTOGRAPHIC CO.

Jean and William Troxell's Canyon Padre Trading Post **(392)** became the Twin Arrows Trading Post in 1960, known for two giant arrows made from utility poles out front. The complex includes a Valentine prefabricated diner. It closed in the late 1990s, but the arrows have been restored.

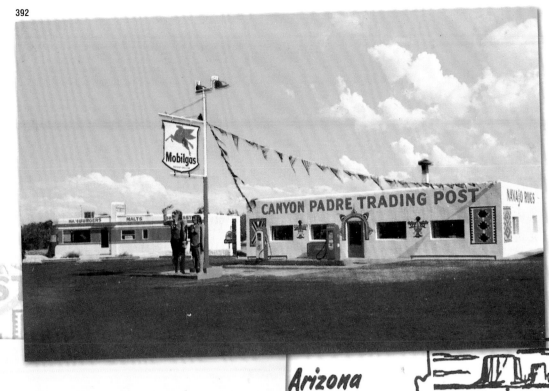

392

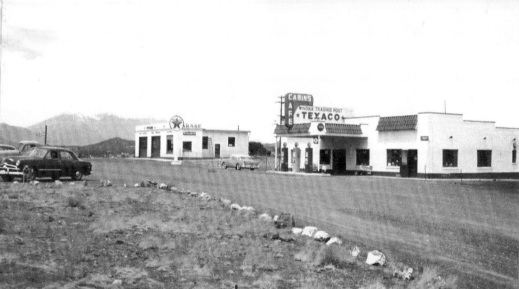

393

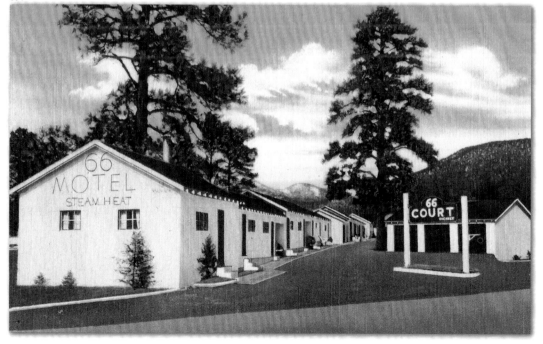

394

Arizona DRIVING IS Different

HIGHWAY 66

It's different because when traveling on U.S. 66 in Arizona you're more than a mile high most of the time.

This spells danger for you!

At high altitudes, the air is "thinner." This makes it harder for you to stay awake -- and when you press down on your accelerator to pass, you'll find that you won't get the same "pick-up" that your car gives you at lower altitudes.

Something else that makes Arizona driving differen[t] is long stretches of road between towns. Thousand[s] of drivers have learned, by accident, that it's might[y] easy to fall asleep at the wheel when driving lon[g] monotonous miles.

It's mighty easy, too, to let your speed creep up ove[r] the posted limit. And this hazardous practice ha[s] brought tragedy to many families traveling in Arizon[a].

Winona is not really a town, but gets a mention in the song "(Get Your Kicks on) Route 66" because it rhymes with Arizona. It actually lies 18 miles east of Flagstaff, and is listed out of sequence in the song. Billy Adams opened the trading post **(393)** in 1924 and built a new one when Route 66 was re-aligned in the 1950s. Long time 66 Motel **(394)** owner Myron Wells served as President of the Route 66 Association and led a group who tried to ban new businesses along Interstate 40. The motel is still in business.

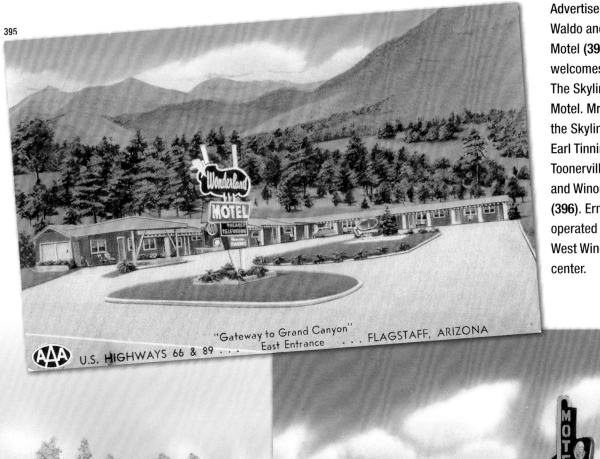

"Gateway to Grand Canyon"
East Entrance ... FLAGSTAFF, ARIZONA

AAA U.S. HIGHWAYS 66 & 89 ...

In The Shadow of the San Francisco Peaks
AAA U.S. HIGHWAYS 66 & 89 ... East Entrance Of ... FLAGSTAFF, ARIZONA

Advertised as the "Motel with the VIEW," Waldo and Adelyne Spelta's Wonderland Motel (395) opened in 1956 and still welcomes travelers today.

The Skyline Motel (397) is now the Red Rose Motel. Mr. and Mrs. Jack McCorhan opened the Skyline in May, 1948.

Earl Tinnin, who had constructed the Toonerville Trading Post between Winslow and Winona, owned the Ben Franklin Motel (396). Ernest Castro and his wife Vera operated it from 1961 until 1976. Later the West Wind Motel, the site is now a shopping center.

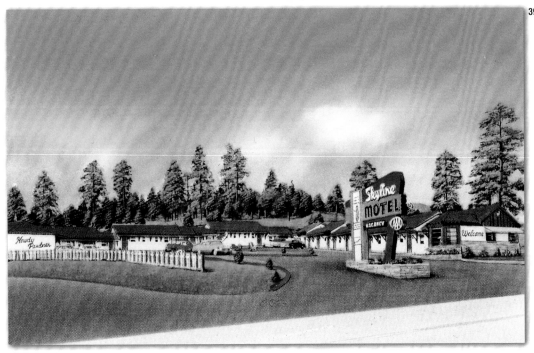

On July 4, 1876, a group of immigrants cut the limbs off a pine tree for a flag staff to celebrate the U.S. centennial. A railroad camp established in April 1880 was named Flag Staff, shortened to one word in 1881. Looking west on Santa Fe Avenue (398), the Commercial Hotel opened in 1888 and was the headquarters of Western novelist Zane Grey. An arsonist destroyed the landmark in 1975.

An old boxcar served as the original Flagstaff depot. It grew to four boxcars before a stone depot was built in 1889. The Santa Fe completed a new depot (400) just to the west in 1926. It is now the Flagstaff Visitor's Center.

City leaders held a public subscription to build a new hotel downtown, which opened on January 1, 1927. A 12 year-old girl won the contest to name it when she suggested Monte Vista (399), Spanish for "Mountain View." The Monte Vista is the oldest continuously operating hotel in Flagstaff.

This marker (401) stood where U.S. 89A split off from Route 66 and 89 at the west end of Flagstaff. The Saginaw and Manistee Lumber Company operated the mill in the background from 1941 to 1954. A fire set as a high school graduation prank destroyed the landmark in 1961.

398

399

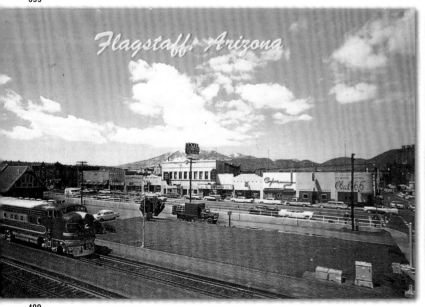

400

401

The Hopi believed the San Francisco Peaks (402) were the home of the Kachina spirits. There are six peaks, Agassiz, Aubineau, Doyle, Fremont, Humphreys and Rees. Humphreys Peak is the highest point in Arizona, at 12,633 feet.

A bumpy auto road to the Grand Canyon opened in 1900 and the National Park Service began construction on a good highway in 1928. This view shows the turn-off (403) from Route 66 between Flagstaff and Williams.

Originally Bethel's Tourist Court, Mike "Starky" Starkovitch's motel (404) became the Royal American Inn.

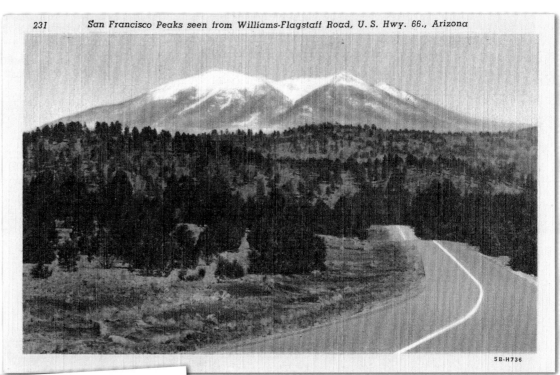

231 San Francisco Peaks seen from Williams-Flagstaff Road, U. S. Hwy. 66., Arizona

5B-H736

Highway to the Grand Canyon and U.S. 66 - Williams, Arizona 7-B-168

Starky's Motel
Williams, Arizona

In the Heart of Town on U. S. Highways 66-89

EL CORONADO MOTEL Vacancy
El Coronado THE BEST COSTS NO MORE
Member CONGRESS CREDIT CARDS
AAA
"Gateway To The Grand Canyon"
U.S. HIGHWAYS 66-89 & 64 . . . WILLIAMS, ARIZONA

Mr. and Mrs. Lee Treece operated El Coronado Motel (405). They offered special day rates for tourists planning to drive across the desert at night. It is now the EconoLodge.

The Del Sue Motel (406) was the first in Williams, opening in 1936. It was operated by Sue Delaney and became the Grand Motel. Williams was founded in 1876 and named for William Sherley Williams, famous trapper and scout. The Bill Williams Mountain Men, shown here on parade (407), honor the pioneer trappers and traders. Williams was the last community on Route 66 to be bypassed. Bobby Troup sang his "(Get Your Kicks on) Route 66" during the bittersweet ceremony when Interstate 40 opened on October 13, 1984.

U.S. HIGHWAYS 66 & 89 . . . In Center Of . . . WILLIAMS, ARIZONA

406

In 1946, Rodney Graves, who also ran the famous Rod's Steakhouse, opened Old Smoky's Pancake House and Restaurant **(408)**. Elvis Presley once ate here, and Old Smoky's is little changed today.

Williams became the "Gateway to the Grand Canyon," when the Santa Fe Railroad began service to the natural wonder in 1901.

408

407

Greetings from WILLIAMS, ARIZONA

ATEWAY TO THE GRAND CANYON
ated on Highway 66 near its junction
the Grand Canyon Highway, Williams is
turesque mountain town in the heart of
reatest stand of yellow pine timber in
S. Summer nights are always delight-
cool at this altitude of 6,780 ft. The town
s its name from Bill Williams Mountain,
is in turn named for a famous pioneer
region. Lumbering is the chief in-
several large mills being located here.

26 March 1946
Fergy! What
ya know! They
ally let me
! So I'm a
y civilian, too
Aint it fun?
Love, Bertha Hjorth

POST CA

Miss Marg
1431 So
Seda
N

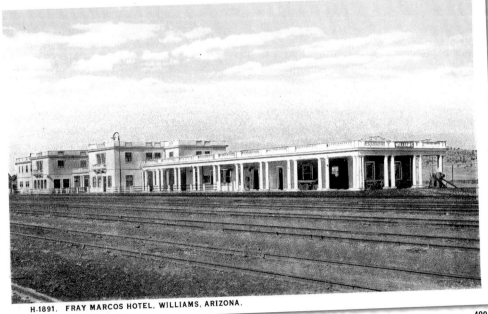

H-1891. FRAY MARCOS HOTEL, WILLIAMS, ARIZONA.

409

The Fray Marcos de Niza Hotel **(409)** was completed in 1908 and the Fred Harvey Company ran the restaurant. In 1989, the Grand Canyon Railway restored the structure to serve as the depot for its steam train excursions to the canyon.

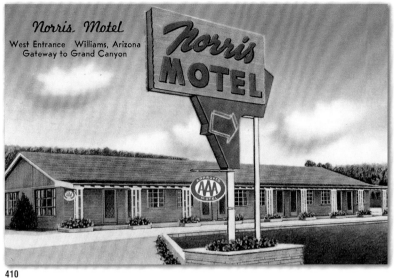

Norris Motel
West Entrance Williams, Arizona
Gateway to Grand Canyon

410

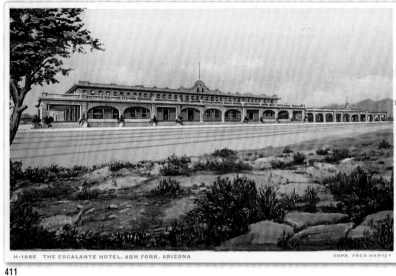

H-1885 THE ESCALANTE HOTEL, ASH FORK, ARIZONA

COPR. FRED HARVEY

411

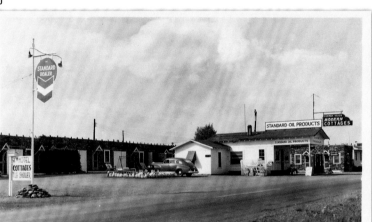

COPPER STATE COURT, ASH FORK, ARIZONA

X721

412

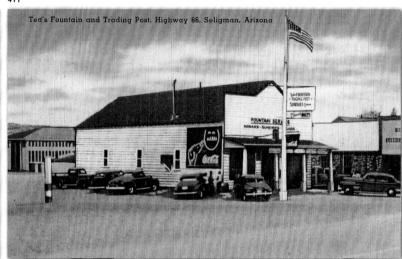

Ted's Fountain and Trading Post, Highway 66, Seligman, Arizona

413

LOOK.. for a sign of a Brontosaurus

The giant Dinosaur sign on Route 66 between Kingman and Flagstaff points your way to excitement, adventure and fun! Just a mile off the highway you'll find a beautiful 8,000 square foot Reception Center. You'll ride down an electric elevator 21 stories into the earth 300,000,000 years into the past to view the wonders pictured inside this folder.

In order to secure the very best elevator for this purpose we surveyed the entire industry and finally settled on The J. B. Ehrsam & Sons Mfg. Co.. Enterprise, Kansas — engineers, designers and builders of custom elevators for specialized assignments.

Back at the surface you'll dine deliciously in the lovely Juniper Room restaurant. And, of course, you will want to browse through the Dinosaur Caverns Curio-Gift Shop — one of the finest shops in the nation.

Plan now to come back again and again — to see the new caverns now being explored — to stroll the exciting paths of Dinosaur Park soon to be constructed. Visit our luxury mo... motel and service station... have every service... traveler.

Dinosaur Caverns are owned by Dinosaur Caverns, Inc., a publicly owned company with offices at the Caverns, P. O. Box 101, Dinosaur City, Arizona. ... Arizona.

NEW ENTRANCE to be completed in 1964. This huge concrete replica of the fierce, flesh-eating Tyrannosaurus Rex will be found crossing under the road with his head pointing toward the Caverns.
Dinosaur Caverns are easy to reach from every major attraction in Northern Arizona. They are open all year 'round.

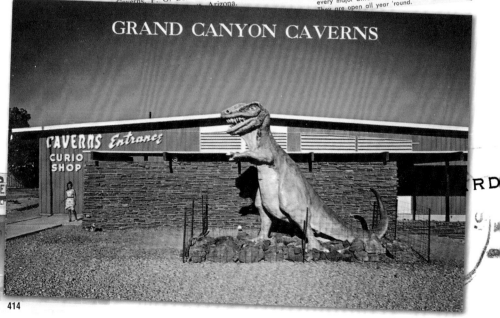

GRAND CANYON CAVERNS

414

Norris and Harold Hanson's firm constructed the Norris Motel **(410)** in 1953. It is now the Best Value Inn. The Harvey House **(411)** in Ash Fork was named for explorer Silvestre Escalante. Citizens tried to save it, but the landmark was torn down in 1968. Ezell and Zelma Nelson operated the Copper State Court **(412)** from 1928 to 1989, when it was sold to George and Brenda Bannister. The garages had railings for tying up horses.

Seligman's preserved Route 66 heritage makes it a popular tourist stop. Ted's Trading Post **(413)** is now Route 66 Historic Seligman Sundries. Angel Delgadillo of Seligman launched the Route 66 revival in 1987, when he founded the Historic Route 66 Association of Arizona. Angel's brother Juan entertained tourists at his Sno-Cap Drive-In. In 1927, Walter Peck was on his way to a poker game when he nearly fell into a deep cave entrance. Known as Yampai Caverns and then Coconino Caverns, it became Dinosaur Caverns in 1957 and Grand Canyon Caverns **(414)** in 1962. Ash Fork **(415)** was bustling until the Santa Fe Railroad moved the mainline in 1950. Interstate 40 opened in 1979, dealing another major blow and fires virtually wiped out the business district. The quiet town today boasts of being the Flagstone Capital of the World.

Peach Springs **(416)** is the headquarters of the million acre Hualapai Reservation. Hualapai means "People of the Tall Pine."

The Peach Springs Trading Post **(417)** predates Route 66. Note the swastikas. To the Navajo, the ancient "whirling log" was a sacred symbol. Imposed on an arrowhead, it actually appeared on Arizona state highway markers until 1942. A new cobblestone trading post opened in 1929.

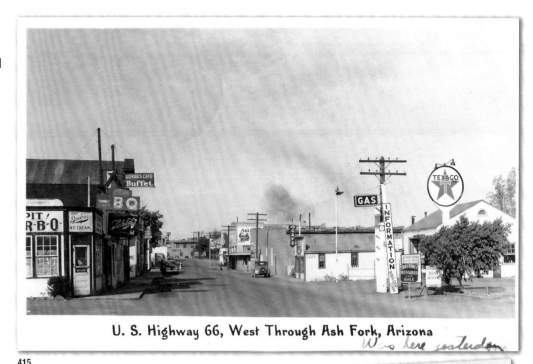

U. S. Highway 66, West Through Ash Fork, Arizona

415

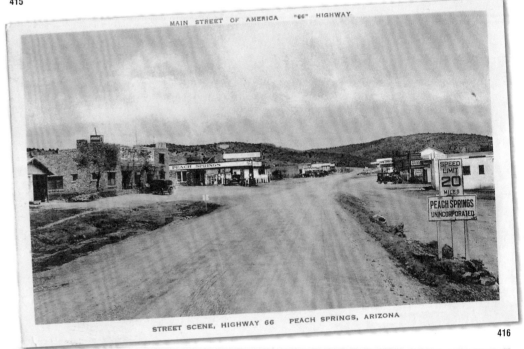

MAIN STREET OF AMERICA "66" HIGHWAY

STREET SCENE, HIGHWAY 66 PEACH SPRINGS, ARIZONA

416

PEACH SPRINGS TRADING POST, PEACH SPRINGS, ARIZONA

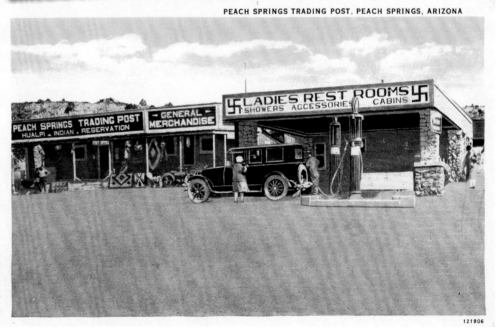

417

The Lockwood Café **(418)** opened in 1937 and served "Chicken in the Rough," the franchised chicken dinner developed by Beverly Osborne of Oklahoma City. The former café is now a church.

Roy Walker opened the City Café **(419)** in 1943, and it was operated by William McCasland for many years. The City Café became the Hot Rod Café, but was torn down in 2009.

Former Harvey Girl Clara Boyd and her husband Jimmy opened a café in 1933. They offered a coffeemaker to the winner of a contest to choose a name. Walter "Tuffy" Spaw came up with the Casa Linda **(420)**. The Casa Linda closed in 1964 and the building now houses a surveying business.

COOLED BY REFRIGERATION

LOCKWOOD Cafe

SPECIALIZING IN CHICKEN IN THE ROUGH

LOCKWOOD CAFE
HIGHWAY 66 — KINGMAN, ARIZONA

418

City Cafe and Texaco Station, Kingman, Arizona

419

EL TROVATORE COFFEE SHOP
DINING ROOM
COCKTAIL LOUNGE
Modern in every way, yet moderately priced.
FABULOUS STEAKS
Kingman, Arizona
"On Top Of The Town"
Photo by Dean Riggins
Pub. by Dean Riggins, 4638 E. Almeria Dr., Phoenix, Arizona
71108

CITY CAFE
AND TEXACO STATION
EAST KINGMAN, ON HIGHWAY 66
24-Hour Service. One of the really Fine Restaurants in Kingman, Arizona, Specializing in Good Food and Courteous Service. Established in March 1945, continuously under the Ownership and Management of Mrs. Willie McCasland. While you dine, your car will be completely and competently serviced by Arlise Finch.

Ate here - July 23 1957

Stayed across the street at the Siesta Motel. No pictures of it!

NEW CASA LINDA CAFE

Casa Linda CAFE

CAFE
FINE FOODS AND BEER

CASA LINDA CAFE — KINGMAN, ARIZONA

420

Arcadia Lodge

U. S. 66, Kingman, Arizona

The Arcadia Court **(421)** opened in 1938. Advertisements said it had the "Finest appointments for the fastidious guest." Frank and Susan Brace took over in 2001 and restored the property, now the Arcadia Lodge.

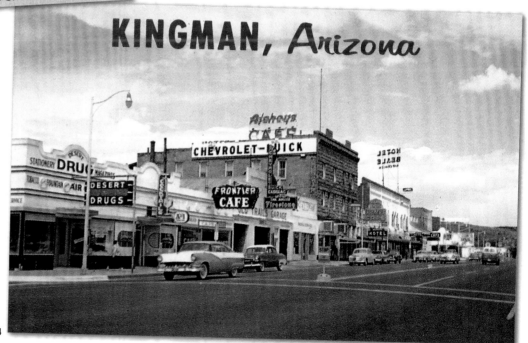

Arizona's Gateway to BOULDER DAM

KINGMAN, ARIZONA U.S. Highway No. 66

Note: Sleeping Dutchman

WHITE ROCK COURT - ON HIWAY 66 - EAST END OF KINGMAN, ARIZ.

Kingman **(424)** was founded in 1882 and named for railroad surveyor Lewis Kingman. Route 66 through town is named Andy Devine Avenue. An informative Route 66 museum is housed in the old powerhouse.

Johanna and Harvey Hubbs ran a boarding house that was purchased by Thomas and Amy Devine in 1906. They renamed it the Hotel Beale **(422)** in 1923, and then sold in 1926. Their son Andy Devine went on to fame as Guy Madison's sidekick in *The Adventures of Wild Bill Hickok* TV series. The Hotel Beale closed in 2000 and has fallen into disrepair.
Constructed in 1935, Conrad Minka's White Rock Court **(423)** was the cool place to stay. Minka drilled tunnels through solid rock into the mountain behind the motel, where he created an evaporative cooler with a water tank and burlap. Note the "Sleeping Dutchman" mountain.

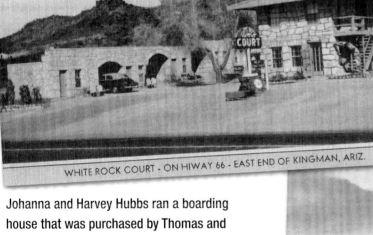

KINGMAN, Arizona

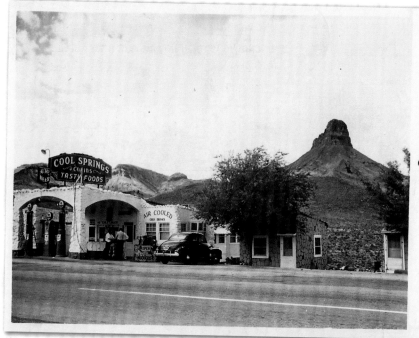

COOL
SPRINGS

THE ONLY
TOURIST
MART

On U. S. Hwy. 66
20 miles west
of Kingman
ARIZONA

E3911

Route 66 climbs into the Black Mountains where N.R. Dunton ran a pipe two miles to a spring and opened Cool Springs **(425)** in 1926. James and Mary Walker took over in 1936 and Cool Springs thrived until new highway opened in 1952. It later burned down and was partly rebuilt in 1991 to be blown up for the film *Universal Soldier*. Ed Leuchtner bought it in 2002 and resurrected the landmark.

425

426

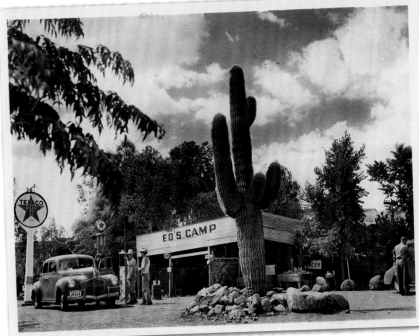

COOLEST
SPOT
ON THE
DESERT

21 miles west
of Kingman,
9 miles east
of Oatman
ARIZONA
on U. S. Hwy. 66

E3910

Prospector Lowell "Ed" Edgarton operated Ed's Camp **(426)**. One dollar rented a cot on a screened porch. The closed camp and its lone saguaro cactus are still there.

Route 66 climbs 1,400 feet in nine miles, reaching Sitgreaves pass at 3,550 feet.

The west side of the grade plunges **(427)** 700 feet in two miles to the remnants of Goldroad **(428)**, a former mining boom town mostly destroyed in 1949 to avoid new taxes. In the days of gravity fed carburetors, locals would drive up the hill backwards!

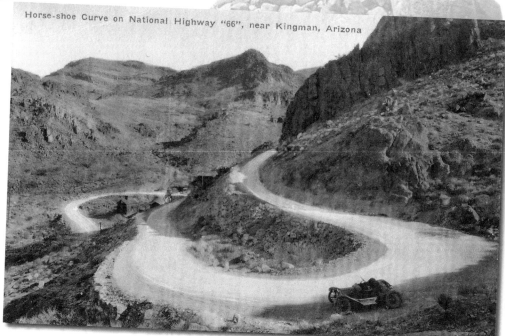

Horse-shoe Curve on National Highway "66", near Kingman, Arizona

427

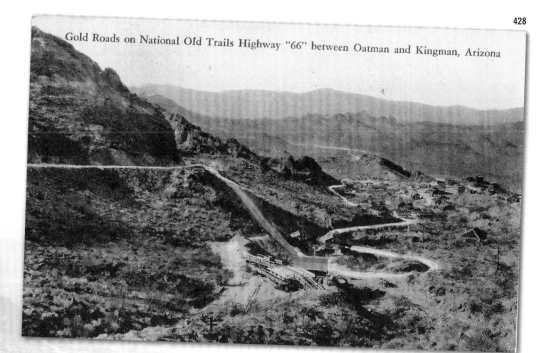

Gold Roads on National Old Trails Highway "66" between Oatman and Kingman, Arizona

428

Oatman **(429)** is named for Olive Oatman, held captive for years by Indians after her family was massacred. Oatman had 20,000 residents before the mines closed. New Route 66 bypassing Oatman opened on September 17, 1952. Within 24 hours, six of the seven gas stations in town had closed. The population fell to about 60. Oatman now attracts 500,000 tourists annually. The descendants of burros turned loose by prospectors roam the streets freely, bumming carrots from tourists and leaving mementos of their visit on the wooden sidewalks.

Colorful shops and cafes line the main street and shots ring out from staged gunfights.

429

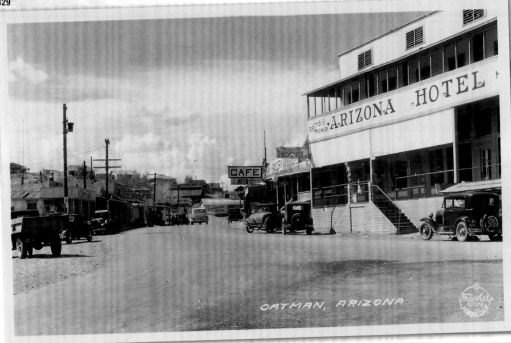

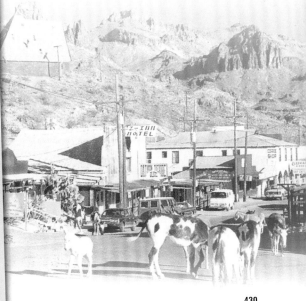

430

The graceful National Old Trails Arch Bridge **(430)** opened on February 20, 1916. The bridge was featured in the motion picture *The Grapes of Wrath*. The railroad bridge at left was converted to carry Route 66 in 1947 and replaced by the Interstate 40 Bridge in 1966. The Old Trails Bridge now carries a natural gas pipeline across the Colorado River.

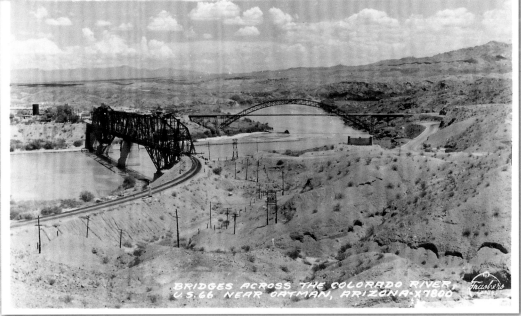

CALIFORNIA *The Golden State*

California, has been the Promised Land for the Dust Bowl refugees, those seeking Hollywood stardom, job seekers and vacationing families. Some of those travelers on Route 66 probably were disappointed with their first glance at the Golden State across the Colorado River. They found that a 150-mile stretch of brutal desert with few services for travelers was still ahead.

Needles is an important railroad town where icons such as the 66 Motel, the Palms Motel and the former El Garces Harvey Hotel/Santa Fe depot still stand. West of Needles, the post 1931 route is covered by Interstate 40, but the National Old Trails Road and early 66 is an easy drive along the railroad through Goffs. The road then runs straight as an arrow in many places where "towns" such as Essex, Chambless and Bagdad were little more than a lonely service station. Roy's Café and Motel at Amboy is a notable survivor.

Barstow is another important transportation hub, where Interstates 40 and 15 meet and the Casa del Desierto Harvey House houses a Route 66 and railroad museum.

Route 66 crosses a lovely 1930s era truss bridge approaching Victorville, home of the California Route 66 Museum. The Summit Inn still serves travelers at the summit before Route 66 plunges down the Cajon Pass. Interstate 15 covers much of Old 66 in the narrow pass, but a wonderful stretch of old highway begins at the Cleghorn Exit, a favorite with railroad enthusiasts.

It can take an entire day to negotiate the countless stoplights and suburban clutter between San Bernardino and the ocean, so many travelers choose the freeway. Route 66 follows Mt. Vernon Avenue through San Bernardino, where the first McDonald's opened in 1948. Just east of Rialto, the classic Wigwam Motel has been restored.

In Fontana, Bono's Historic Orange is one of the last of the orange shaped stands once common in California and there are still some 66 era remnants through Rancho Cucamonga, Upland, Glendora, Azusa, Monrovia and Arcadia.

Route 66 enters Pasadena along the Route of the annual Tournament of Roses Parade. Pasadena is a beautiful city with many architectural landmarks, including the 1913 Colorado Street Bridge over the Arroyo Seco. There are a couple of alignments into Los Angeles, but the Arroyo Seco Parkway (Pasadena Freeway) is scenic and historic. The first urban freeway west of the Mississippi River, the parkway opened in December, 1940. From 1953 to 1964, Route 66 used the Hollywood Freeway with its four-level interchange.

The Mother Road originally ended at 7th and Broadway in downtown Los Angeles, the heart of the theater and shopping district. The historic highway now follows Sunset Boulevard onto Santa Monica Boulevard, and the famous "Hollywood" sign is visible on the hill above. Hollywood landmarks like Grauman's Chinese Theater and the Walk of Fame are just to the north. Sixty-six through Beverly Hills crosses Rodeo Drive, the shopping district for the rich and famous. In West Hollywood, Barney's Beanery is one of the oldest restaurants in the Los Angeles area.

From 1936 to 1965, the official western end of Route 66 was at Lincoln and Olympic Boulevards in Santa Monica. But there are two symbolic ends to Route 66. A Will Rogers Highway marker is located in Palisades Park, where Santa Monica Boulevard reaches Ocean Avenue. Another sentimental end point is at the Santa Monica Pier. Here, travelers can dip their toes into the Pacific Ocean, celebrating making it "More than 2,000 miles all the way" as the famous song says.

The Palms CLEAN, AIR-COOLED MODERN COTTAGES

NEEDLES, CALIFORNIA Near Business District G. and O. AUSTIN

GROCERIES ◆ COLD DRINKS ◆ ICE ◆ EATS

431

POST

Needles, Calif. Hi-Ways 66 and 93

July 4 194_

Dear *Sis & Bro.*

We are staying at THE PALMS

The grand canyon was beautiful but sure had a hot thrilling ride this P.M. Will start across the desert about 1 A.M. How we wished you were along. lots of rain. Love

Susie, Bill & B.

432

Needles, California

NEEDLES

433

Greetings from
**NEEDLES
CALIFORNIA**

The Palms **(431)** was originally located on the west end of Needles, but the cabins were moved to the split at Front Street and Broadway in the late 1930s. It later became a bed and breakfast named the Old Trails Inn, but is now long term rentals. Needles **(433)** was founded in 1883, and the name comes from the jagged peaks of the Black Mountains. Route 66 originally followed Front Street, K Street, and Spruce Street to the Needles Highway. The later route followed Broadway. This wagon **(432)** serves as a welcome sign and photo opportunity on Route 66 entering Needles from the east.

The El Garces Harvey House and railroad depot **(434)** was named for a missionary, Father Francisco Garces. It closed in 1949. Allan Affeldt, owner of La Posada in Winslow, Arizona, began restoration in 2007.

H-2233 EL GARCES, FRED HARVEY HOTEL, NEEDLES, CALIFORNIA

434

Wayside —At Essex, Calif.

435

Essex offered the most traveler services between Needles and Amboy. The Wayside **(435)** was popular because it offered free water from a well out front. Only the post office is still operating today.

The Amboy Crater **(436)** is a volcanic cinder cone, 250 feet high and 1,500 feet in diameter. It is surrounded by 24 miles of lava flow. Volcanic activity in this area occurred as recently as 500 years ago.

Essex was the turn-off point to Mitchell's Caverns **(438)**, in the Providence Mountains State Recreational Area. Jack and Ida Mitchell originally developed the caverns for tourists beginning in 1934.

Bagdad was once a major shipping point for gold. Alice Lawrence operated the café **(437)** during its heyday, when it had the only juke box and dance floor for miles. It closed in 1972 and inspired the 1988 movie *Bagdad Café*. The film was actually shot 50 miles to the west in Newberry Springs. No trace of Bagdad remains today.

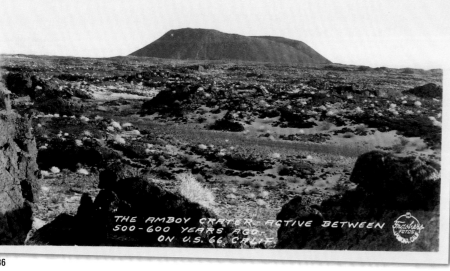

THE AMBOY CRATER ACTIVE BETWEEN 500-600 YEARS AGO. ON U.S. 66 CALIF.

436

437

STOP AND SEE "DAVE" FOR CALIFORNIA TRAVEL INFORMATION BAGDAD, CALIFORNIA — 210 MILES EAST OF LOS ANGELES ON HI-WAY "66"

438

Mitchell's Caverns
23 MILES FROM ESSEX, CALIF.
275 MILES EAST OF L.A. on U.S. 66

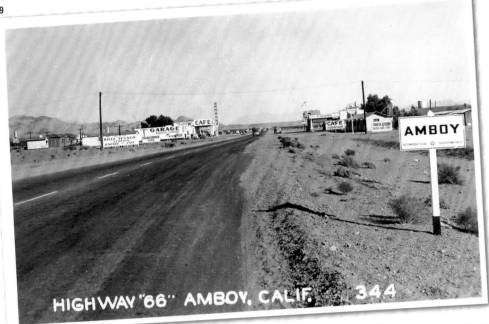

HIGHWAY "66" AMBOY, CALIF. 344

Amboy **(439)** was established as the first in a series of railroad stops between Barstow and Needles named alphabetically from West to East. After Amboy, those stops were Bolo, Cadiz, Danby, Essex, Fenner, Goffs, Homer, Ibis, Java and Khartoum. There were several roadside businesses in Amboy until Interstate 40 opened in 1972.

Roy and Velma Crowl opened Roy's **(440)** at Amboy in 1938 and Roy became partners with his son-in-law Buster Burris in the 1940s. The famous sign was erected in February 1959. Burris owned Amboy from the 1970s to 1995. Restoration began after Albert Okura, owner of the Juan Pollo restaurant chain, purchased the town in May 2005.

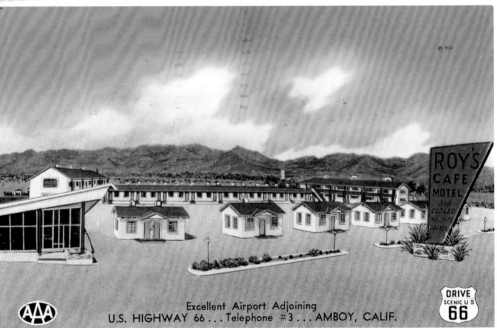

Roy's Cafe & Motel
U.S. Highway 66... Telephone #3
AMBOY, CALIFORNIA
Ceramic Tiled Showers... Air Cooled.
Vented Panel Ray Heat... Cross Ventilation
Excellent Airport Adjoining... Garage.
Roy Crowl and "Buster" Burris, Owners & Operators

Excellent Airport Adjoining
U.S. HIGHWAY 66... Telephone #3... AMBOY, CALIF.

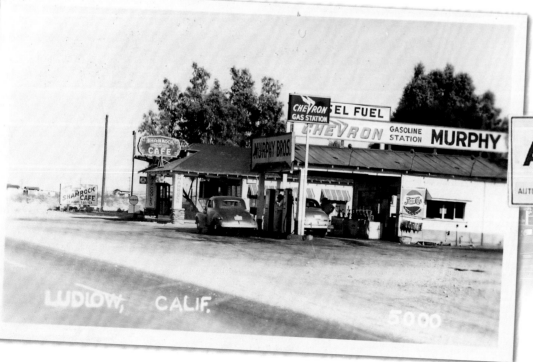

LUDLOW, CALIF. 5000

Water had to be brought in by tanker car to the isolated community of Ludlow, named after the man who repaired Santa Fe railcars. The Murphy brothers owned much of the town, including a general store and the station shown here **(441)** on Route 66. These buildings are in ruins today.

An important subsidiary line met the Santa Fe at Waterman Junction. In 1886, the community was named Barstow **(442)** for William Barstow Strong, the president of the railroad.

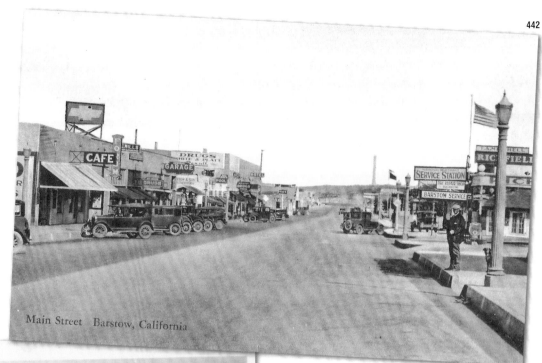

Main Street Barstow, California

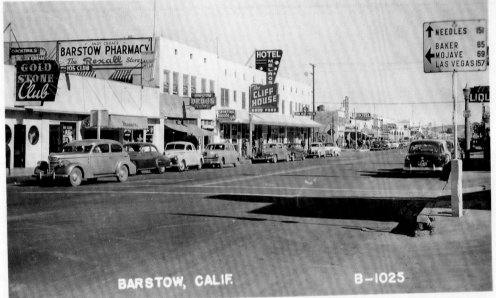

BARSTOW, CALIF. B-1025

The Barstow business district **(443)** was originally located near the Harvey House and railroad shops. It was shifted to Main Street in 1925, due to railroad expansion.

Barstow continued to be a major junction point when the highway system was laid out. U.S. Route 66, 91 and 466 converged here. Today, busy Interstates 10 and 15 meet in Barstow.

Barstow's Casa del Desierto ("House in the Desert') Harvey Hotel **(444)** was completed in 1911. The City of Barstow saved it from demolition in 1989. It now houses the bus and Amtrak stations, along with the Mother Road Route 66 Museum and the Western America Railroad Museum.

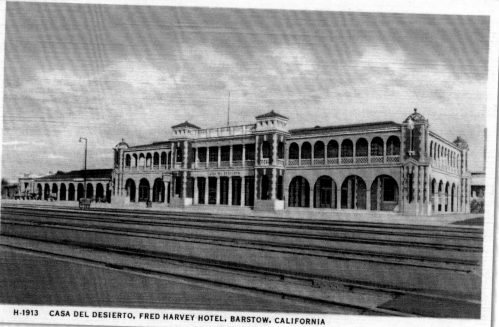

H-1913 CASA DEL DESIERTO, FRED HARVEY HOTEL, BARSTOW, CALIFORNIA

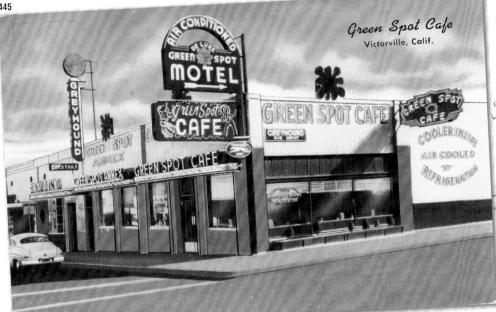

Green Spot Cafe
Victorville, Calif.

Hello Florence,
How are you and
Fred. I finally made
it to California - by
car - it has been a
wonderful trip and
I'm enjoying it
Love and best
wishes
Roberta
P.S. We stayed here last

Mrs. F. Pence
Xenia
Ohio

445

446

Victorville was known as Mormon Crossing, and then a railroad stop called Huntington Station. It was later named for railroad car repairman Jacob Nash Victor and changed to Victorville **(445-446)** in 1901 because of mix ups in the mail with Victor, Colorado. The Victorville area was once a popular spot for filming western movies and was the home of the Roy Rogers Museum. Cajon Pass **(447)** has been the gateway to Southern California for centuries, used by Indians, missionaries, pioneers, the railroad and finally by Route 66. The first paved roadway opened in 1916. Another route was constructed in 1931 and Route 66 was upgraded to four lanes in 1953. I-15 replaced 66 in 1969.

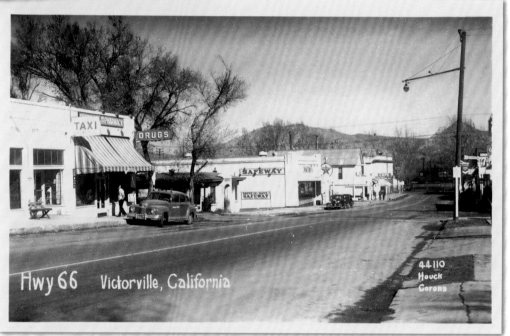

Hwy 66 Victorville, California

44,110
Houck
Corona

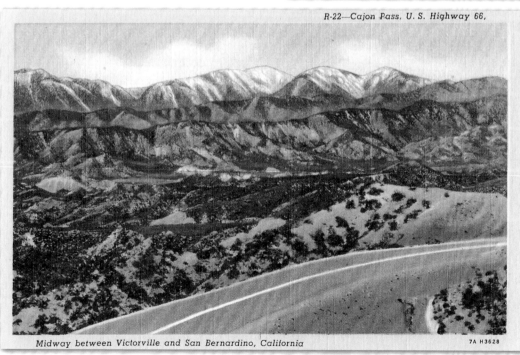

R-22—Cajon Pass, U. S. Highway 66,

Midway between Victorville and San Bernardino, California

7A H3628

447

The Spanish established the mission of San Bernardino in 1810. The mission closed in 1834, but the site became an important stopping point on the Spanish Trail and Mormon immigrants founded the town in 1851.

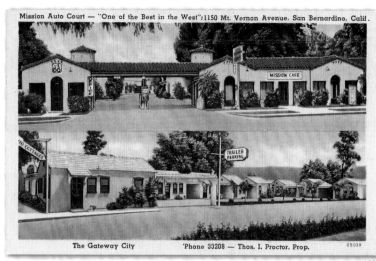

Mission Auto Court — "One of the Best in the West"; 1150 Mt. Vernon Avenue, San Bernardino, Calif.

The Gateway City 'Phone 33208 — Thos. I. Proctor, Prop.

450

Thomas Proctor's Spanish Style Mission Auto Court **(450)** was constructed in 1935. Route 66 through San Bernardino followed Cajon Boulevard to Mt. Vernon Avenue, past the 66 Motel **(451)** and the Le Mae Motel **(453)**. The route turned west at 5th Street and curved onto Foothill Boulevard City Route 66 used Kendall Drive to E Street and 4th Street. The world's first McDonald's was located at 14th and E Streets, where the McDonald's Museum is today. The Spot Café **(448)** was located at the intersection of Route 66, Kendall Drive (City 66) and Business U.S. 395 east of San Bernardino.

The Mount Vernon Motel **(452)** was on Mt. Vernon Boulevard, just south of the intersection with Cajon Boulevard. The fire department burned it down for practice. Andy's Motel **(449)** is now the Lido Motel.

Motel 66

1400 No. Mt. Vernon Ave. (U.S. 66, 395 & 91)
San Bernardino, California

451

Mt. Vernon Motel

"*San Bernardino's Finest*"
2140 Mt. Vernon Ave. (U. S. 66 - 395 - 91)
San Bernardino, Cal.

452

Le Mae Motel

1860 Mt. Vernon Ave. (U.S. 66, 395 & 91)
SAN BERNARDINO, CALIF.

448

449

Andy's MOTEL

2180 N. Mt. Vernon Ave.
San Bernardino, Calif.
Hospitality Is Our Specialty

453

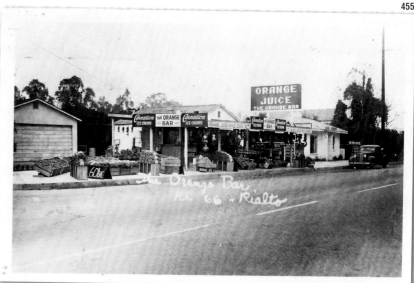

The Wigwam Motel **(454)** in Rialto was the last of seven to be constructed, opened by Frank Redford in 1949. It had fallen on hard times, as evidenced by the slogan "Do it in a Teepee," but was resurrected by Manoj Patel.

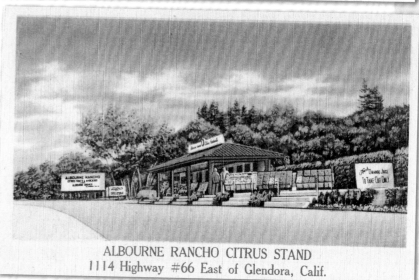

ALBOURNE RANCHO CITRUS STAND
1114 Highway #66 East of Glendora, Calif.

The "Inland Empire" was once known for its citrus groves, and orange stands lining the route. They included this example **(455)** at Foothill Boulevard and Eucalyptus Avenue in Rialto and the stand at the Albourne Rancho **(456)**. West of the Wigwam, an original stand shaped like an orange sits next to Bono's Restaurant. Route 66 follows Huntington Drive through Duarte. The Hi-Way 66 Foothill Motel **(457)** became the Capri Motel, but was torn down for a housing development in 2008. The Sportsmen's Tavern **(458)** catered to the upper class, offering wild game that was raised on the property.

152

In Glendora, Route 66 originally jogged north to stay on Foothill Boulevard and later shifted to Alosta Avenue. Monrovia also has two Route 66 alignments. The oldest followed Foothill Boulevard, past the Casa Bonita Motel (459).

The route later was shifted to the south over Huntington Avenue, where the Oak Park Motel (460) is still in business.

MOTEL CASA BONITA "Sweetest on 66" MONROVIA, CALIF.

Oak Park Motel, 925 E. Huntington Drive (U.S. 66) Monrovia, Cal.
One of Los Angeles' Newest and Finest Luxury Motels

Mon-Arc Motel
917 W. Huntington Drive (U. S. 66)
MONROVIA, CALIF.
One Mile East of Santa Anita Race Track

A Honeymoon Suite

The WESTERNER HOTEL
Arcadia, Calif.

Heated Pool and Sun-Deck

The Mon-Arc Motel (461) was located a mile east of the famous Santa Anita horse racing track. The track parking lot was used as a Japanese internment camp during World War II.

In Arcadia, Route 66 turns onto Colorado Place, where the Westerner Hotel (462) is now the Elite Westerner Inn and Suites.

463

Carpenter's
125 W. Huntington Dr. (Santa Anita)
Arcadia, Calif. Phone DO-79980

Harry Carpenter operated several other restaurants, all offering Beverly's Osborne's Chicken in the Rough. A menu for Carpenter's **(463)** in Arcadia noted that all their pies "Are Baked on the Premises by a Woman Pastry Chef."

The Hillcrest Restaurant **(464)** in East Pasadena was later known as Pat Mitchell's El Rancho Hillcrest, the "Restaurant with a Conscience." A "Gentleman's Club" is listed at this address today.

The Frontier Drive-In **(465)** was across from the Santa Anita Race Track. It was torn down in the 1960s to make room for a gas station.

464

465

Located in Arcadia
250 W. Colorado
(Across from Santa Anita Race Track)

Virginia Draper opened Draper's House of Modes **(466)** in 1927. That first store grew into Draper's and Damon's, which has 44 locations and a catalog circulation of 30 million. The building is now a dentist's office.

Room rates started at $2 at the Grand Motel **(467)**, owned by Abraham Koslow. It was later managed by Mr. and Mrs. Hans Holm. The Quality Inn Pasadena Convention Center is located here today.

Gwinn's **(468)** was both a sit-down and drive-in restaurant, designed by Harold Bissner and Harold Zook. It later became Benji's and the site is now an overflow lot for a car dealership.

466

DRAPER STUDIO of MODES
Ladies Ready to Wear
1855 E. COLORADO ST.
N. PARKWOOD BLVD.

467

GRAND MOTEL EXCELLENT

on Highway 66 GRAND MOTEL
Pasadena, California

POST CARD

Mrs Sui C. Wright
3136 E. Third St
Tulsa
Oklahoma

468

GWINN'S RESTAURANT and DRIVE-IN
2915 E. Colorado Blvd. (U. S. 66) Pasadena, Calif.
One of Pasadena's Finer Restaurants

The 1926-1931 route approaching Los Angeles originally followed Fair Oaks Avenue through South Pasadena, then onto Huntington Drive and North Broadway. From 1931-1934, it turned from Fair Oaks onto Mission Street, where the landmark Fair Oaks Pharmacy is located. Route 66 then moved to cross the Colorado Street Bridge and turn southwest on Figueroa Street through Highland Park. Figueroa became Alternate 66 when the Arroyo Seco Parkway opened in 1940. At the time, it was expected that the freeway would "solve traffic congestion for all time to come." The parkway is now six lanes of pandemonium with a high rate of accidents due to the curves and very short ramps.

Located 3875 E. Colorado, Pasadena 8, Calif.

Bella Vista Motor Court
on Highway 66 3448 E. Colorado St.
Pasadena, California

CROQUET AND BADMINTON

WESTER HOSPITAL

469

470

Bennie Taylor ran the restaurant at the Altadena Country Club **(469)** before opening his own place, offering all you could eat for $1.75.

Owners of the Bella Vista Motor Court **(470)** included Mr. and Mrs. George Farmer, Charles Sanders and Charlotte and Frank Karbiner. The site is now an auto dealership.

The Arroyo Seco Bridge **(471)** opened in 1913 and carried Route 66 from 1936 to 1940. Eleven concrete arches span the 150 foot deep Arroyo Seco. A barrier was added in 1993 to deter jumpers from the structure sometimes known as Suicide Bridge.

The Arroyo Seco Parkway **(475)** linking Pasadena and Los Angeles opened on December 30, 1940, the first freeway west of the Mississippi. It was named the Pasadena Freeway in 1954 and became California 110 in 1981.

P-4 ARROYO SECO, COLORADO STREET BRIDGE, SHOWING HOTEL VISTA DEL ARROYO,

PASADENA, CALIFORNIA

1A-H456

471

473

3589 E. COLORADO BLVD.
PASADENA, CALIF.

472

The building occupied by Fisher's **(472)** now houses the Gin Sushi Restaurant. Mr. and Mrs. K.H. MacKenzie were owners of the Gypsy Garden Motel **(473)**.

Pasadena (474) was founded by Midwesterners looking to escape the harsh winters. At one time it had the highest per capital income in the U.S. Three of the Figueroa Street Tunnels (476) on the Arroyo Seco Parkway were constructed in 1931 and a fourth opened in 1936, when Route 66 was routed through the tunnels. They carried northbound and southbound traffic until 1970, and now carry only northbound traffic.

Each New Year's Day, the world focuses on Colorado Boulevard for the Tournament of Roses Parade (477), first held in 1890. A college football game was added in 1902 and the Rose Bowl Stadium opened in 1923. It once had a capacity of over 100,000 people.

474

Business District, Colorado Blvd., Pasadena, Calif.

475

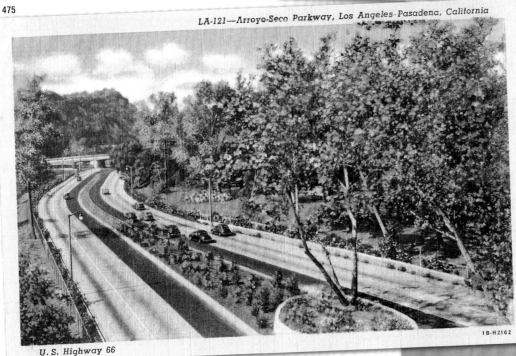

LA-121—Arroyo-Seco Parkway, Los Angeles-Pasadena, California

U. S. Highway 66

476

LA-12 BOULEVARD THRU ELYSIAN PARK, LOS ANGELES, CALIFORNIA

Greetings from the **Tournament of Roses** PASADENA CALIFORNIA

477

California - The Golden State

Eminent domain was used to force the Mexican-American community out of Chavez Ravine for a proposed housing project. When that plan was abandoned, the city sold the land to the Los Angeles Dodgers. Dodger stadium **(478)** opened in 1962 and also was the home of the California Angels from 1962 to 1965. The Beatles played their second to last concert here in 1966. The Paradise Motel **(483)**, with its purple neon, still stands on Sunset Boulevard, although the Texaco station is gone. From 1926 to 1936, Route 66 ended at 7th and Broadway **(479)**, the heart of the historic Broadway Theatre District. The route was then extended over Santa Monica Boulevard **(484)**, turning onto Lincoln Boulevard briefly before terminating at Olympic Boulevard.

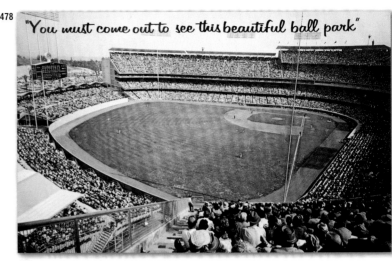

478

"You must come out to see this beautiful ball park"

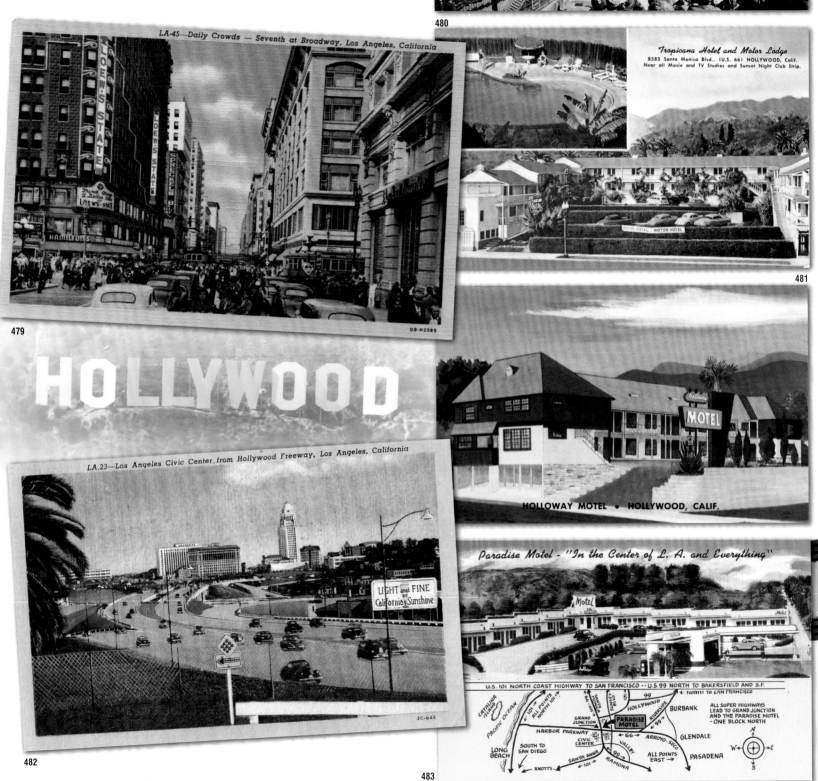

480

LA-45—Daily Crowds — Seventh at Broadway, Los Angeles, California

479

Tropicana Hotel and Motor Lodge
8585 Santa Monica Blvd., (U.S. 66) HOLLYWOOD, Calif.
Near all Movie and TV Studios and Sunset Night Club Strip.

481

HOLLYWOOD

LA-23—Los Angeles Civic Center, from Hollywood Freeway, Los Angeles, California

LIGHT and FINE are California's Sunshine

482

HOLLOWAY MOTEL • HOLLYWOOD, CALIF.

Paradise Motel - "In the Center of L. A. and Everything"

U.S. 101 NORTH COAST HIGHWAY TO SAN FRANCISCO -- U.S. 99 NORTH TO BAKERSFIELD AND S.F.

483

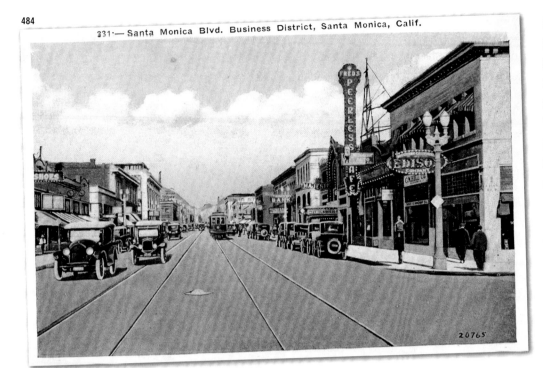

484

231.— Santa Monica Blvd. Business District, Santa Monica, Calif.

Before the Hollywood Freeway (482) opened on December 27, 1950, Route 66 followed Sunset Boulevard before turning onto Santa Monica Boulevard Los Angeles City Hall at right center was constructed in 1928 and was featured in the TV series "Superman" and "Dragnet." The famous Hollywood sign atop Mt. Lee is visible from Route 66. It was erected in 1923 and originally spelled out "Hollywoodland," promoting a real estate development named after Hollywood, Ohio. The Holloway Motel (481) is still in business today. The Tropicana Motel (480) and Motor Lodge in Hollywood developed into the Ramada Plaza Hotel. Route 66 continues through West Hollywood and Beverly Hills, into Santa Monica. Jim Morrison of the Doors often stayed at the Alta Cienega Motel (485) because it was close to the band's office.

Alta Cienega Motor Hotel,
1005 No. La Cienega Blvd. (U. S. 66 at Santa Monica
Los Angeles 46, Calif.

"Most Centrally Located to all Points of Interest."

n Restaurant Row, Close to Studios and Broadcasting Stations, Night Clubs and Beaches.

485

Wm. Tell Motel and Apts.
2509 Santa Monica Blvd., Santa Monica, Cal.
on U. S. 66
Will Rogers Highway

486

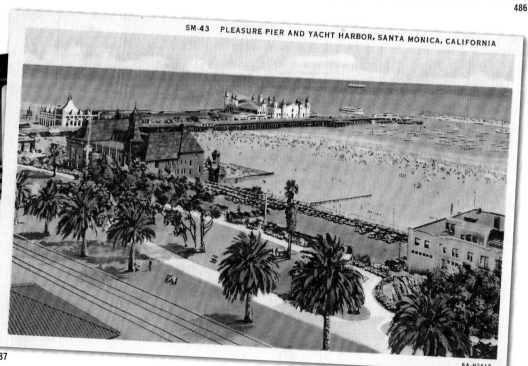

SM-43 PLEASURE PIER AND YACHT HARBOR, SANTA MONICA, CALIFORNIA

The $1.5 million dollar William Tell Motel and Apartments (486) offered a lush tropical setting. The site is now a chain pharmacy. The Santa Monica Municipal Pier (487) opened in 1909 and the amusement pier was added in 1916. The neon sign made its debut in 1941. Officially, Route 66 never extended to the Santa Monica Pier, but it serves as a more satisfying symbolic end to the journey.

487

Index

Printed in Italy by Nuovagrafica (Carpi, Modena), may 2011

FSC
www.fsc.org
MIX
Paper from
responsible sources
FSC® C074518